# CHRISTOPHER WILMARTH

# CHRISTOPHER WILMARTH:
## LIGHT AND GRAVITY

## STEVEN HENRY MADOFF

WITH CONTRIBUTIONS BY
NANCY MILFORD AND EDWARD SAYWELL

PRINCETON UNIVERSITY PRESS
PRINCETON AND OXFORD

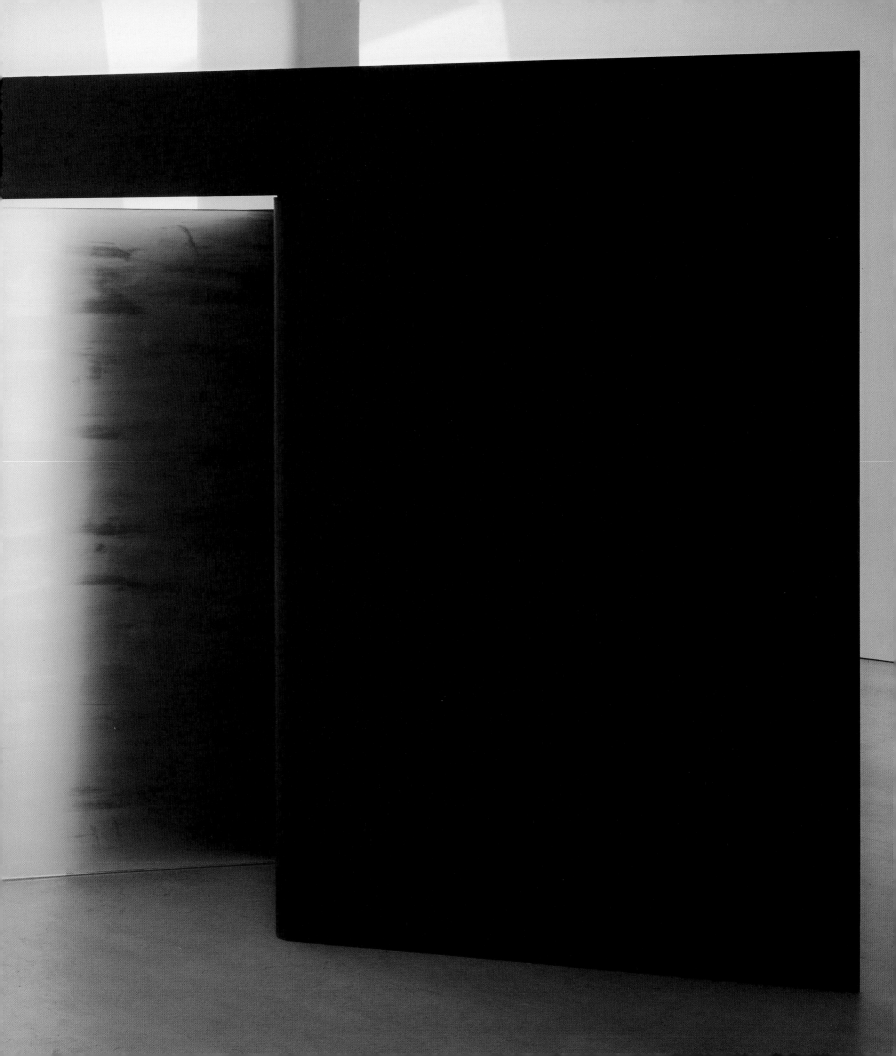

## ACKNOWLEDGMENTS

This book would not have been possible without the generous support of Edward R. Broida, Maxine and Stuart Frankel, the Maxine and Stuart Frankel Foundation for Art, Agnes Gund and Daniel Shapiro, Richard Menschel, and Stephen and Dorothy Weber. We are deeply grateful to them and to the artist's widow, Susan Wilmarth-Rabineau, and his longtime dealer, Betty Cuningham, who shared their knowledge, memories, and moral support throughout the long process of bringing this book into print.

Cover: *The Whole Soul Summed Up . . .*, 1979–80 (detail of plate 93)

Frontispiece: *Days on Blue,* 1974–77 (detail of plate 77)

Published by Princeton University Press, 41 William Street, Princeton, New Jersey 08540
In the United Kingdom: Princeton University Press, 3 Market Place, Woodstock, Oxfordshire OX20 1SY
pup.princeton.edu

Designed by Joel Avirom
Design assistants: Jason Snyder and Meghan Day Healey
Composed by Duke & Company, Devon, Pennsylvania
Printed by Bolis Poligrafiche, Bergamo, Italy

Printed and bound in Italy
10 9 8 7 6 5 4 3 2 1

*Library of Congress Cataloging-in-Publication Data*
Madoff, Steven Henry.
  Christopher Wilmarth : light and gravity / Steven Henry Madoff, with contributions by Nancy Milford and Edward Saywell.
    p.  cm.
  Includes bibliographical references and index.
  ISBN 0-691-11359-9 (alk. paper)
   1. Wilmarth, Christopher.  2. Sculptors—United States—Biography.  I. Milford, Nancy.  II. Saywell, Edward.  III. Title.

NB237.W523M33 2004
730'.92—dc22
[B]    2004041464

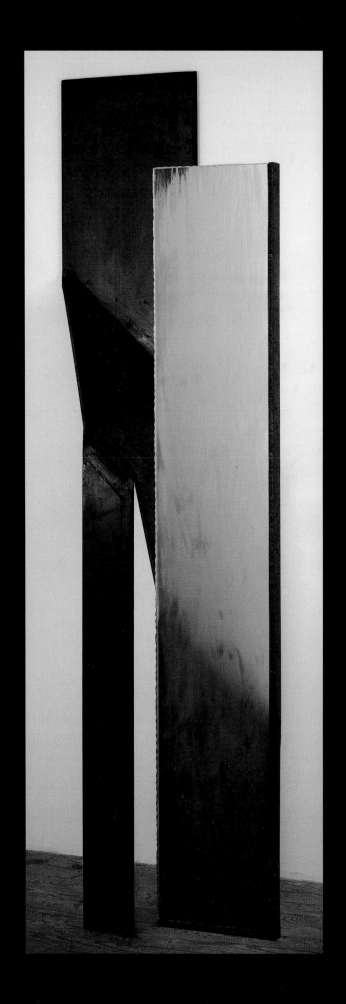

*Works of art are always
the product of a risk
one has run, of an
experience taken to its
extreme limit, to the
point where man can
no longer go on.*
—RAINER MARIA RILKE

*Two forces rule
the universe:
light and gravity.*
—SIMONE WEIL

# LIGHT AND GRAVITY:
# THE ART AND TIMES OF CHRISTOPHER WILMARTH

## Steven Henry Madoff

The lovely thing about glass—if you can invest the inanimate with mercurial intelligence, and the central figure of our story surely did—is how it loves the light and changes it. Glass has the cunning ease of a magician with a white handkerchief that turns, miraculously, into a wriggling rabbit; what carefree wonder! Yet who among us hasn't stared into a sheet of glass and seen what looks like the true pallor of our tiny selves, floating off as the dark comes down? Over his brief and tragic creative life, Christopher Wilmarth came to know the moods of glass so fluently that it seemed like a well of mortal time. It held his eye in a plane of light. It was entirely dream worthy.

Wilmarth's love of glass began with the sea and the city and island light. He arrived in New York in 1960 to study at the Cooper Union for the Advancement of Science and Art; a boy of seventeen come from San Francisco, come from the soft, golden light of the West to the whiter, somehow more angular light reflecting off the Hudson and the great harbor at Manhattan's southern tip. The Fulton Fish Market still occupied the piers, and Wilmarth found himself there one day in 1963, staring at ice. He took its photograph (plate 3). The fish lay in ice-packed crates and the light glistened, catching the glinting scales, the discs of eyes, but the ice itself seemed to hold fathoms of space, an illusion of depths, and Wilmarth, a young sculptor, was in the habit of crafting space and volume. He loved the mystery of the light at different times of day, and the ice caught that, too. What else could capture it?

Glass. In the years ahead, not too far ahead in fact, it would become his ideal material to summon all the light of the day, embodying "things that physically exist," as he put it, "only to locate that which doesn't."[1] And it seems now, in the easy wisdom of hindsight, a material smartly suited for the times. There were vast ranges of expression to taste in the

LEFT, PLATE 2
*Zinc Wall*, 1963. Zinc and wheel on wood panel, 18 × 12¼ × ⅞ in. (45.7 × 31.1 × 2.2 cm). Estate of Christopher Wilmarth, New York

BELOW, PLATE 3
*Ice, Fulton Fish Market*, 1963. Photograph, 6½ × 4⅜ in. (16.5 × 11.1 cm). Estate of Christopher Wilmarth, New York

art world of the mid-1960s, as there are today. Wilmarth was on his own, just testing the pavement's grit after graduating from Cooper Union in 1965, hunting the streets and his light-hungry imagination for an art that would be his alone. But unlike today, when no aesthetic dominates the table, the biggest portions then were given to two overarching sensibilities.

On the one hand was Pop art's razor-edged ironies of postwar America, its glut and splendor. Say, Roy Lichtenstein's cartoon catalogue of secondhand emotions and firsthand goods; say, Andy Warhol's glare of cash and death, his grainy silkscreen paintings of Green Stamps and car crashes, his Elvises brooding gorgeously with a gun. Pop was brightly illustrative, with its brilliant smile and air-conditioned laugh, and its dissection of the American way was nothing less than clinical.[2] On the other hand was Minimalism—no less chilling, though given to a different notion of material ascent. Here was an abstract art of reduction, of three-dimensional objects bristling with rigor, with the stripped-down glory of the industrial thing itself—aluminum, steel, bricks, pure geometries and the "obdurate identity" of materials, as the artist Donald Judd called them in his famous essay "Specific Objects."[3]

For a sculptor coming up at that extraordinary moment in American art, the seduction of this austere work seemed to speak with the rectitude of an almost Emersonian self-reliance.[4] It jettisoned the ritz of Pop. It threw off the angst-driven drama of the self that was so much the signature of Abstract Expressionism, which had ruled the art scene in the 1950s. This strict art, with its authority of grids, severe surfaces, and repeated shapes, had the look

of inevitable logic, of a new sculptural landscape that found a kindred spirit in the boxy International-style buildings towering in midtown Manhattan.

The idiom of Minimalism was all around Wilmarth. It couldn't help but influence his hand. In any case, he spent his days making boxes: cabinetry to help pay a young sculptor's rent. Some of those cabinets had glass fronts. Glass is an industrial material, too: flat, shiny, hard, cool, and yet open to the warming possibilities of light. It fit the times as a sculptural material that wasn't much used in art—hadn't been used much since the days of Constructivism in the early decades of the century—and it also fit Wilmarth's private needs. It suited his emotional tenor. It was his blade to grind against the common wheel.

How could the young Wilmarth know that the art world he inhabited in the middle of the 1960s, with its torrent of theories and rapidly dealt deck of styles, was playing out the end of the modernist traditions rooted in the works of Auguste Rodin and Paul Cézanne nearly a century before? Yet Wilmarth's art, for all its ticking invention, is an emblem, I think, of that closing moment. Something unique and ravishing is there; something truffling through the canons of modernism, consuming, adventuresome, yet conservative, too. And when he died, when he hanged himself in his studio at the age of forty-four, sunk in the pit of depression, his last works showed no less fidelity to the traditions he admired. Within Wilmarth's sculpture is a select museum of modernism, light-flecked and quiet, swallowed whole by time.

To think of Wilmarth's work is to imagine time's arrow reversed, shooting backward through twentieth-century art, tracing its ordered course, as the dominant art historians of the last century wrote and taught us. Wilmarth loved the narrative, and he loved his particular household gods: Cézanne, Brancusi, Matisse, Giacometti. He writes carefully in a notebook from his second year at Cooper Union: "*Cézanne Cont.* He was concerned with the structure of the objects & their relation to other objects. He negated the Renaissance concept of perspective because the objects would shoot out the back of the picture—He stressed the play of things."[5] The good student learns his lesson well; "the play of things" will prove the everlasting summary of Wilmarth's way with light and shadow.

That same year, 1961, he constructs a little wooden piece called *Structure (A Man's Back)* (plate 4), a precocious homage to Brancusi's *Kiss* (plate 5), which was made, of course, in another world and time. But the romantic in Wilmarth is alive. He breathes the past in and breathes it out. The piece speaks a rough patois of Cubism and Constructivism, but its enwrapping arms come straight from Brancusi. Here the play of things begins.

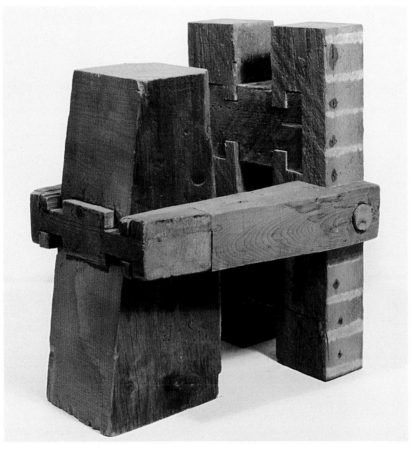

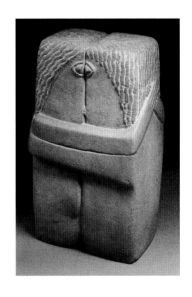

The space between Wilmarth's lovers—she of the softened angle of the back, he of the stolidly rectilinear with regimented stripes to affirm flatness and geometry—is sweetly open. They are as much front as back, and despite the title the woman surely seems the point as much as her suitor. The air between them is telling, as we will see. It's a little pocket of unconsummated longing, which can be seen another way: as a small clearing, a welcoming space to dream.

Years later, in a notebook kept from 1974 to 1976, the sculptor copies out a quotation from Matisse: "I have never avoided the influence of other people. I should have considered that as cowardice and a lack of sincerity towards myself."[6] In fact, Wilmarth never expressed anything but love for the influences of the past on his work. He may have understood the history of modernism as a chain of episodic ruptures; a continuous siege on the questions of what an artwork is and how it addresses the perceiving eye, as all the manifestos from Suprematism to Surrealism, Futurism to Fluxus loudly cry.[7] Yet it was still a chain, just as Cézanne once said, "One does not substitute oneself for the past; one merely adds a new link to its chain." So it was with Wilmarth: he didn't believe in any one art as the last thing.

STEVEN HENRY MADOFF

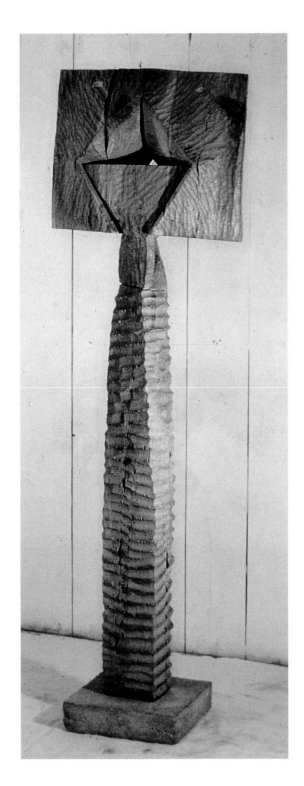

In the second half of the sixties, the studious hunger of his eye is clear; he is building the museum inside his works. Even earlier, the drawings made at Cooper Union of two women—his young lover, Susan Rabineau (who became his wife in 1964), and a classroom model named Yolande—are love letters to Matisse. Wilmarth is smitten with the long curve of a tapering line rich with the submissive gravity of flesh. The draftsman's ode is clear: the voluptuous is a matter of touch. Yet it's more, and more in two ways. You can feel the pressure of the charcoal intimating the cushion of flesh, a fullness from within, the ripeness of matter. But while the drawing is meant to represent a luxurious, even fertile, body, it is also about drawing itself: a bountiful field for the seeds of the young artist's style.

There are drawings of Yolande and of Susan that exude the confidence of a fluent, learning hand. They get the numinous flesh and the Matissean distribution of elegant black strokes that coalesce as spare, decorative, and airy all at once and translate the frank pleasure of being. I don't think it's too reductive to say that being is the grounding subject of aesthetics, and artistic developments as they play out in theories and styles are the different ways we've tried to corner the slipperiness of being. Wilmarth's early art already shows his particular sensitivity to that slipperiness—a yielding to the elusive—and any number of his beginning works find their ways into the mist around the definite. Just think of the title of another of his early sculptures, *Her Sides of Me* (plate 6), a carved Brancusian column/figure with a head that shows the influence of African art not on Wilmarth so much as on the Cubists and on Brancusi, who influenced him. The modernist history of styles is churning in that internal museum of his art, yet the title of the work, with its sidelong address to Susan, is about openness, multiple meanings, and the invitation of the indefinite. We've entered the territory of Arthur Rimbaud's famous remark, "Je est une autre"—I is an other—but absent the alienation. Here male and female are joined with a phallic, receiving shudder of the romantic and the sexual, half hermaphrodite, half Don Juan, split and fused. The permutations are the point. The sexual evocation is of Wilmarth's evolving but abiding focus, the wished-for porosity of things: skin, matter, identity.

You see it again—the traffic between inside and outside, between being and style—in a Yolande drawing that offers a slipstream of still loosely Matissean lines, now forced to flow around what can only be called an implant; an operation that wouldn't have been possible without the dream-soaked collage world of Surrealism (plate 7). The seductiveness of styles is easily mated to the desirousness of the drawing's subject. The juxtaposition of forms happily startles us: a thing shaped like a heart, shadowy and plush in the murk of rubbed charcoal, is pushed into the middle of this otherwise elegantly cambered drawing of the figure. Two styles—one seeing the real and one unseating it; Matisse's sharpness and ease and Surrealism's peek under the hood of surface motivations—are yoked by violence together, as Samuel Johnson said of metaphor. Skin and interior, consciousness and subconscious, are abruptly and simultaneously in sight. And to add to this density, that heart is somehow breastlike and bottomlike, too—erotic pictures flipping over into each other, yet, I think, with something more than libidinal glee.

What we're instructed in, as Wilmarth instructs himself, is the play of the malleable and the merging: bodies and the more austerely abstract forms to come that are no less inscribed with historical styles sinking into their skins even as they become transparent in glass. The absorption works quickly and expansively. *Gye's Arcade* (plate 11), a recollection of a covered passageway of shops in Paris, lies right on the floor, a sparkling skeleton of curves and architectural spines that nods as it steps decorously over the violated form of Giacometti's Surrealist *Woman with Her Throat Cut* (plate 8). Russian Constructivism plays its hand, only more so.[8] Vladimir Tatlin's *Corner Counter-Relief* (plate 9), with its fidgety scaffolding of planes derived from Cubism and held in place along a tense, descending wire, becomes Wilmarth's chosen inheritance. El Lissitzky's utopian architectural abstractions (plate 10)—his "Proun" series, as he called them—with their lightened planar forms like weight being lifted away and lines like extending wires, entice the young sculptor's eye no less.[9]

Wilmarth had already moved decisively in 1968 toward the architectural and geometric. With the works that start to appear in this period, he becomes an anatomist of condensed spaces. He summons bodies that aren't gone but, like all the moments in modernist art pooling and shifting in his sculpture, are simply pulled further in. So we find the rounds of glass and the polished cylinder of plywood in *Cirrus* (plate 12), which are a transformation of the languid trunks of his early figurative images, as if he were lifting them up and laying them out, making the bridge into abstraction. You can almost hear the christening fizz of champagne uncorked. The variations multiply, advance, chat amiably with each other. By *Late* (plate 13), two years after this inaugural voyage, the sheer verve of Constructivism

PLATE 7

*Yolande,* 1965. Charcoal on cream wove paper, 24³/₈ × 18.6 in. (61.9 × 47.3 cm). Fogg Art Museum, Harvard University Art Museums, Cambridge, Massachusetts. Margaret Fisher Fund

STEVEN HENRY MADOFF

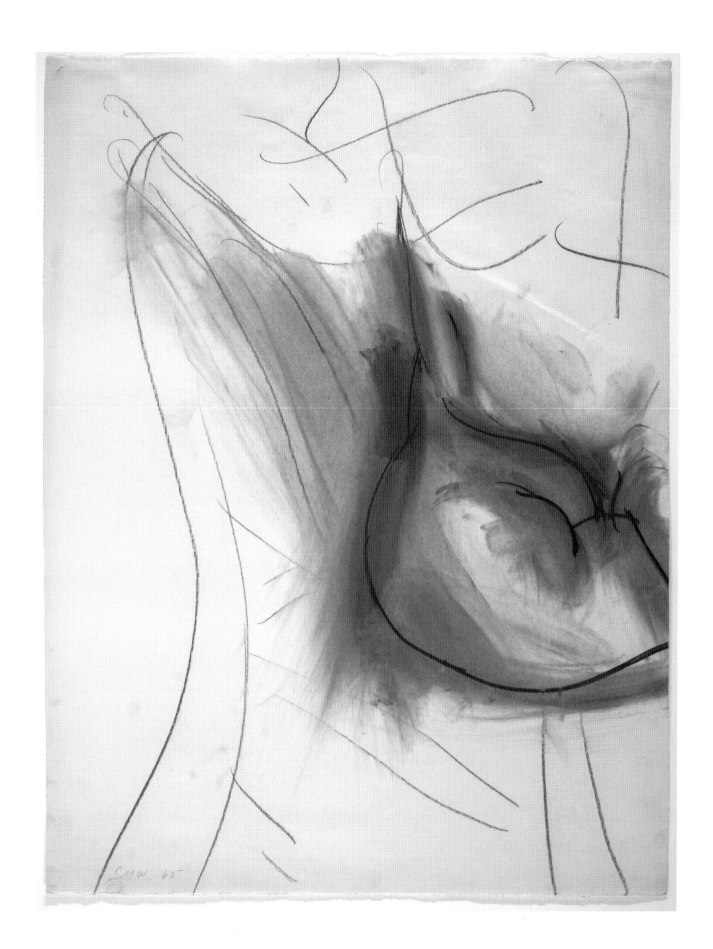

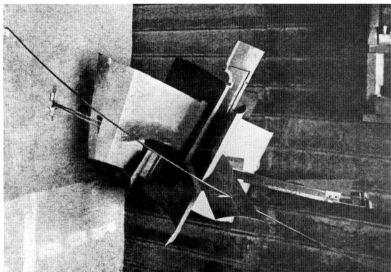

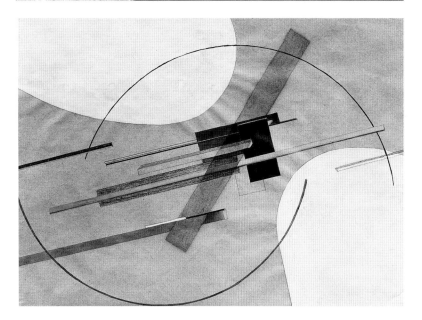

TOP, PLATE 8

Alberto Giacometti (Swiss, 1901–1966), *Woman with Her Throat Cut*, 1932. Bronze, 8 × 34½ × 25 in. (20.3 × 87.6 × 63.5 cm). The Museum of Modern Art, New York. Purchase

CENTER, PLATE 9

Vladimir Tatlin (Ukrainian, 1885–1953), *Corner Counter-Relief*, 1914–15. Mixed media. Location unknown

BOTTOM, PLATE 10

El Lissitzky (Russian, 1890–1941), *Proun*, 1922–23. Gouache, watercolor, India ink, conté crayon, graphite, and varnish on paper, 8⅜ × 11¾ in. (21.3 × 29.8 cm). Solomon R. Guggenheim Museum, New York. Gift, Estate of Katherine S. Dreier, 1953 (53.1343)

OPPOSITE, PLATE 11

*Gye's Arcade*, 1969. Glass, 18 × 72 × 72 in. (45.7 × 182.9 × 182.9 cm). The Corning Museum of Glass, Corning, New York. Purchased in honor of Susanne K. Frantz with funds provided by the Ben W. Heineman Sr. Family; Roger G. and Maureen Ackerman Family; James R. and Maisie Houghton; The Art Alliance for Contemporary Glass; The Carbetz Foundation; The Maxine and Stuart Frankel Foundation; Daniel Greenberg, Susan Steinhauser, and The Greenberg Foundation; Polly and John Guth; and The Jon and Mary Shirley Foundation

STEVEN HENRY MADOFF

OPPOSITE, TOP, PLATE 12
*Cirrus,* 1968. Glass and wood, 24¼ × 94 × 15⅜ in. (61.6 × 238.8 × 39.1 cm). Estate of Christopher Wilmarth, New York

OPPOSITE, BOTTOM, PLATE 13
*Late,* 1970. Wired glass, etched glass, gun blue steel, and steel cable, 30 × 59 × 8 in. (76.2 × 149.9 × 20.3 cm). The Edward R. Broida Collection

BELOW, PLATE 14
*Blued,* 1969. Corrugated glass and gun blue steel, 74 × 35 × 5 in. (188 × 89 × 12.7 cm). Private collection

sings. Tatlin's very first Constructivist invention, his *Bottle: A Painterly Relief* of 1913 (whereabouts unknown), included glass and wire filigree. *Late*'s cable, which acts as both line and support, and the wire grid in the glass hearken back to Tatlin, just as the sculpture's weightless dynamism has the grace of Lissitzky—Wilmarth's sleek rectangles and curves dancing under the gaze of the Russians' tutelary spirits.

What all of this says, this art "born of long reflection on the past," as Robert Hughes wrote of Wilmarth's work years later, is summarized in a sentence written years earlier by T. S. Eliot, when he reckoned in "Tradition and the Individual Talent" that "the historical sense involves a perception, not only of the pastness of the past, but of its presence"; that art from every epoch has in the serious artist "a simultaneous existence and composes a simultaneous order."[10]

———

Yet if it was true that this love of past and present was everywhere alive in Wilmarth's work, voraciously absorbing stylistic permutations in the bridge years between the mid-sixties and early seventies, something else was happening around him. All of the swiftly melding historical features of his art, all of his figures melting into more abstract expressions, couldn't have come at a more contrary time. It happened that the scenery was being chewed up by Minimalism's aggressive and imporous notion of art-as-modernist-endgame. Of course, there was other scenery.[11] But the idiom of Minimalism was dominant, and one of Minimalism's most dominant forces, Donald Judd, had already thrown down the gauntlet in an interview in 1964. "I'm totally uninterested in European art," he said, "and I think it's over with."[12] So much for Cézanne's links in the chain.

No matter how blinkered that view seems now, it spoke to the Zeitgeist, to the future-forward of the American imperium that found its way into the art world as it did everywhere else: spiritually uninterested, devoutly attuned to the materially new. The Minimalist object as the logical end of the modernist line took its cue initially from an argument not about sculpture's past but about painting's, and the critic Clement Greenberg was the *magister ludi* of this logic. "The essence of Modernism lies, as I see it," Greenberg wrote in his essay "Modernist Painting" (1960), "in the use of the characteristic methods of a discipline to criticize the discipline itself, not in order to subvert it but in order to entrench it more firmly in its area of competence."[13] He tightened his grip in demanding that modernist art had to "eliminate . . . any and every effect that might conceivably be borrowed from or by the medium of any other art."

What this came to for advanced sculpture in the early sixties was Judd's review of contemporary work, "Specific Objects" (1965), with its relish in naming materials as if they were irresistible dishes on a menu. "Materials vary greatly and are simply materials—Formica, aluminum, cold-rolled steel, Plexiglas, red and common brass, and so forth. They are specific. If they are used directly, they are more specific. Also, they are usually aggressive. There is an objectivity," he noted with what seems like delicious satisfaction, "to the obdurate identity of a material."[14] Judd's own art couldn't have been more confrontational in its bared geometry, its industrial repetitions, its shiny candy-colored surfaces—a pugnacious Americana of the present, reveling in materialism as the index of the real (plate 15).

Here was an ending, an over-with, that was also marked by Robert Morris's "Notes on Sculpture," which he published the following year in four parts, like a quartet of bombs dropped to negate the past and reshape the landscape after his own fashion. So it was, for example, that the "autonomous and literal nature of sculpture demands that it have its own,

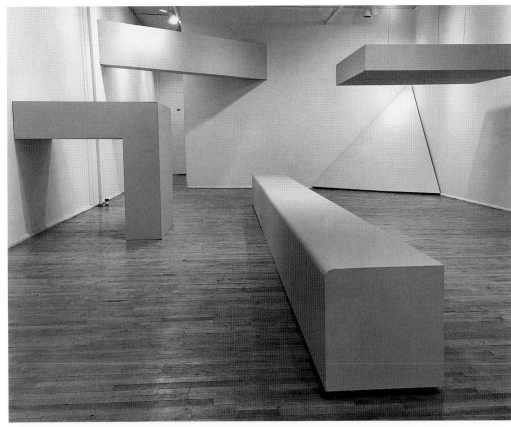

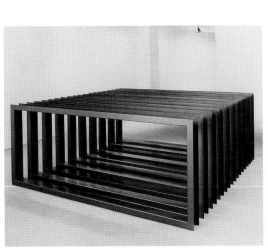

ABOVE, LEFT, PLATE 15
Donald Judd (American, 1928–
1994), *Untitled*, 1966. Painted steel,
4 × 10 × 10 ft. (1.2 × 3 × 3 m).
Whitney Museum of American Art,
New York. Gift of Howard and Jean
Lipman (72.7a-j)

ABOVE, RIGHT, PLATE 16
Robert Morris (American, born
1931), installation at Green Gallery,
New York, 1964. Clockwise
from left: *Table, Corner Beam,
Cloud, Corner Piece, Floor Beam*.
Courtesy Sonnabend Gallery,
New York

equally literal space—not a surface shared with painting."[15] True to his word, his plain boxes were stubbornly literal, painted neutral gray or mirrored, enforcing the gravity-ridden sense of anchored surface and outline, of a depth-defying exterior (plate 16). And while Morris differed from Judd in arguing the importance of the viewer's role in completing the experience of the work (he saw sculpture as an environmental laboratory where simple shapes in space would be perceived in the round by a mobile spectator), this class of objects was nevertheless about self-limiting subtraction, about a self-critical putsch to cleanse the medium of impurity.

For a moment, consider these years again. By 1968 Minimalism had become the academic style, the de rigueur of our native sculpture. Already, in 1966—the *annus mirabile* of Minimalism, with major gallery exhibitions by Judd, Carl Andre, Sol LeWitt, and the ur-surveys of the aesthetic, *Primary Structures* at the Jewish Museum and *Art in Process: Development in Structure* at Finch College—Lucy Lippard wrote in *Art International*: "It must have looked easy when Don Judd, then Robert Morris, and later Sol LeWitt and Carl Andre began to attract attention, but the mould has hardened fast for their imitators. Monochrome, symmetry, single forms, stepped or graded color or shape, repetition of a standard unit, the box, the bar, the rod, the chain, the triangle or pyramid, are the new clichés."[16]

And yet here is America. Martin Luther King and Bobby Kennedy are assassinated. Vietnam is in full tragic rage, and there's rioting in the streets. Meanwhile, the Minimalist box, sealed and impregnable, looks like it just dropped in from another planet. Even more than the product of a narrowed logic bent on the triumph of its own material means, it seems like a wish for oblivion, an industrial-strength barrier to the chaos of feelings. Its Spartan fierceness finds the new at the cost of the self; to shut down expressive options with an imperious *no* that deemed the past outmoded and done, and buttressed the present with the implacability of its history-less surfaces, the blank fixity of the irreducible thing. Is this blankness utopian? If it is, its Eden is a very cold, very silent place indeed. As James Meyer writes,

Minimalist art pushes its muteness, its "claims of semiological refusal, its *demanticization*."[17]

But Wilmarth has no urge to "demanticize" anything. Quite the opposite. True, he says, "I've always had absolute, rigorous respect for the identity of the material, to make neither the glass nor the steel look like anything but what it is."[18] This is clearly the parlance of Minimalism. As I've said, having grown up as an artist in the hot zone of Minimalism, Wilmarth speaks this way with native ease. Yet identity for him isn't the specific object armored against the past and the subjective, that has no *is* but itself. In fact, Wilmarth's ambition is to create the unspecific object; an object that dematerializes, that physically exists, as I've quoted him, "only to locate that which doesn't."

He is all about between-ness, as we will see in so many ways, and he holds a curious place. He isn't a radical modernist like Judd proclaiming the end. He didn't break with the past, didn't invent a vocabulary that was taken up as art's dialect of the day. Very few artists have that strategic, galvanizing, high-altitude jolt of vision that is, at last, all hedgehog burrowing down into one thing and one thing only. Nor did he match the leap made by Eva Hesse—which means work that offered a dramatic, organically inspired alternative to Minimalism, while borrowing the serial, the abstract, the new materials that were signa-

tures of Minimalist art. Nor can he rightly be called a postmodernist. For postmodernism came after that endgame of Greenberg's, so strenuously exercised by Judd in sculpture, by Robert Ryman in his serial white paintings. Or should I say that postmodern art doubts all the endgames of modernism, all its declarations of rapturous ruptures, and so it throws the narrative aside and embraces a vast stylistic plurality—a weightlessness of history. Between these extremes, Wilmarth edges toward the omnivorously historical, but he still believes in the narrative. "The past is nourishment and support for the present," he writes in a letter.[19] He's kindred with his past, with the links in Cézanne's chain. There is a glinting nostalgia about the work, a sweetness in Wilmarth's moment, as if he lived luminously in the brief suspension of twilight.

Betwixt and between summarizes so much of Wilmarth's art—the sense of moving between historical styles, figures and abstraction, surface and interior; the play of things yielding and coalescing like bright pools of mercury. I'm reminded of the scene in Jean Cocteau's film *Orpheus* in which the poet touches the mirror, which looks hard at first and then ripples as his hand and then his whole urgent body step through this remarkable portal, down into the underworld to find his Eurydice, his muse. And in turn I think of Gaston Bachelard's remark in *The Poetics of Space:* "But how many daydreams we should have to analyze under the simple heading of Doors! For the door is an entire cosmos of the Half-open."[20]

Over the whole of Wilmarth's career, the sense of passing through forms and matter— of glancing through the half-open at the physical and then past it into what could be called the after-physical or after-matter—reveals itself in his suggestions of doors, of windows, of clearings, even the opening of a book. He pulls us into the realm of transition, of transparency and translucency. That's the realm of the glass. In his breakthrough piece worked on over 1970 and '71, *Tina Turner* (plate 18), the proposal of sculpture as portal, as a passage for the eye, couldn't be clearer. Or not *exactly* clearer, as clear is only half of the open door. Wilmarth has added another historical surface to his art: the etching of the glass with hydrofluoric acid, painted on with a feeling brushwork, an autograph of soulfulness that hearkens back to Minimalism's emotional opposite, Abstract Expressionism. The expressive marks of acid on the glass are a sign of Wilmarth's intention to humanize the bare Minimalist thing. So the marks suggest more than determined pressure on the hard, flat, manufactured surface; something more purposefully impulsive, something rising up from that surface to lead us from what Yve-Alain Bois calls Minimalism's "pretense to reach the realm of the real"[21] into another visual and metaphorical place; certainly a realm of the emotive, of pathos.

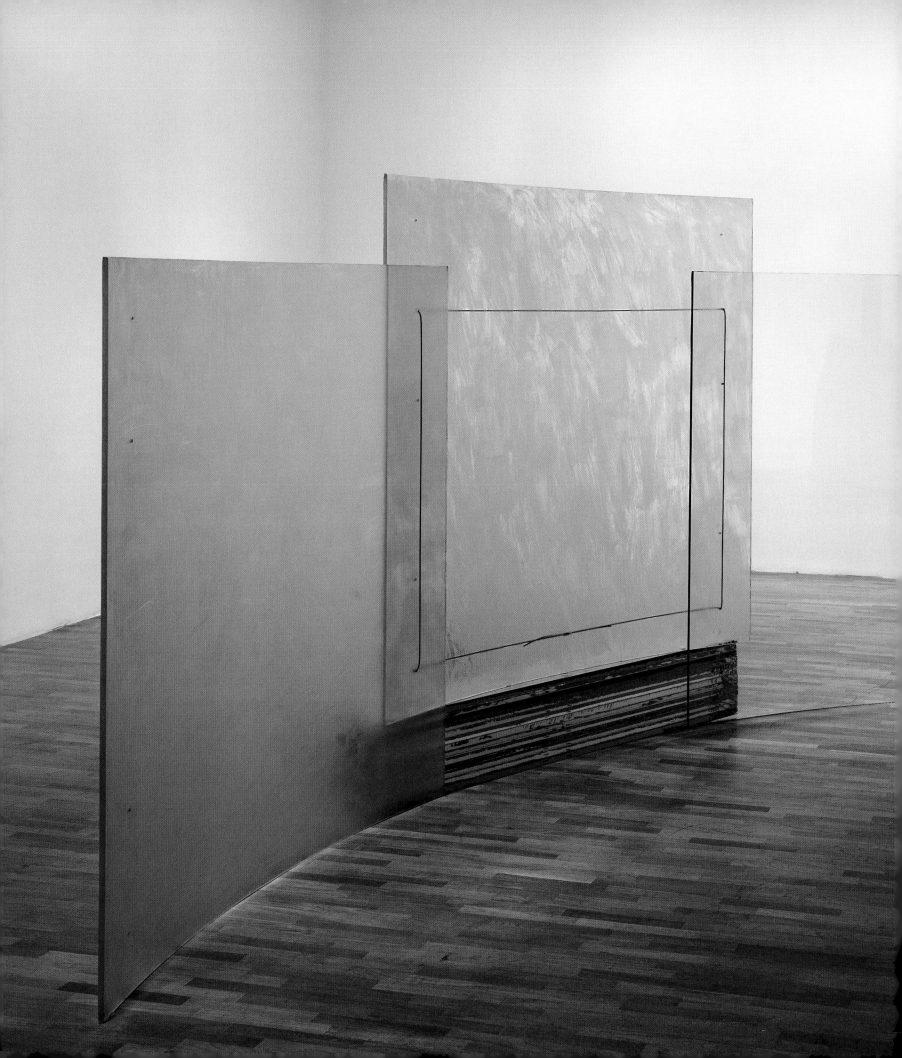

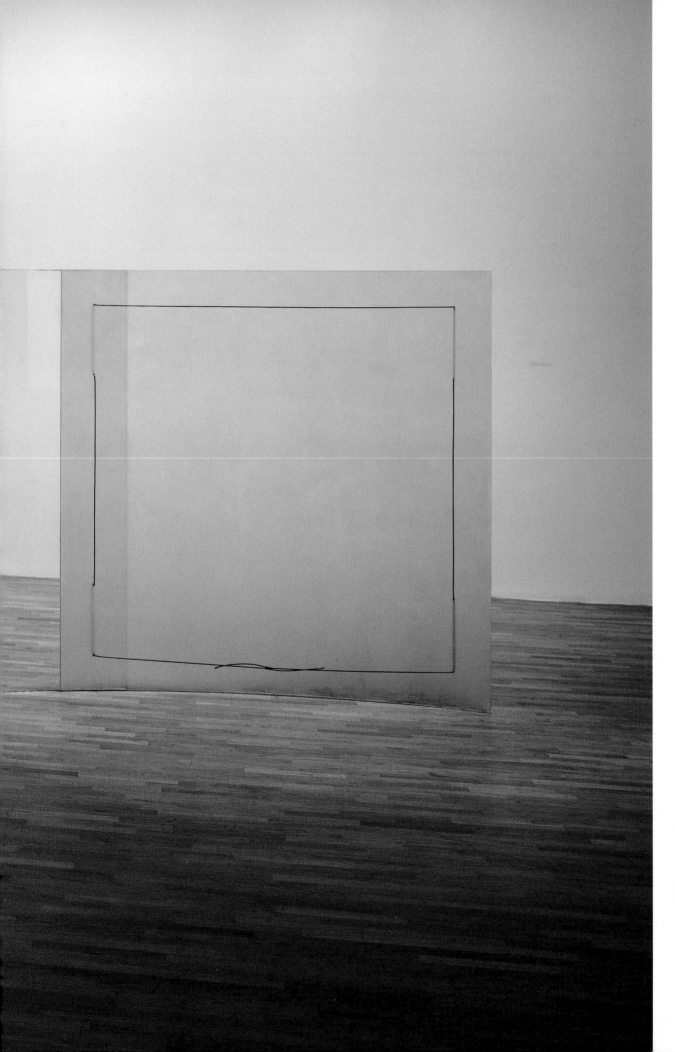

The glass is milky, foggy—is it Wilmarth's childhood air, the mists roaming coolly over San Francisco? Possibly. But as your eye travels along *Tina Turner*'s four curving plates, the effect is of walking in the woods and finding thruways of light and then a clearing, a space among the trees. Or, just as well, of buildings and avenues. Either way, you see the sculpture's shifting status as an earthly thing. Its planes are solid, diffused, and transparent. And while three of them hold tight to the ground, one is lifted, sticking its neck over the line of gravity. We're moved away from Morris's strictures about neutral surfaces and fixed weight that achieve his notion of sculpture's purity. But then purity can be a condition that comes after annihilation and approves of it. Wilmarth is far more interested in the impure. He pierces his surfaces with cable, which has the elegance of a pencil line. Its not-quite-straightness is the mark of vulnerability; it forces the glass open to admit the personal, the tender, just as the scarring with acid does. How can the work be tender and violent at the same time? But it is. The cable loops in and out, before and behind, about hereness and thereness, being and not. Like Hamlet, it pauses before a mortal question and helps us learn to wait. The sculpture's scrims of green-white light stutter, throwing shadows

PLATE 19

*Tarp*, 1971. Etched glass and steel cable, 26¼ × 68½ × 4½ in. (66.7 × 174 × 11.4 cm). The Museum of Modern Art, New York. Advisory Committee Fund

STEVEN HENRY MADOFF

through its minimal surfaces: not the cool of industrial swagger, but the slow warmth of the human hand.

The cable Wilmarth wove through his glass ever after came by inspiration from John Roebling, the nineteenth-century engineer and inventor of strands of steel twined to hold his bridges up, the most famous among them the Brooklyn Bridge. Yes, there's the use of the wire in Tatlin as a precedent in art, but the Roebling cable strikes, as it were, a more personal chord. What moved the sculptor was Roebling's soaring architecture, open and freeing (just as it had moved another artist transplanted to New York, Hart Crane). Wilmarth and his wife, Susan, would take long walks over the Brooklyn Bridge; it's the subject of a long recollection in writing and of the sculpture *Gift of the Bridge* that went with it (plate 135). Even at seventeen the young artist marks in a notebook, with a typically casual approach to punctuation: "Bridges—symbol of connection escape trying to put life in new perspective. The Bridge is the great symbol of change—."[22] And years later, in fact the year after he finishes *Tina Turner*, he writes a ruminative and troubled note to himself:

> The subject in my work has always been the same. It has never changed—it is always there. Sometimes it is clear and very close—other times—other long times—it is obscured. *I* obscure it when I am afraid; when I am weak and hopeless but it nonetheless remains—my subject. I have never been able to put it (the content of my work) in words. I haven't tried much. I sometimes like(d) to think it was the result of moments I spent sitting on a platform leading to Welfare Island from the Queensboro Bridge in October 1960. Maybe what happened then was the first time I could see the subject. It was not really a visual experience or one of description (words). It was a feeling.
>
> Recently a student asked me what my imagery was is (the class in part deals with regeneration of personal imagery)—I started to sweat as I struggled to answer (which went something like this: 'It's the feeling one gets in certain places when the configuration & identity of objects, the quality of time & light & one's position in relation to this place (psychological) merge in (for) a (spiritual) significant (human) moment'). That is as close as I've ever gotten.[23]

What he wants to capture is caught in those parentheses—the psychological, the spiritual, the human—as if they were little windows, little doors framing the fragile self that flutters and sweats. First there are the pencil and charcoal drawings, the twenty-two "Plat-

form Dreams" made from 1960 through '63 that recall those October days. They're sketchily Cubist at times, stacked and interlocking shapes—platform, bridge, water—that manage a loose topography, a downward view all solid and fluid like his groped-for feeling. The gray gossamer of lines and erasures are landscape and inscape, and a hint of figures, too. What Wilmarth does so early on in these drawings, evident in the fifteenth image in the series, prefigures the glass and its shadows (plate 20). The sculptor's means evolve, tighten, yet he still needs to show us, show himself, that same subject embodied in hard matter shifting toward the ineffable. So comes the glass, dreamily fogged or left clear, half open. And what is Wilmarth showing us? Not merely the outside of a Minimalist object—the artist and critic Mel Bochner once wrote of Minimalism that "there is nothing behind these surfaces, no inside, no secret, no hidden motive"[24]—but the inside, too. If he can have them both simultaneously, then the cosmos of the in-between is pictured. The cable is the apparatus, the interlocutor of the glass, that helps to draw out the doubleness of things. It's the tension between the physical and the space of reverie. It serves practical ends: this slight but sturdy wire binds the glass and sometimes holds it to the wall. But its translation of Matisse's supple line into a thread of steel dips down, moves the eye through, moves across. Like

STEVEN HENRY MADOFF

Wilmarth's notion of the bridge, it is a symbol of change. It catches mutability within the boundaries of the sculptures.

You see this in the small pieces for the wall made in 1971 and '72, drawings, as Wilmarth called them, done in etched glass and cable, which go again and again at the porous bounds between the fixed and the loosed. *Untied Drawing, Homage to Marinot, Half Open Drawing* (plates 22–24) all present the wall relief as a picture and its frame—and I think

LEFT, PLATE 22

*Untied Drawing,* 1971. Etched glass and steel cable, 19 × 17 × 1 in. (48.3 × 43.2 × 2.5 cm). Collection of George G. Hadley and Richard L. Solomon, Lakeville, Connecticut

BELOW, PLATE 23

*Homage to Marinot,* 1972. Etched glass and steel cable, 17 × 17 × 1 in. (43.2 × 43.2 × 2.5 cm). Philadelphia Museum of Art. Given by Dr. Luther Brady

OPPOSITE, PLATE 24

*Half Open Drawing,* 1971. Etched glass and steel cable, 24 × 17½ × 1 in. (61 × 44.5 × 2.5 cm). Collection of Dallas Price-Van Breda, Santa Monica, California

of Robert Morris again, marching his polemical banner around, saying: "An object hung on the wall does not confront gravity; it timidly resists it. . . . The ground plane, not the wall, is the necessary support for the maximum awareness of the object."[25] It must be that Wilmarth is after a different awareness: he means to question gravity, to lift it, to fill the glass with light as helium fills a balloon or to empty it again. *Untied Drawing*'s dark, serpentine cable pulls us down into the glass, while in other works the cable is there, it seems, to frame the watery, shifting cast of light that oscillates between shallow and deep. The glass is stacked or cut through (see the slits in *Marinot*) for space to break out. The light is reflected,

STEVEN HENRY MADOFF

refracted, absorbed. The picture space ebbs or surfaces, as the physical fact of the material comes forward or recedes. In its cunning ease, we see the glass as a changeling creature that's both two-dimensional picture plane and three-dimensional sculpture. It is the double dream of Bachelard's half-open door.

But there is something else that happened. I need to pause here to tell it—a day in 1971 when our central figure is with his friend, a man he admires, who means something deeply tuneful to his work, the sculptor Mark Di Suvero. Di Suvero was much at odds with the Minimalists. There's an anecdote out of that past, an exchange between Judd and him, with Judd complaining that Di Suvero's slashing beams of wood and chains were like Abstract Expressionist brushstrokes, so much opposed to Judd's cool passion for the static. On another day, Di Suvero retorted that Judd wasn't an artist at all: he didn't make his own work, he had it fabricated for him. He argued that Judd's art, and Morris's as well, showed a "commercial acceptance of the technological world that disavows all of the joy and the tragedy and accepts regimentation."[26] That same sentiment rang true over the years for Wilmarth, who still bristled in 1985 at Frank Stella's famous Minimalist call-to-arms made more than twenty years before, "What you see is what you see." So Wilmarth writes in a letter: "It's a disease, this materialistic 'what you see is what you see' denial of the spirit (but a perfect vehicle for trade)."[27] Elective affinities hold, Wilmarth's and Di Suvero's friendship was made, and one day they decided—just out of amicable amusement—to make something together.

Di Suvero offered up gnarled-looking pieces of steel. Wilmarth was intrigued. He put glass in front of them. Lightness and darkness. The visually penetrable and the impassable thing. Another way of telling that story of *between* heaved up into the visible, and the title they gave the work was joined from pieces, too—*Di-Wil-Vero* (plate 25). To his small quiver of glass and cable, Wilmarth now added the steel sheet in various conformations. Soon enough it became indispensable to him as a way to shoot at his target: the amorphous, the chameleon skin of being in the world and somehow being somewhere else, falling into the light and then falling out.

Wilmarth is calling us forward. He's beckoning us to stop, to look at the illusion in the picture frame, and for the eye, as it were, to step through. He is thinking about a place, a clearing with its perimeter like the boundaries of the glass. And inside is the little space to dream that he first set out between his two wood lovers reaching toward each other in *Structure (A Man's Back)*. His means are more flexible now, and we've seen how he's drawn

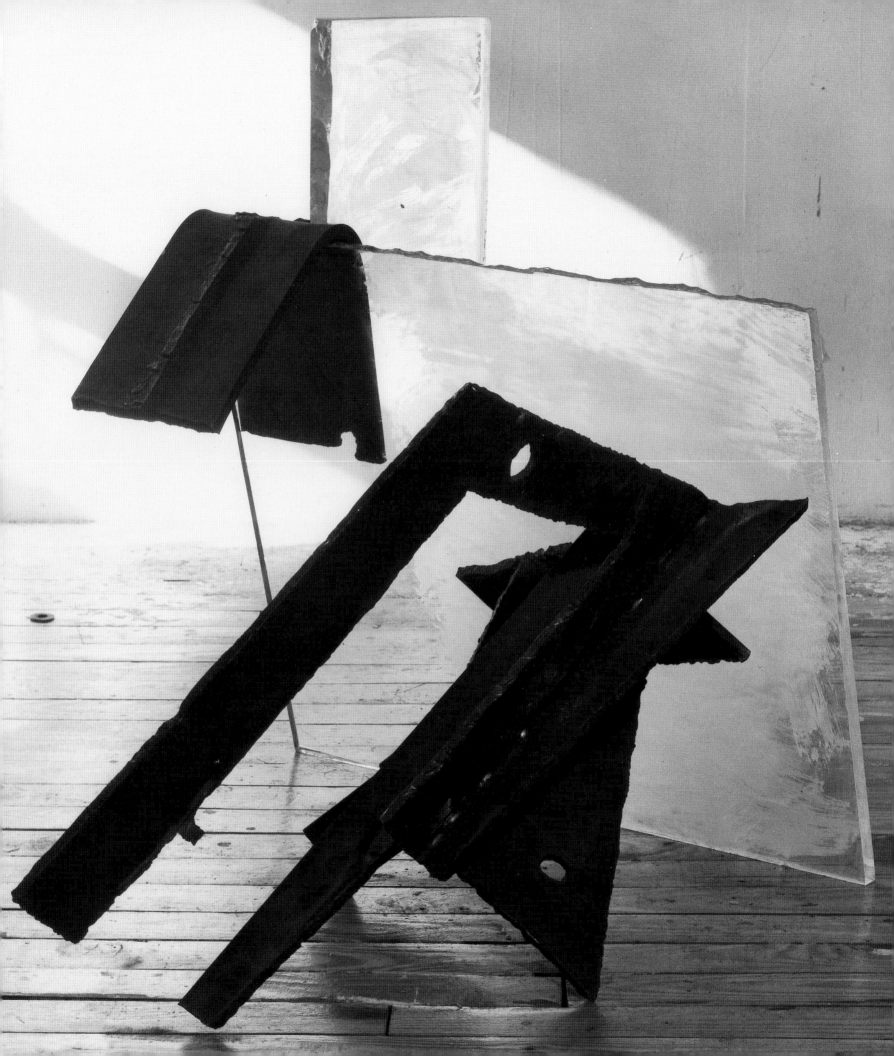

LEFT, PLATE 26
*Stream*, 1972. Etched glass and steel cable, 78 × 38 × 8 in. (198.1 × 96.5 × 20.3 cm). Estabrook Foundation, Carlisle, Massachusetts

OPPOSITE, TOP, PLATE 27
*Six Clearings for Hank Williams*, 1972. Etched glass and steel rods, six units, each 17 × 17 × 1 in. (43.2 × 43.2 × 2.5 cm). Collection of Frances Dittmer

OPPOSITE, BOTTOM, PLATE 28
*Lining*, 1971–72. Clear and etched glass, and steel cable, 78 × 39 × 6 in. (198.1 × 99.1 × 15.2 cm). Collection of Maxine and Stuart Frankel, Bloomfield Hills, Michigan

STEVEN HENRY MADOFF

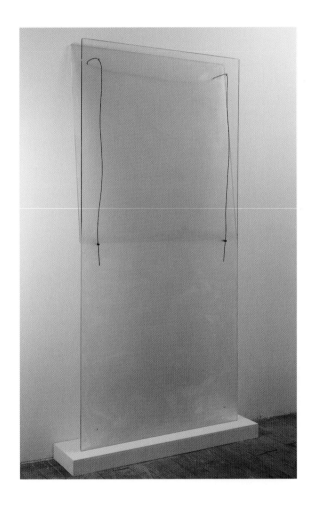

to the marked-out shapes of one portal or another, windows or doors. In the early seventies, he parses the form of the window in *Six Clearings for Hank Williams* (plate 27), and he gives us the full length of a threshold in *Lining* (plate 28), whose title tells us once more about insides and outsides. Its diaphanous, tilting, layered sheets of glass and their loose cables insinuate a frame, a window, and a standing space. In *Stream* (plate 26), made within months of *Lining,* I sense the game of the great U of cable pulling us up into the wider, etched glass above (a picture frame again, a window) with transparency below, as if it were a Cartesian pun about mind and body—mind that's all the dreamy fog of reverie and a body whose curved legs hold us to the clear practicality of gravity and ground.

The place that Wilmarth beckons us to is a shimmering sort of place with a shimmering subject. It's about coming into being and dissolving into the ambience, which rings with a certain pantheistic longing. Emerson, whom Wilmarth admired and read, wrote in his essay "Nature": "Every moment instructs, and every object: for wisdom is infused in every form."[28] There is that specific yearning in the sculptor to find in the metaphysical place a sympathy with nature, a salutary rightness that makes the world apprehensible and full. The agency of this transposition is the light. We need to think again about Wilmarth's use of light to accentuate both the two-dimensional and three-: the way it scintillates on a surface so that the eye is drawn to the flat plane, and the way the light becomes a sculptural material, taking on volume in the glass, defining space and depth. It attracts the eye at every stopping point, from shallow to deep, as a guide through. He wants the light to illuminate *inwardly,* to elucidate a place that stands for a distillation of presence. "For as long as I remember," Wilmarth writes in 1977, "I would tell stories to myself and make magic. Only I didn't

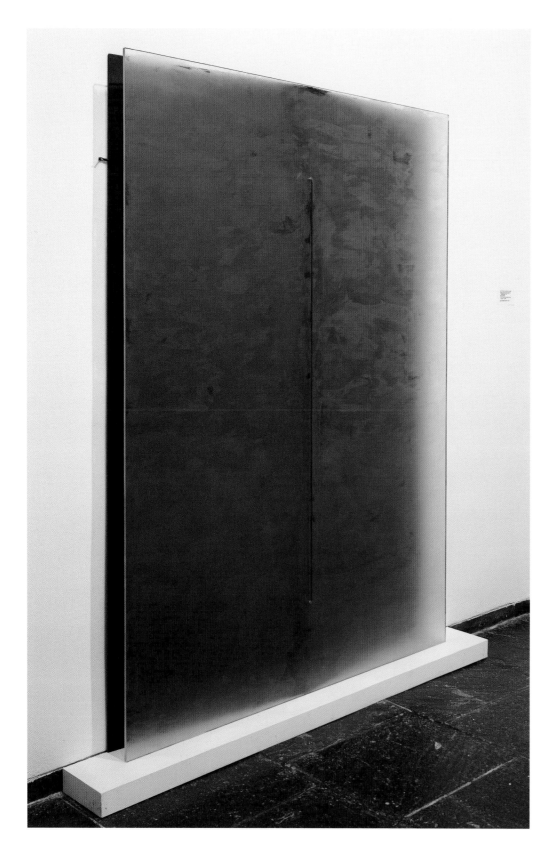

STEVEN HENRY MADOFF

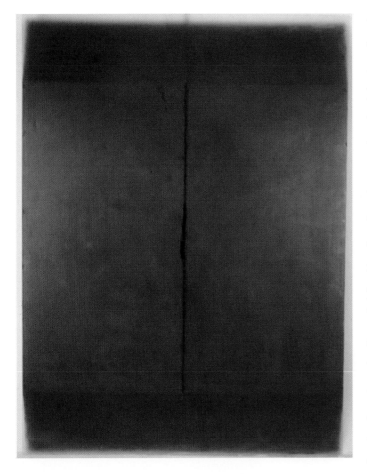

think of it that way: I never thought that I lived in my head. I was always on the lookout for a place with the light just so and the colors right (red and yellow almost never seemed right) and if I was quiet, or hummed a long time just one or two notes, that I would become transparent and be a part of the place I was in. Then I could talk to the trees or a special corner."[29]

This strange sense of fusion with the landscape implies the body that becomes, as Emerson says, another form in which wisdom—an essence of things—is made clear. Wilmarth joked about it, writing on one occasion that he was "in the transportation business." But his fantasy of being transparent, in which he can talk to the trees (and presumably they talk back), suggests his greater need for mutability. This is the sense of the body being betwixt and between, the body and place mixing fluently with each other.[30] More than half a century before Wilmarth wrestled with his metaphysical yearning for the changeful thing, the Futurist Umberto Boccioni exhorted his fellow artists in typical manifesto style, which means in all capitals: "LET'S SPLIT OPEN OUR FIGURES AND PLACE THE ENVIRONMENT INSIDE THEM."[31] Did Wilmarth ever read this? I don't know. But what he made bears something wonderfully like that notion, which he called a "hybrid event" of "person-place."[32]

In his "Nine Clearings for a Standing Man" (plates 29, 30, 40, 48, 136), executed in 1973, Wilmarth reaches a first summary of these thoughts, impulses, and influences; he crosses a threshold. But you arrive at a threshold from someplace else, and there are numbers of works that point like clues to the "Nine Clearings." If the pages of images in this volume are turned with nimble speed, at least in my mind's eye they become a sort of flipbook: pieces like *Normal Corner*, *Normal Corner (Yard)*, *Deeps L.A.*, and *For Roebling* (plates 32–34, 50) riffle by, with their play on light and resistance, as do the more architectural entryways of *Tina Turner*, *Lining*, and *Stream*, joined in a single formal continuity. They have the pleasure of antic figures rushing toward the end of their hand-cranked story. Here you find not the comic, but the ludic—the mind at the dexterous play of things. You can see that while the sensibility of Minimalism was largely antithetical to Wilmarth, its rigorous way

of thinking through shapes was not. His geometric forms are relentlessly tugged up, down, flattened, and made mystical with that foggy etching, turned over in his head as endless riddles for the eye and for the heart, too, as the light in the glass takes on a poetic brightness or subsides into dolor.

Now come the "Nine Clearings," working back through his past and then along the links of his loved modernist chain. Matisse's own series of wall reliefs, *Back I–Back IV* (plates 35–38), is his wellspring and principal source. The "Backs" inspire with the force of their visual logic, methodically shedding the clothes of representation for the bareness of a coolly reasoned, almost brusque abstractness. The four stations of the transfigured nude proceed from a lovely figure distinct from the wall it leans against to a spare configuration of solid forms, roughly human, that look for all the world like a poor mortal in Ovid's *Metamorphoses* punished by the gods, slowly turning into a tree. But I mean to be more than whimsical here. *Back II* already suggests to the Matisse scholar Jack Flam that its background "no longer appears to be an actual wall against which the figure leans, but functions more as an abstract spatial ambience."[33] John Elderfield, the chief curator of the department of painting and sculpture at New York's Museum of Modern Art, where Wilmarth would go to see the "Backs," explains the way Matisse accomplished this effect by transforming the roundness of the figure with a Cubist geometry that flattens it to

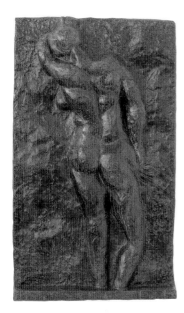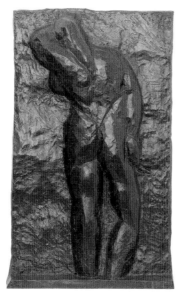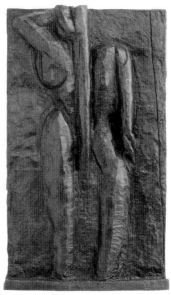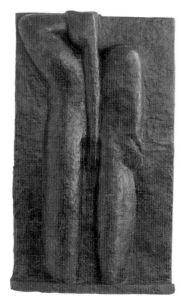

the back plane. "As in Cubist painting," Elderfield notes, "this flattening of the figure opens it out to us, showing us more of it than is consistent with a single point of view."[34]

The "Backs" are almost as much painting as they are sculpture; they're conceived like "a three-dimensional monumental painting,"[35] as Flam says—indeed the first in the series was made while Matisse was at work on the grand paintings *Dance* and *Music*, populated with brilliant, life-size figures. The "more" of these wall reliefs—their Cubist gathering of multiple views, their concord between painting and sculpture—is fundamental to the complexity of the "Nine Clearings."[36] Like the "Backs," Wilmarth's nine lambent screens of glass and steel have a formal joy about them—something stiff and hieratic, but softened and set into infinitely slow motion by the light. Matisse's pictorial logic of the figure opening out into ambient space is a key to unlock the "Clearings": while the glass, cable, and steel parade their Constructivist heritage, they enact the charged spectacle staged by the Cubists and Matisse, exciting the eye with the tension of packed and opened forms. All of these features are there in the Wilmarths, carefully plotted, as they resound with their likeness to Elderfield's description of *Back III*: "a series of broad vertical zones of light and dark tonalities that carry the eye across the surface."[37]

Look at *Clearing #3* (plate 40), light raking from the left. The steel plate is bent all the way down from top to bottom on both sides, with its central plane looming, so that the angled weight of the abstraction takes its comportment from Matisse's woman, her left arm raised, giving air to that side of the relief. In the Wilmarth, the channel on the left between

the glass and the steel is revealed by the light, creating a milky blue-green stripe hovering in the glass. It calls back to Matisse all the more strongly, summoning one of the painter's most abstract compositions, his stately 1914 oil on canvas, *French Window at Collioure* (plate 39), with its verticals in greens, blues, brown, and black, moving between threshold and the illusion of open space, between frame and portal.[38] Like the Matisse, indeed like the painting *and* the "Backs," *Clearing #3* divides to conquer: blue-green shape, greenish gray middle with a line of cable that neatly slices its central form in two, then another stripe of the same color where the steel bends back, and a fourth made of shadow, which is lighter and fades into semitransparency—an act of transformation that dematerializes the surface and sends us once again to the shadow on the left. The shadows seem suspended in the sculpture's picture plane, which is what this large sheet of glass appears to be;

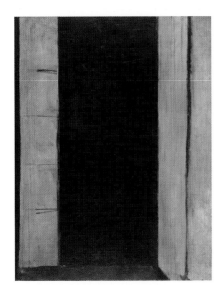

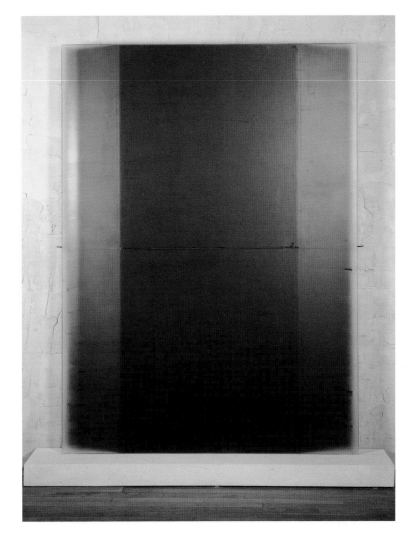

Abstract Expressionist brushstrokes of acid covering its surface. This is true for all of the "Clearings."

Now we notice the edges of the work, too; the clearing has its perimeter.[39] On the left edge of *Clearing #3*, we see a dark line, almost black. Along the top of the piece, the edge becomes a pleasurable dalliance with the light: it teases a luminous green out of the glass, rides it over the darkness of the middle plane, as if it were a flashlight showing the path out of darkened woods, and then at the right it becomes dark, too, as if to say something has come to an end, it is done. If you stand straight in front of the piece, the right edge confirms that sense of closure, as does the edge on the bottom. But if you move just a little to the right, the right edge is really aglow, a promise of something or a memory of a passage through. It upends the notion of weight so present before the viewer. It's like a zip in a Barnett Newman painting that's meant to raise the ante of the ecstatic, suggesting what it might be like to be conscious and bodiless, looking out of the world.

There's something ceremonial about this procession of noble shadows in the glass; something about the abstracted figure erect in the clearing of the glass so redolent of air and mist. Because the "Nine Clearings" are all just larger than average human size at eighty inches tall, they approach the stateliness and distance of public sculpture but still hold an intimate relationship to the viewer. We accommodate our own bodies to the works, transposing ourselves with the abstract figure there in the shadows and light. Elderfield speaks about the "the reconciliation of volume and surface," about the way that "figure and ground modify each other" in Matisse's "Backs," which are apt phrases for what we also see in the "Nine Clearings." But there is this difference: Wilmarth doesn't have a hunger to reconcile. No, he prefers that the simultaneous two-dimensional and three-dimensional readings, the coexistence of the pictorial and the sculptural, offer up a multiplicity. The work is liminal—it stands on the threshold between many things: surface and depth; solidity and the gauzy feel of shadow; front and behind; inside and outside. He looks through to a space imagined free of the gravitational anxieties of psychic weight; that same space where Wilmarth hums and envisions himself invisible. He exchanges matter for the notion of after-matter—still tied to matter, to being on earth, but now crossing into his space of reverie, as the shadow wanders in the glass like a fact melting in a wafer of light. To look at the bent steel sheets through the glass is to read an essay on order as it moves toward dissolution, toward the freedom of formlessness.

But this is hardly alchemical. Through the interactions of the glass, the steel, and the light, we see the way meanings build, see what happens to figure and ground. When the

light lies brilliantly on the surface of the glass, so that there's only the slightest perception of depth, the glass seems to grow almost (but not quite) solid, to take on the counterintuitive role of a ground that floats above its figure, with the steel as figure appearing to recede behind it. Yet in more even light or with sidelong illumination, the light sinks in and makes that milky translucency in the glass, as if it were a sheer curtain. The shadows made prominent in the spaces between the glass and the bends of steel seem to step forward. They're the figure levitating above the ground of the steel plate. And there's at least one more reading: the simple drawn elegance of the steel cable is the figure (particularly when it's used vertically, with the wraithlike presence of a Giacometti statue) on the ground of stacked planes and volumes beneath it. In a broader sense, Wilmarth leaves his own figure there, too. The painting of the glass with acid (plate 41) was a means for him to recuperate the emotional and spiritual ambitions of Abstract Expressionism to contemporary sculpture after Minimalism, recording the motion of the sculptor's arm, the impulse of feeling flowing through the wrist and hand onto the skin of the object. The work isn't only about the pictorial flux of figure and ground but also about his own live figure leaving its trace on the glass ground as a place of memory. All of these identities animate the works, stepping in and out of their portals (which could not be more explicit than in the last of the "Clearings," with its hint of open doors), as if in constant exchange, as if in perpetual movement.

This endless stream of meanings is a way, I think, to float free; or as Wilmarth said almost gnomically about the "Nine Clearings": "The romance surmounts its containment."[40] It's easy to slide from the physical to the metaphorical and metaphysical in Wilmarth's works— they can have that Fred Astaire quality of getting lighter and lighter on their feet. When I consider this free-floating romance, I'm immediately put in mind of a tendency in the sculptor's drawings.

Except for the gloomily beautiful drawings at the end of his life, which were wholly achieved works in their own right, Wilmarth's graphics in charcoal and graphite and water-colors were done after the sculptures that were their subjects. It was a way to write down the syntax of the forms and see what new sentences they'd lead to. (But one more exception: I don't mean the technical drawings here, either. For example, the one made for the sculpture *Alba Sweeps* [plate 43], with its specifications for fabricating the piece [plate 42]. One can easily forget that before the work gets filled with metaphysical intent, it is eminently physical: its steel plates are saw cut, sheared, spot welded, made of mild black carbon steel or Everdure bronze; the sculptor's instructions are for the metal to be cleaned, straightened, grooved, and that there should be no hammer marks. The same is true for the glass.

BELOW, PLATE 42
*Alba Sweeps*, 1972–73. Photocopied and taped paper, 11 × 14 in. (27.9 × 35.6 cm). Fogg Art Museum, Harvard University Art Museums, Cambridge, Massachusetts. The Christopher Wilmarth Archive, gift of Susan Wilmarth-Rabineau

OPPOSITE, PLATE 43
*Alba Sweeps*, 1972–73. Etched glass and bronze, 60 × 60 × 36 in. (152.4 × 152.4 × 91.4 cm). Private collection, San Francisco

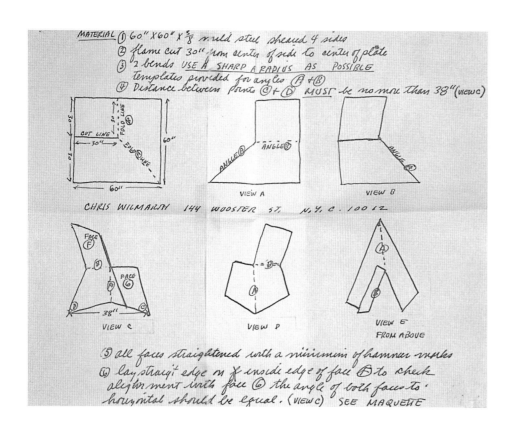

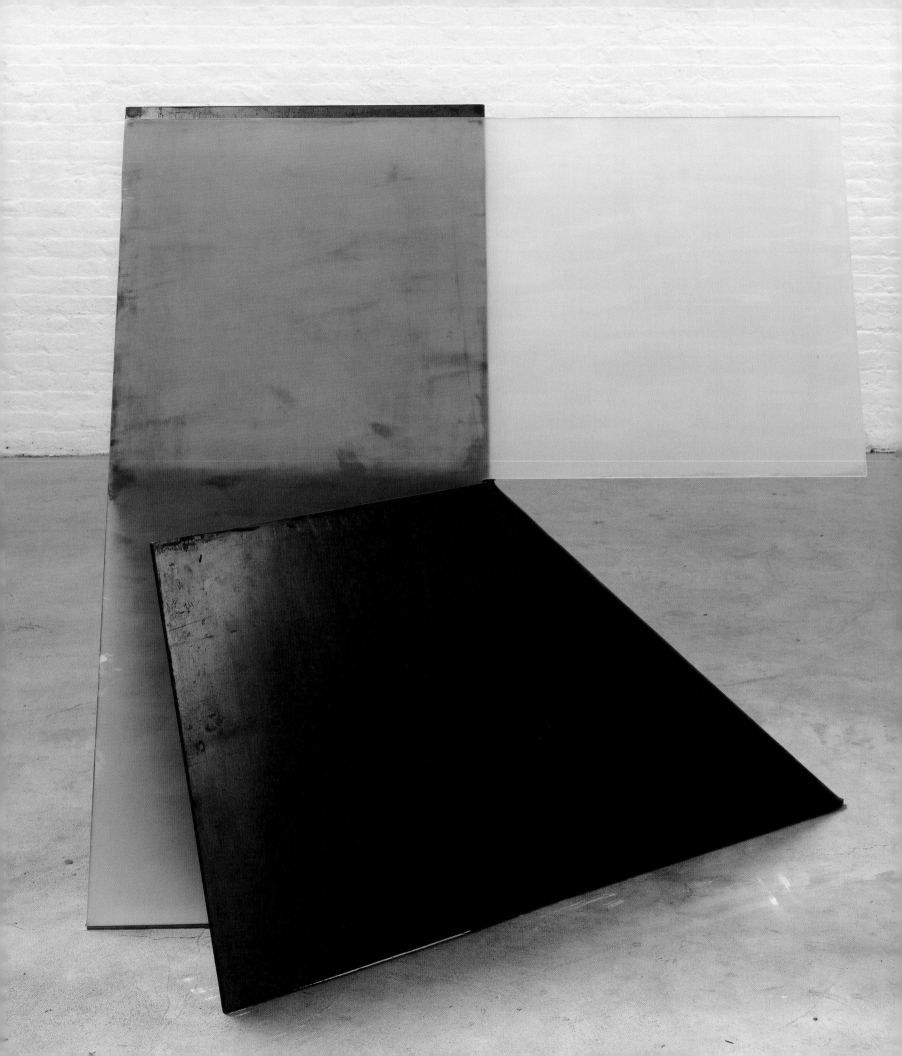

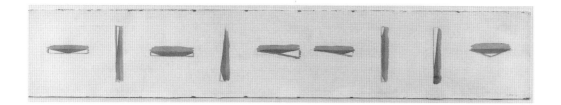

Wilmarth talks about the "medium seam" for the edgework, grinding out any wavers on edges, grinding a ³⁄₁₆-inch radius on the corners; he wants to come and check the measurements himself prior to delivery.)

This careful regard for the physical apportionments and positions of a sculpture's elements is vivid, too, in the images called the "edge drawings." They're a little like battle maps. A territory is seen from a height. Notations of shadow, of bent planes and the glass, are rendered—witness *Edges of the Nine Clearings* (plate 44), done two years after the sculptures were completed. Many of Wilmarth's edge drawings show a light pencil line or a pen's mark set off from the rest of a sculpture to articulate the formal play of angles bent into the metal, although watercolors primarily do the job in this drawing. A rhythm is set up, carrying from one image of a *Clearing* to the next, and there's a percussive quality to the edges. The images of the sculptural forms are cut out of the top sheet, so the edges are real, not drawn. An actual space is created that mimics the space between the glass and steel of the sculptures. The drawing has a fragile, atmospheric quality, and an architectural one: the washes in grays and greens, the sketchy pencil marks, the planar forms, the razor edges delineating space. But what I'm struck by is the notional transaction between the physical and the release from it. While the aerial perspective of the drawing has a durable practicality— thoughts about angles and metal and space and shadows—there's something about the *hovering* that gets at Wilmarth's nonliteralist urge to lift matter away, as if it were the scrim behind which the truth of being lingered in the air, the romance surmounting its containment.

Two other exemplary drawings, one in a private collection and one at the Fogg Art Museum at Harvard University, where Wilmarth's archives reside, carry this reading. The first is a curious little piece entitled *Orange Delta for Tony Smith* from 1973 (plate 45), done after the sculpture *Orange Delta for A.P.S.* (plate 46) of the same year. (A. P. stands for Anthony Peter, hence Tony, for whom Wilmarth worked as an assistant from 1967 to '69. Smith's importance to the younger sculptor was greater than temporary employment, as we'll see in the work *Wyoming*.) At the bottom left of the drawing's top sheet, Wilmarth constructed a bisected rectangle—or two squares joined. The square on the left is divided top right to bottom left, so that two isosceles triangles appear. The entire rectangle is cut out of the top sheet,

STEVEN HENRY MADOFF

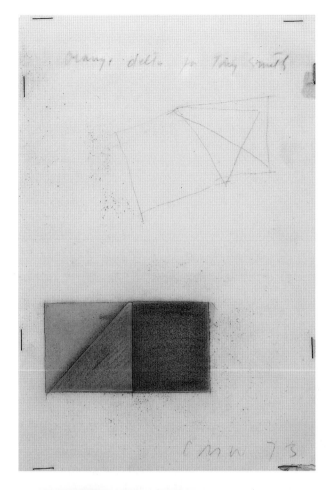

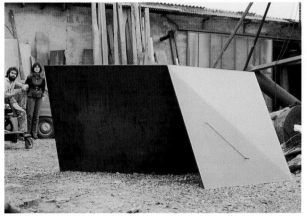

removed to make an absence. Then on the sheet below it, a heavy coat of graphite runs horizontally back and forth to create the square on the right, and the top triangle of the left square is done with a softer, smudged touch. On a third sheet down, the sculptor has drawn his lower rectangle, filled it out to leave the long marks of his pencil showing, which follow the angle of the base of the triangle, the title's delta. (How does "Orange" play in the name of the piece? A sentimental touch: Smith hailed from South Orange, New Jersey.) One short line is heavier than all the rest at just about the dead center of this triangle, like a marker on a map. It pulls my eye in, taking on the weight of a fourth level of depth. Or perhaps a fifth.

Why a fifth? Because there is a ghost on the top sheet that seems to dangle in the air above the drawing below. It is off-angle and indefinitely drawn; a rough doppelganger of the other rectangle, so rooted in the world. The outlines of this phantom appear to waver, are even erased along the left side to suggest a yet greater sense of lightness, of matter going away. In the sculpture, this flitting form is represented by the canted glass plane. Here in the drawing, Wilmarth has reversed his squares within this top rectangle, and the triangles themselves are doubled into four still more provisionally angled quadrants, everything breaking down into finer and finer bits—as the drawing itself seems to shuttle between waking life and dream, assertion and interrogative, world and mind. Held together by staples, the layered sheets capture the sculptor's need to make his work dimensional, and they look like strata pressing downward, tugged by gravity, while that little slip of a rectangle above shows that its trajectory is *elsewhere*, heading off into the invisible. The drawing doesn't end with a full stop. It loves the ellipse.

Even more than in the *Orange Delta* drawing, the opulently serene *Study for the Ninth Clearing* (plate 47) plays up the transition from matter to after-matter. A passage of cerulean blue seeps down, as if it were a concentration of the aqueous green atmosphere of the picture, as well as the shadow caught between glass and steel. Black chalk lines at a sharp angle approximate the conformation of the bent steel plate, while a thin rectangle in front marks, possibly, a boundary wall. Triangular cutouts in the sheet,

with another sheet behind it, once again turn the drawing into a shallow sculptural form, echoing the Matissean character of a three-dimensional painting that the "Clearings" take on. Alongside the cutout on the left, the wash of green gives way to a wide area in tan, almost a stain, that appears nimbuslike: light seeping in. The passage is more abstract than all the rest. It feels unanchored, hovering and swallowing the pencil lines in its path. It lifts the drawing up, like a cloud in a Fragonard, and beside it or under it, perhaps, are the rudiments of the sculptural organization of a space. The blue of the shadow soaks into the surface with the sumptuousness of velvet: a field of meditative energy reached through the half-open door of the physical. The feeling, concentrated in that blue, is of pure pres-

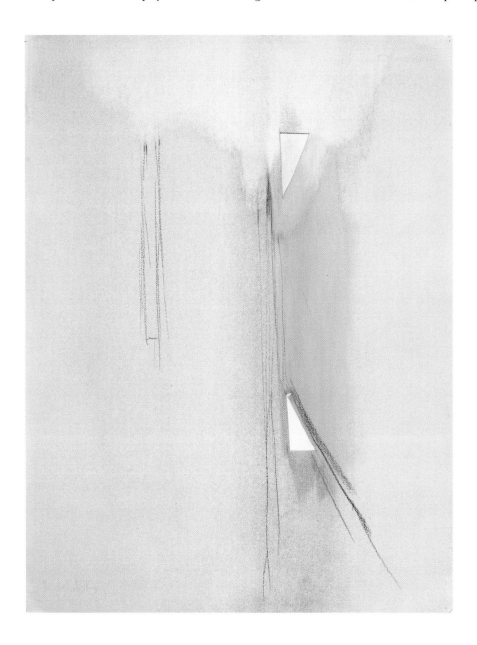

STEVEN HENRY MADOFF

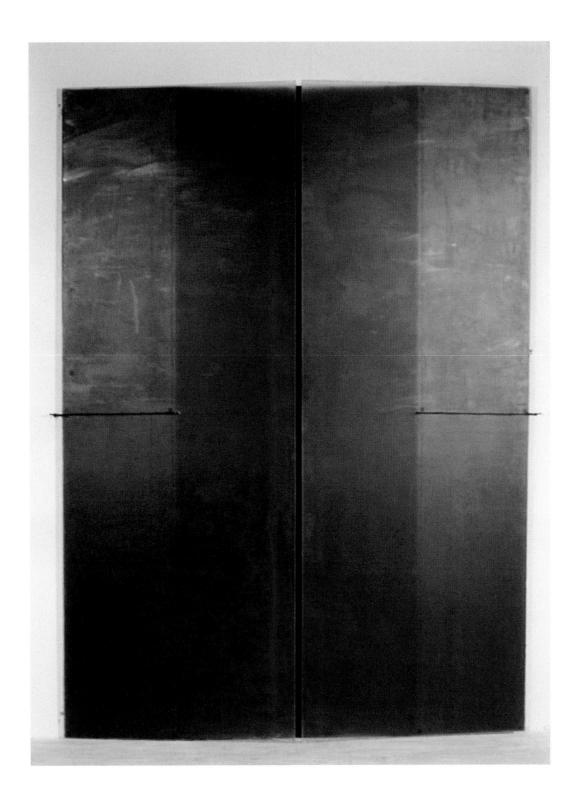

ence, as if to say, Here is a distillation of the empirical that liberates; magnet and magic, altar and illuminating prayer. Once more, we look down at the image as if we were floating in the air: we're suspended above it, he is above it, because we have the imagined and luxurious advantage of being conscious and yet without the burden of the body. The notion is both Transcendentalist and Symbolist—it speaks to the artist's craving to find on the other side of the visible a continuum of the inner life, not gravity but grace.

What the drawings show is another, perhaps more intimate, reading of Wilmarth's mind. Yet the multiplicity, the *fullness* of meanings that fight against constriction, is obviously a signature of the artist's wriggling temperament. There's another way that he expresses his urge to capture the essence of being, as if his great plates of glass were slides under a microscope. I'm thinking of the light in the glass again, but now as an aspect of time— what I want to call presentness. In his essay "Nature," Emerson speaks of the enchantment of the woods and open landscapes that makes us forget our daily lives; "all memory obliterated by the tyranny of the present, and we were led in triumph by nature."[41] The tyranny of the present is apparently a happy one: the freshness of the instant immerses us in the balm of nature, freed from the dull weight of the manmade world.

This is Wilmarth's goal, to evoke the moment of an obliterating present in which man and nature are fused—what he called, as I quoted him before, "a hybrid event" of "person-place." His mysterious pantheism, as he disappears into the landscape and talks to the trees, is about formlessness or fluid form, about a hybridism made possible by suspension in a bubble of time, by a presentness in which the laws of physics are waived. There's a passage in William Faulkner's perfect little novel from 1929, *As I Lay Dying*, that gets at this abstract idea. At the high arc of the story, as a country family tries to breach a rushing river and take their dead mother to her burial place, the son Darl, something of the book's philosopher, says, "It is as though time, no longer running straight before us in a diminishing line, now runs parallel between us like a looping string." And later he says, "It would be nice if you could just ravel out into time."[42]

I think of Wilmarth's cable looping through the glass in many works, materializing then growing smudged as charcoal, and now seeming like a diagram of time's movement, a wire tracing the circuit of the light as it loops through the glass—in front of, inside, and behind—on its circadian round. Time as another of Wilmarth's plenitude of meanings (so antithetical to the static and unambiguous material fact of Judd's specific objects) builds in the glass, and light is its agent. The light is the engine of continuous time, the perpetual present tense. In the ever-changing light, the glass shifts, if you will, from adjective to verb,

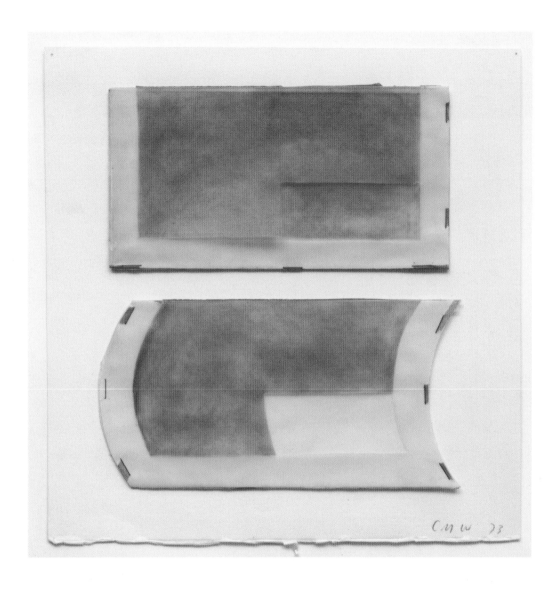

PLATE 49

*Given Image,* 1973. Graphite on tracing paper, stapled, 12³/₈ × 12¹/₈ in. (31.4 × 30.8 cm). Private collection, Woodland Hills, California

from still pictorial description to the active form that's meant to engage us. And there's another condition of time at work, the time of the past tense, of memory's album of pictures that recalls each station of the light that, one by one, changed the mood of the sculpture and transformed its identity.

Wilmarth's own identity is intricately braided into this play of time and figures, landscape and inscape. In his 1974 statement for the exhibition of the "Nine Clearings" at the Wadsworth Atheneum, he writes: "I associate the significant moments of my life with the character of the light at the time." And he goes on to say: "For years I have been concerned with the complex problem of implying the human presence in a non-objective art. The concept of the self-generated form approaches a solution in that the sculpture attains a living presence. The layering of material has organic implications, but it was the feeling of people

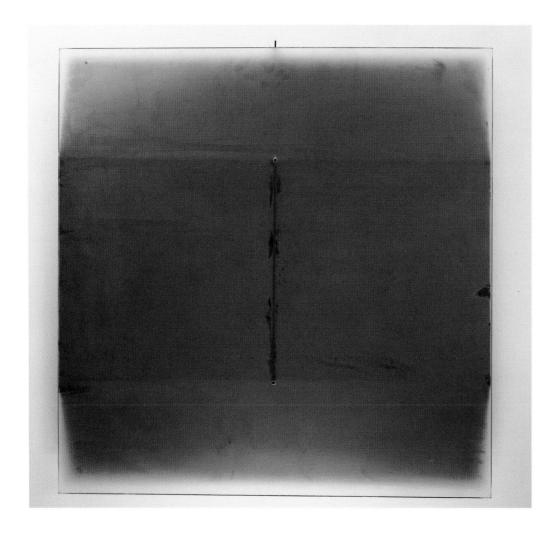

in places and the special energy certain places have long after the people have gone that provided insight into my concern with the figure."[43] He's sweating already, germinating that sentence about his work—the one so full of parentheses like portals—that he'll deliver to his students six years later: "It's the feeling one gets in certain places when the configuration & identity of objects, the quality of time & light & one's position in relation to this place (psychological) merge in (for) a (spiritual) significant (human) moment."

For Wilmarth, light and time are ways to become liquid and free, to double himself in the glass and to evoke that ethereal energy of the person-place. He becomes more and more open, merged with ambient space like Matisse's "Backs" and the multiple viewpoints in Cubism. Jean Metzinger wrote in 1911 that the Cubists "uprooted the prejudice that commanded the painter to remain motionless in front of the object." To move around the object and then to show so many views at once was a speed-driven compression of moments perfect for the new cosmopolitan life of the twentieth century. This was liberation.

ABOVE, PLATE 50
*For Roebling*, 1973. Etched glass, steel, and steel cable, 40 × 40 × 2³⁄₈ in. (101.6 × 101.6 × 6.1 cm). Collection of Barbara and Edward Okun, Santa Fe, New Mexico

OPPOSITE, PLATE 51
*Tied Drawing with Clearing*, 1974. Etched glass and steel cable, 19 × 19 × 1 in. (48.3 × 48.3 × 2.5 cm). Private collection

STEVEN HENRY MADOFF

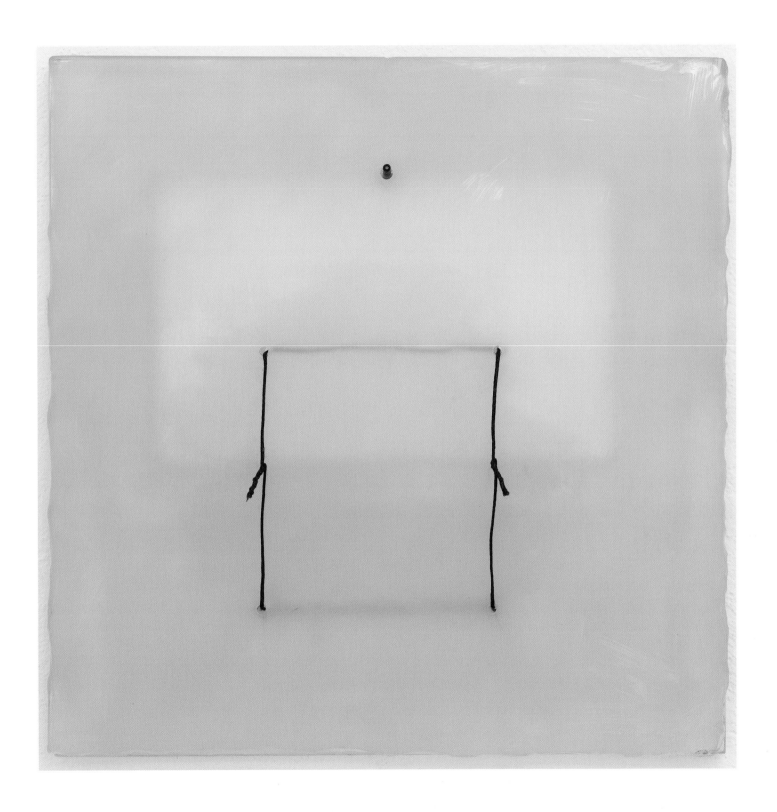

"Formerly, a picture took possession of space," Metzinger wrote, "now it reigns also in time."[44] The links in the chain go forward as well as back. While the Cubists approached the condition of sculpture in their paintings, Wilmarth takes account of Cubist painting in his sculptures and thrives. As he pictures the figures in the glass, light and time are his allies. They help him project himself, suspended in unfettered space, in the fullness of time, into the clearing.

These were good years. The sculptor had done well, really from the start—admired for his intensity and skill at school, given grants early, exhibited young. Three years out of Cooper Union, he'd had his first one-man show at the Graham Gallery in New York. The next year, 1969, he was awarded a National Endowment for the Arts grant and appointed an instructor at Cooper Union. A Guggenheim fellowship followed and then a year as a visiting artist at Yale—art school Valhalla in those days. In 1973 he spent three charged months in Milan, Italy, creating fifteen sculptures for an exhibition at the Galleria dell'Ariete. Then came the "Nine Clearings" and their critical success at the Wadsworth Atheneum. And so it went.

An old English ditty goes: "He that would thrive / Must rise at five; / He that hath thriven / May lie till seven."[45] But Wilmarth, despite his roll of good fortune, seemed incapable of lying till seven, mating his dreaming mind instead with rapid formal inquiry. The themes and variations tumble out in these years. He wasn't a Robert Morris, who donned one aesthetic after another as it took hold in the art world. Instead, his nature was to be protean, yet to hunker down. As early as 1961, Wilmarth wrote in a class session's notes, "An artist is constantly digging to see the whole world. He uses a street more than just as a place of travel." Then later on the same page: "Transparencies are used to diffuse an interior—the

ABOVE, PLATE 52
*Back,* 1972. Etched glass and steel, 16 × 48 × 1¼ in. (40.6 × 121.9 × 3.2 cm). Collection of Caroline Wiess Law, Houston. Promised gift to The Museum of Fine Arts, Houston

OPPOSITE, PLATE 53
*Side Slip,* 1973. Etched glass and steel, 27½ × 52½ × 11½ in. (69.9 × 133.4 × 29.2 cm). Collection of Maxine and Stuart Frankel, Bloomfield Hills, Michigan

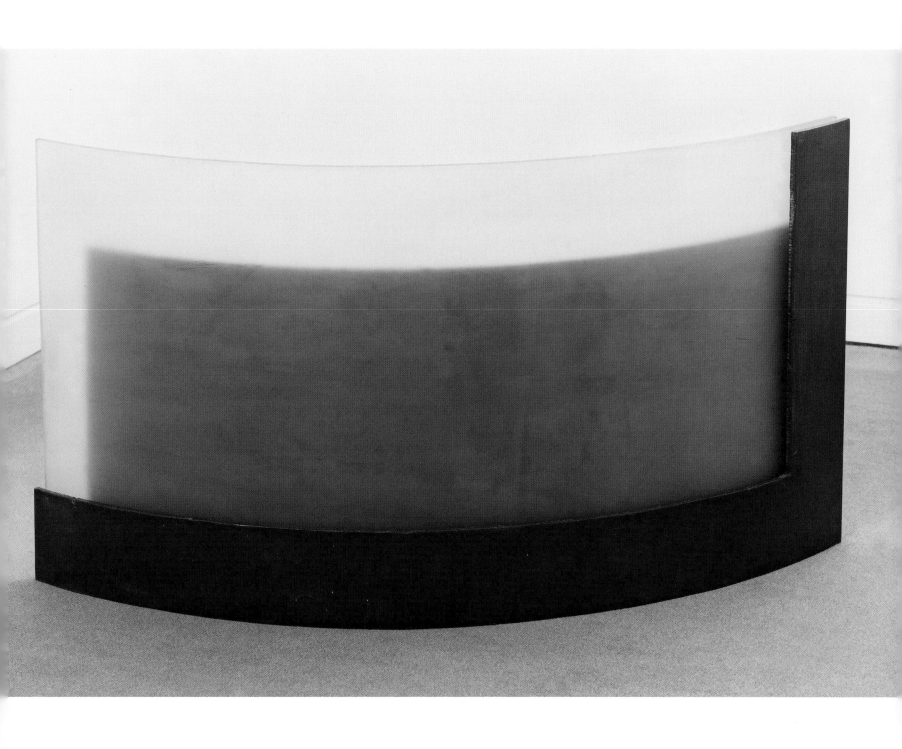

image needs to lose (your) its weight."[46] In the seventies, he became fluent in turning forms over, transposing elements, taking things off the wall and putting them back on, weighing and lightening. But what we see first in this classroom musing is the incipient churn of metaphysical thoughts. Travel becomes a metaphysical index for Wilmarth ("I'm in the transportation business"); and it is more than just a street, it is a world.

The fullness of the glass in the "Nine Clearings," ripe with the presentness of time and the sweet thought of stepping free from the body with all the ease of disrobing in the soft light and solitude of a forest clearing, wasn't limited, of course, to the wall reliefs. Mobility, we know, is Wilmarth's mode; his writings and drawings tell us as much. He hovers above, moves around, envisions portals to pass through. The changefulness of his three-dimensional picture plane, figure and ground shifting in shallow space, are one kind of mobility—a movement in and out, back and forth across a surface. But then, so is sculpture in the round. This isn't to say that Wilmarth didn't see differences in the ways reliefs and sculpture in the round are made nor in the ways that viewers experience them. Yet the aspiration embedded in this mobility was the same: to stalk change, to stay unstill. It was an aspiration that expressed itself not only as a physical act of movement but as a shape.

Wilmarth circles the work, literally, in his early art, and the circle is fused with time. I think of *Cirrus* (plate 12), for example—in his debut show at Graham—and shortly afterward, the interrupted, implied, standing, horizontal, or doubled circles in *Fats* (plate 54),

ABOVE, PLATE 54

*Fats,* 1971. Etched glass and steel cable, 12 × 30 × 12 in. (30.5 × 76.2 × 30.5 cm). The Edward R. Broida Collection

OPPOSITE, TOP, PLATE 55

*Fontella,* 1970. Etched glass and steel cable, 12 × 21 × 5 in. (30.5 × 53.3 × 12.7 cm). Yale University Art Gallery, New Haven, Connecticut

OPPOSITE, BOTTOM, PLATE 56

*Little Bent Memphis,* 1971. Etched glass and steel cable, 42 × 92 × 5 in. (106.7 × 233.7 × 12.7 cm). The Edward R. Broida Collection

STEVEN HENRY MADOFF

*Fontella* (plate 55), *Little Bent Memphis* (plate 56), *Panoply's Angel* (plate 58), and many more. Among the few paintings he made, the very first was *The Letter "O"* (plate 59), followed two years on by *Filter (for Trouble)* (plate 140), with its three ovals strung through, presciently, with strands of wire. "It is a non-directional shape," Wilmarth says about the circle in a 1968 interview, "yet it is the fastest, speediest form you can use. A circle to me is a portent of activity. . . . When I finish a piece, because of the fact that it is a circle, it never stops moving."[47] In the last decade of his life, when he comes back to the sphere in the blown-glass, headlike forms for the "Breath" series and later works, they are like circles dragged down and distorted. Change becomes a decaying loop in time, an orbit along increasingly eccentric paths that were strewn with bad emotions and spiritual depletion, with light and with rot.

But until those years, the shape of the circle and then of a viewer's circular movement around the work was a more hopeful sign in his art, I think; a more

*Wilmarthian* symbol of the rapidity of change as an antidote to the fixed. He wants complicity in the act. In a letter from 1975, in which he talks about the heady experience of visiting Brancusi's *Endless Column* the previous year, rising in the distance in Târgu-Jiu, Romania, he writes: "The strength of the pleasures of 'coming upon' a work of art are [*sic*] too rarely considered. The effect on the viewer is one of discovery, *personal* discovery & the viewer did make the choice to turn *that* corner & was rewarded with acknowledgement & the release and exchange of energy commences."[48]

There's an intriguing bit of Robert Morris in this, who first proposed in his "Notes on Sculpture" essays in 1966 that the spectator's mobile engagement, the orbit of the work by the viewer, was essential: it completed the sculpture as a personal, phenomenological experience. Yet Morris's spectator and Wilmarth's go separate ways. Morris judged that "the better new work takes relationships out of the work and makes them a function of space, light, and the viewer's field of vision." Which is to say that he wants to evacuate as much meaning and significance as possible from the object itself. But the *horror vacui* this creates—after all, humans hunt meaning the way heat-seeking missiles hunt humans—means that the significance has to be transferred somewhere else. That somewhere is into the zone of experiential space, with its endless nuances of light and other conditions, of which the viewer is a nimble and fundamental part. This delicate transaction with the sculpture de-

STEVEN HENRY MADOFF

pends on the object's readiness, its Minimalist formation, to be absorbed as a simplified, whole shape—a gestalt that's swallowed by the spectators' eyes, as it were, consumed as they go around the object. But more interesting still, with regard to Wilmarth, is Morris's emphasis that the time of the object is the time of the viewer perceiving it, the one integrated with the other.[49]

Wilmarth wants his object, which is a surrogate for the self, to be just as integrated with the surroundings. Like Boccioni, he wants to split himself open and tuck the landscape inside him. He wants the glass, which is a snare for the light as the light is the visible sign of time, to stand as a clearing in which time is all presentness. You could possibly make that argument for Morris's notion of time, too, though I wouldn't be certain of it. Morris, being

a performer at heart, wants the action to move along. Time for him is about duration, I think; about experiencing the work as a kind of performance in which the spectator is a player. But even if we were to suppose for the smallest instant that he wanted the spectator to become transfixed in that imagined state of ecstatic and absolute presentness, it's still a leap to get from the physical thereness of Morris's encounter with the object (all his talk about the gravity of the sculpture while pooh-poohing the wall relief as a compromise of that gravity) to Wilmarth's often-stated aim: precisely to get through and out of the body, to just leave the damned thing behind. Another way to state this is to say that the self-consciousness of experiencing the work as an end in itself is Morris's goal but not Wilmarth's, who sees the work instead as a tool to get over to the spiritual. So Wilmarth says of his art with piety (though it may sound precious to our ears today) that it is "an instrument of evocation and requires as catalyst the soul of a sensitive person to engage its process of release, its story, its use."[50] I can't imagine Morris saying anything like this at the time.

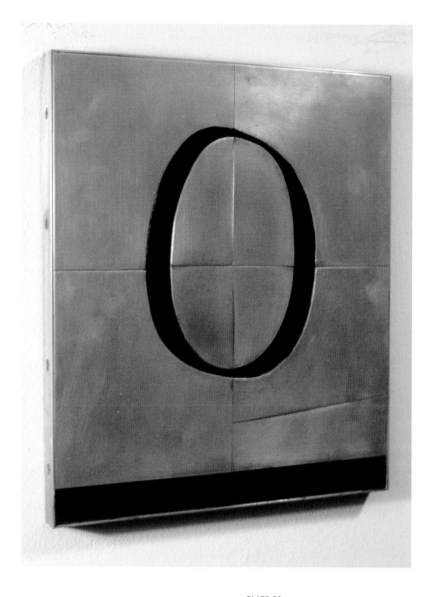

To engage in Wilmarth's story, then, isn't to read the work's gestalt, but just the opposite. The idea of perceiving this simplified, whole shape in the flow of space and time and apprehending it, a universe in which the spectator is one with the oneness of the object, is replaced by a universe whose boundaries are far less distinct; a universe (like ours) in which a multiplicity of meanings thrives—which is to say a place of potential fullness but also of doubt. The very fact that the metal is meant to set up an internal strain of material debate with the glass is evidence of that: the steel sheet and cable can pull the glass down and in, despite the lifting quality of the light, while the atmospheric murk of the glass insinuates that the metal plate behind it may be less solid and carry less weight than it actually has; that it, too, may float. Over and again Wilmarth stresses his skepticism about the heft of final

definitions. He writes, "I have always wanted to find a place, or make a place or a thing that by its nature, its energy, its EMISSIONS, would render ineffective the confining power of the Group."[51] The work, full of multiplicity and duality, bears him out: the melding of styles in the sculptures' permeable skins; the transparency and translucency; the shifting figure and ground; the flickering and changing edges; light and shadow; light and time.

When you do get to circle one of Wilmarth's sculptures in the round, what becomes clear is that the work's gestalt is impossible to fathom; the configuration just keeps changing too much. That's not to say that there isn't a biased view, a card that the sculptor keeps sliding out from the bottom of the deck. That would be the glass, which, after all, is literally the most eye-catching element of the sculptures. It draws the viewer to the front of a piece, underlining yet again the pictorial aspect of the sculptor's art. I would be hard-pressed to name too many of the floor-standing sculptures that you wouldn't amble up to and say with assurance, Here is the front. Yet even though that's the priority of the composition, the work is no less various in its account of shape and space and perception. On the contrary, we already know about the manifold character of the glass. The glass simply leads where the rest of the piece follows—into the land, I suppose, of "emissions."

Wilmarth's *Wyoming* (plate 61) inhabits that place. It's typical of any number of pieces made from 1972 until 1980—among them *Alba Sweeps* (plate 43), *Susan Walked In* (plate 60), *Sender* (plates 63 and 64), *Calling* (plates 65 and 66), *Gift of the Bridge* (plate 135), and *Long Leavers Gate* (plate 67), which is a rare piece in that it actually sits in the landscape. Primarily, as we know, the landscape is meant to sit in the sculpture, and the rigors of *Wyoming*'s geometry and materials make Wilmarth's customary argument that the work is first empirical, then gets translated into the non-world, the un-weight of dreaming, a walkabout for the mind.

The sculpture's large square of steel is the size and form of its glass sheet. It's an homage to the square, and Kazimir Malevich's tilted, ethereal painting from 1918, *Suprematist Composition: White on White* (plate 62) jumps to mind, as Wilmarth knew it well from regular visits to the Museum of Modern Art. "My new painting does not belong to the earth exclusively," Malevich wrote with customary bravura to a friend. "The earth is thrown away like a house eaten up by termites. . . . I am transported into endless emptiness, where you sense around you the creative points of the universe."[52] Evidently, he was in the transportation business, too. Wilmarth's glass in *Wyoming* has the lightness of a structure lifting off its foundation of steel, steel that's cut in quadrants and folded in various directions—the foundation itself splayed and spun around. The twisting rhythm of the piece quite literally deconstructs

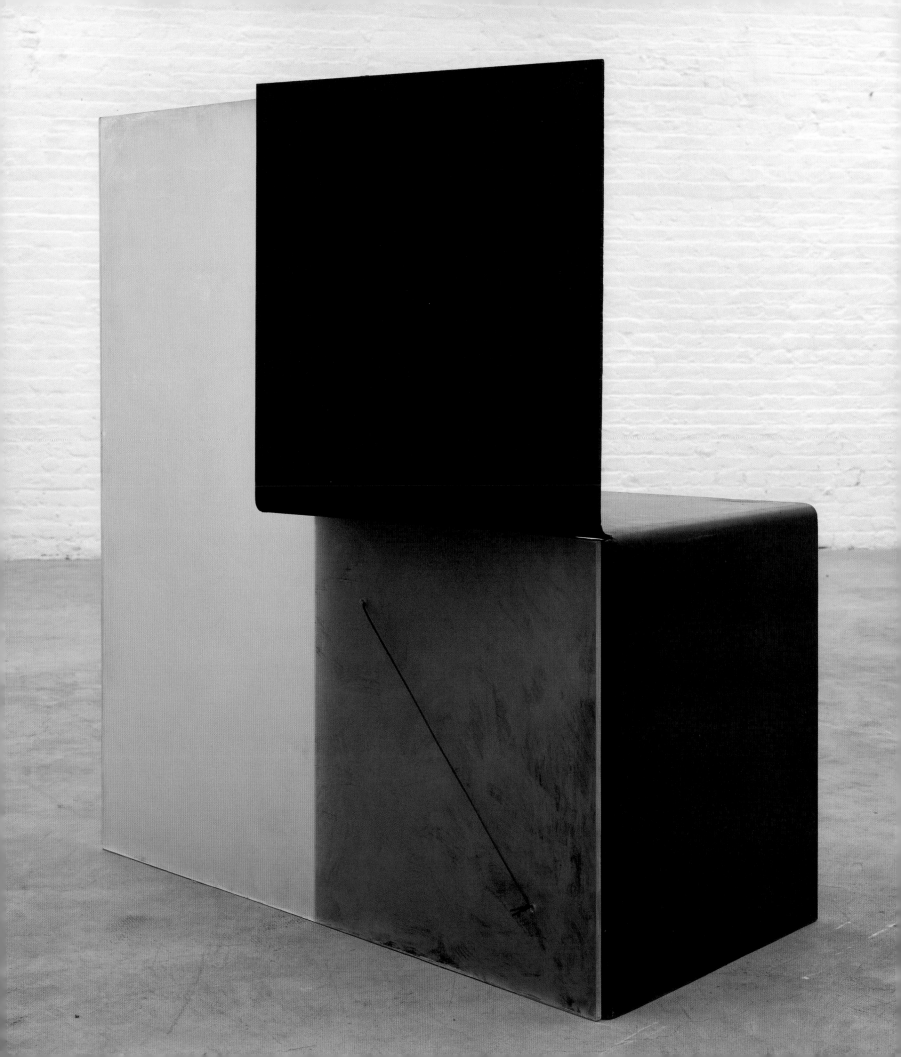

OPPOSITE, PLATE 60

*Susan Walked In,* 1972. Etched glass,
steel, and steel cable, 60 × 60 ×
30 in. (152.4 × 152.4 × 76.2 cm).
Collection of Susan Wilmarth-
Rabineau, New York

RIGHT, PLATE 61

*Wyoming,* 1972. Etched glass and
steel, 60 × 58 × 73 in. (152.4 × 147.3 ×
185.4 cm). Estabrook Foundation,
Carlisle, Massachusetts

BELOW, PLATE 62

Kazimir Malevich (Russian, 1878–
1935), *Suprematist Composition:
White on White,* 1918. Oil on canvas,
31¼ × 31¼ in. (79.4 × 79.4 cm). The
Museum of Modern Art, New York.
Acquisition confirmed in 1999
by agreement with the Estate
of Kasimir Malevich and made
possible with funds from the
Mrs. John Hay Whitney Bequest
(by exchange)

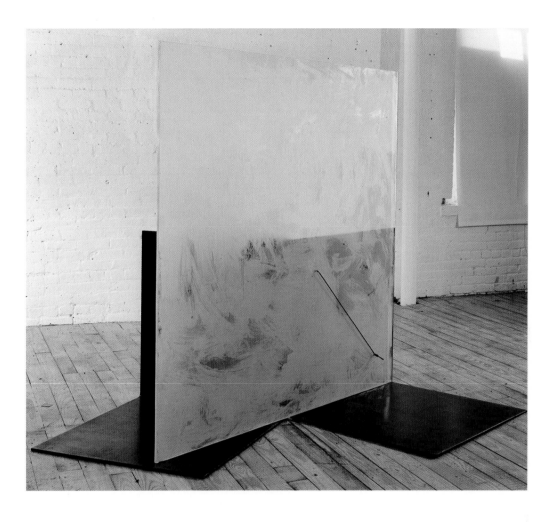

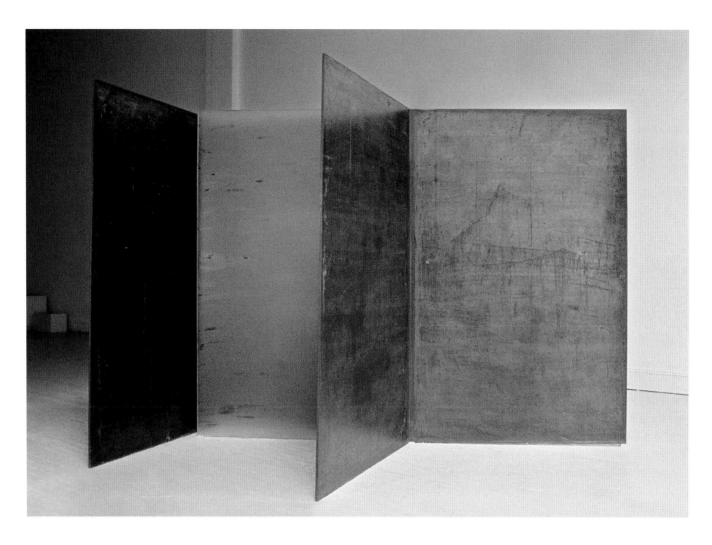

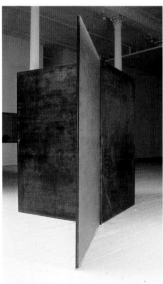

*Sender,* 1974. Etched glass and steel,
6 ft. 6 in. × 8 ft. 8 in. × 4 ft. 4 in. (2 ×
2.6 × 1.3 m). Dallas Museum of Art.
Gift of Dr. Joanne H. Stroud

*Sender,* view from the back

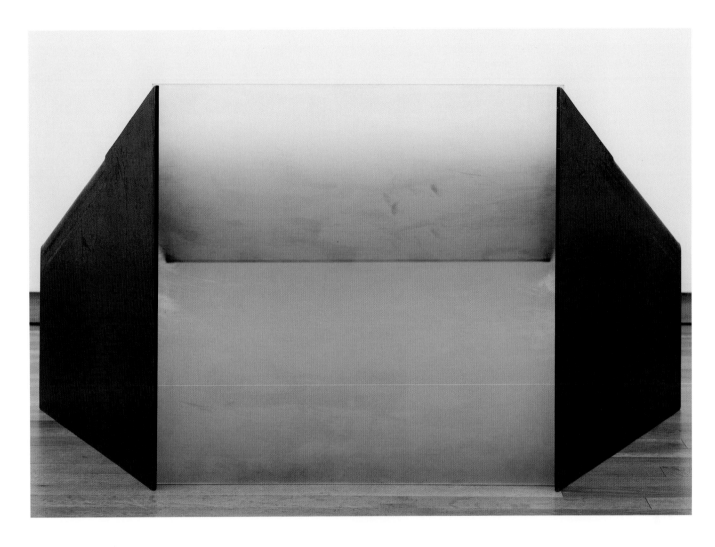

**ABOVE, PLATE 65**
*Calling* (maquette), 1974. Etched glass and steel, 24 × 48 × 24 in. (61 × 121.9 × 61 cm). Private collection, San Francisco

**RIGHT, PLATE 66**
*Calling* (maquette), view from the back

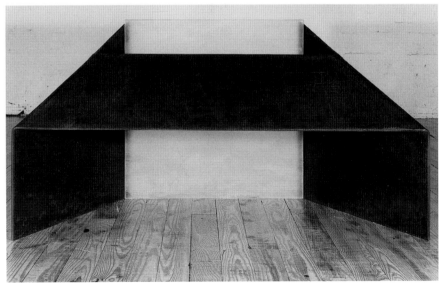

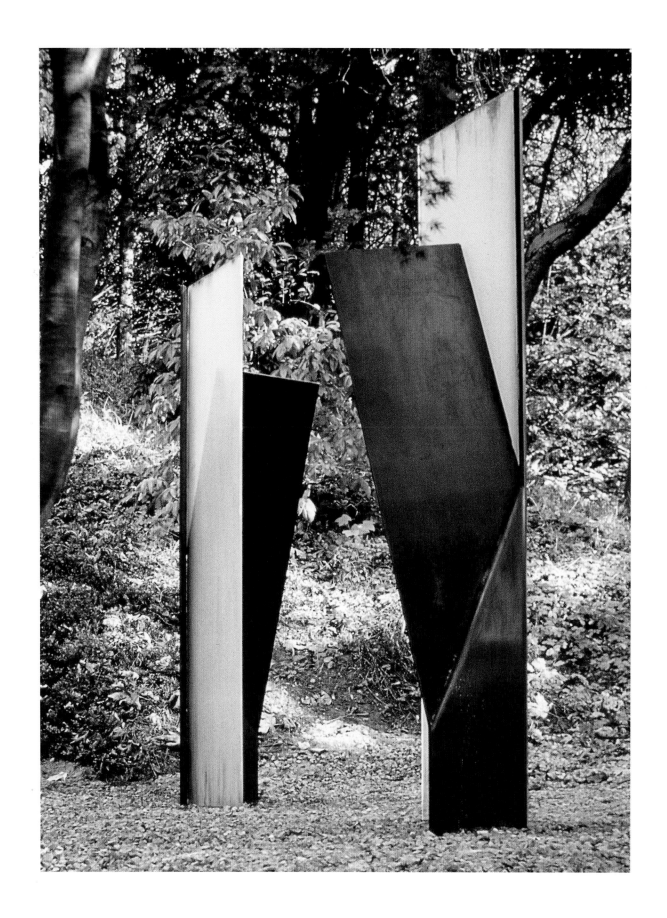

the whole of the steel square as the viewer walks around it, while the glass either leaps forward toward the eye if you're in front of it or is cut dramatically in two if you see it from behind (plate 68).

Wilmarth wants the whole, but he also wants the fragments. The steel sheet, sheared and bent, is a contortion of a square, a square root uprooted: half base, half stacked vertical akin to its use in the wall reliefs. The cable, pitched at a rakish 90 degree angle, unites and divides. It ties the two plates together while it neatly bisects a partial square of steel, shooting right to left, from darkness into the light, yet it holds them nonetheless. *Wyoming* looks tranquil enough, with a broad stream of light falling across all that whiteness and coolness skimming the etched glass. But the formal restlessness of the piece fills the space; it won't settle as a whole. And while I think of Malevich's topsy-turvy flight toward cosmic spirit, a more grounded influence on Wilmarth was Tony Smith, for whom, as I've mentioned, the young sculptor worked, and whose own intricately angled geometric sculptures were bad news to the Minimalists and their call for reduced forms.[53] Smith's *The Snake Is Out* (plate 69), wriggling and arching in space, is based on irregular polyhedrons, and just such internally complex relationships of a sculpture's form spelled trouble—or so Morris states in part 2 of his "Notes on Sculpture." For Morris back then, complex forms made an impure experience because they weren't scrubbed suitably clean of detail and of the stickiness of their own possible meanings, which he argued could be rendered only by the active spectator. But this essentially physical understanding of an artwork's impact on a viewer was anathema to

OPPOSITE, PLATE 67
*Long Leavers Gate*, 1980. Etched glass and bronze, height 90 in. (228.6 cm). Collection of Illsky Nordstrom, Seattle

BOTTOM, LEFT, PLATE 68
*Wyoming*, view from the back

BOTTOM, RIGHT, PLATE 69
Tony Smith (American, 1912–1980), *The Snake Is Out*, 1962. Painted steel, 15 ft. × 23 ft. 2 in. × 18 ft. 10 in. (4.6 × 7.1 × 5.7 m). Raymond and Patsy Nasher Collection, Dallas

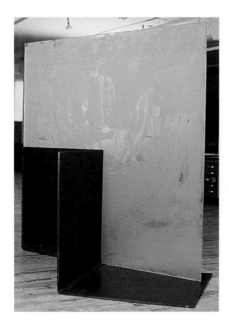

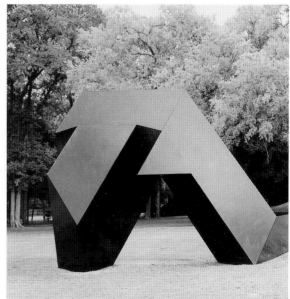

Smith in turn, who championed "the inscrutability and mysteriousness of the thing," as he put it, and thought of his sculptures "as presences of a sort."[54]

You can hear those words echo in Wilmarth. Their sentiments, absorbed by visual and physical osmosis from Smith as well as by natural affinity, become intrinsic to the younger sculptor's art, and they're incarnate in *Wyoming*. Wilmarth wants its materials and forms—honoring the solid and the less solid, brimming with wholeness and questioning it—to represent a notion of phantom energy generated by the constant raveling and unraveling of the physical. It's a veritable debate on being. Look from the side, and the etched glass is a brilliant sheet inscribed with the presence of its author's hand. From the back, the steel dominates—it's all durable heaviness, the angle and tuck of obdurate material. From the front, where we're likely to spend most of our time looking, the sensual pleasures of the colors, the glinting brushwork, the nearly sueded surface of the steel, easily convince us to like the world. Yet the glass wants to pull us up, make us feel lighter than the world, as if the earth were thrown away, and that is the metaphysician's idea.

He is prowling; circling above, behind, around. What was it in that glistening ice so many years before, what illusions of depth as Wilmarth's figure, leaning over to take the photograph, left its shadow there, melting? In 1978 Rosalind Krauss wrote in her essay "Sculpture in the Expanded Field" that modern sculpture, beginning with Auguste Rodin's *Monument to Balzac* (plate 70) from the 1890s, lost its toehold in the ground of public function. The monument's civic pride of place gave way to sculpture's inward turn, as the *Balzac*, with its immense subjectivity in place of accessible convention, suggests to Krauss in the forlorn detail that it was never erected on the site for which it was commissioned. Its casts roamed, and sculpture in its modernist phase became, in this sense, siteless.[55] This is an interesting and accomplished idea—one of the more compact propositions about modernism's willful exclusivity—and evidence of its truth may lie in the twentieth century's exploitation of that rootlessness: the growth of the art world's commercial network.

Most of the works Krauss cites won't fit in galleries, and that's a key to their siteless state, wandering, as it were, in the landscape. The large earthworks by Mary Miss or Robert Smithson or Michael Heizer, the grand outdoor structures by Alice Aycock or George Trakis, and many more vanguard extensions of the once-limiting term *sculpture* contradicted the pristine white boundaries of the modern gallery's walls. Yet they still found their ways into the ever-expanding system of the art market, in which documentation became a saleable surrogate for a difficult-to-define or physically outsize piece. At the same time,

most of the sculpture in the late seventies—from Eva Hesse's to Gordon Matta-Clark's to Anne and Patrick Poirier's to Nam Jun Paik's and up and down the ladder from forward-looking to conservative—lived perfectly well in a gallery setting. And they, too, fit the description of "sitelessness," but in a different aspect: the nomadic life of the artwork propelled from one place to the next by commercialism and capital, from studio to dealer to collector to another dealer or to an auction house and collector and then, possibly, to a museum and possibly deaccessioned to another auction house or dealer, and so on and so on in an endless round. There were, and are, commissions still made both for monuments and for less history-driven site-specific pieces, but for the vast output of sculpture (and other genres), the art can't depend on a site to frame its story. It has to internalize its narrative, tote its story with it, otherwise the eddy and swirl of capital will carry it away from its local meaning so that it seems like nonsense (and "nonsense" became an all-too-familiar slap at art in the modernist era as in our own, sometimes right but just as often ignorantly wrong).

Much of this, of course, has to do with the spectator, with what the viewer is given in order to grasp a work's meaning.[56] Judd, for example, didn't care about the viewer and was typically blunt about it.[57] For all the definitions articulated in "Specific Objects" and his other writings, I don't think it unfair to say that hermeticism permeates Judd's art the way jasmine and spice inhabit the scent of Shalimar. Morris thought that the story of the work was one with the story of the spectator and of the environment, their meanings bound together in experience, and he built his installations to create a charged spatial atmosphere to make the point. Wilmarth is more specific about his spectator. His work, remember, is an instrument that requires "the soul of a sensitive person to engage its process of release, its story, its use." And we know what that story, in effect, is about: sitelessness. He talks of the romance of the work surmounting its containment; about energy rendering ineffective the confining power of the group. "I have tried to make sculptures that invoke a spiritual disembodied state," Wilmarth writes.[58] And to what end? What is this instrument's use? It carries the world inside itself, perhaps because the world outside—the world of art and commerce most pointedly—becomes difficult to accept. He's uncomfortable with the physical, and so he leans toward what I've called the after-physical, the body opened into a clearing, the shadows melting in the glass.

I don't think it's terribly speculative to say that while Wilmarth's work seemed to be going well—with his art selling, the award of a second NEA grant in 1977, a second exhibition at the Wadsworth Atheneum that same year, and the reviews positive—he was not at home in

the local scenery. He was always a tumultuous man. In turn argumentative, charming or hostile, macho, pensive, way up or sinking, holier-than-thou, articulate or stubbornly silent, and fiercely loyal, he could seem like a revolver with one bullet left in the chamber. You never knew when the hammer was cocked. He had left his dealer of the time, Paula Cooper, and a contretemps with a new gallery left him outraged and without representation. There were other offers, but darkness was brimming over. He once wrote out a quotation attributed to Emerson that he kept in his studio: "Nothing is more sacred than the laws of our own nature and we must thoroughly look within ourselves and not permit outside standards to be imposed upon us."[59]

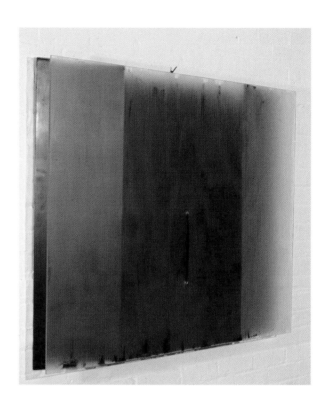

The sculptor now suffered openly from the ways of the art world. In 1976 he writes in a notebook about a drunken night: "The evening continued with me being loud & basically jovial at Fanelli's

STEVEN HENRY MADOFF

PLATE 73
Wilmarth picketing André Emmerich
Gallery, New York, September 23, 1978

and on to the corner of Grand and Wooster where I gave a loud and critical 'street speech' to the artists in the lofts there. The content was basically correct: i.e. the subversion of poetry in art to materialistic ends signified by (to me) the commercialization of the arts in our ghetto SOHO."[60] Wilmarth takes on the classic role of the avant-gardist, enacted first perhaps by Charles Baudelaire, whose poems vent their spleen at the bourgeois class, expressing his belief that the work of art is eaten in the acid bath of capital. So it was, two years later, with the sculptor's mind unchanged and with the deep stubbornness and idealism of self-reliance, that he opens his own space to show and sell his art. His work, for a time, would have its own site. He calls it the Studio for the First Amendment, with its own little logo, and he houses his private exhibition hall in the building on Wooster Street in which he and Susan live. Here Wilmarth follows in the path of the classic vanguard once more. The Studio charted the same course as Gustave Courbet's defiant exhibition of his pictures in a gallery he had built for them alongside the Beaux-Arts section of the 1855 Exposition Universelle in Paris. Courbet's paintings were accepted for the exposition, but he found fault with the way they were shown and mounted his counter-display, pronouncing with Napoleonic grandeur: "I conquer freedom, I save the independence of art."[61]

Now Wilmarth's Studio for the First Amendment stood alongside the galleries of SoHo, and he could roar his independence as well. In another dispute the year he opened the space, this with the André Emmerich Gallery, he carried a placard outside Emmerich's building on Fifty-seventh Street in New York that read "Fight Feudalism in the Arts" and wrote a statement to the press (never published): "One of the ways that art can be accepted in a market culture is by bringing it into that system and treating it as a commodity. If an artist collaborates in this they [*sic*] remain an artist in name only. Light manufacturing and market manipulation become their modus operandi. Their art becomes truly useless, a clone of Art, as the spiritual sinks beneath the greed. It is because I refuse to enter this arena of spiritual death that I picketed the resale exhibition of my sculpture at the André Emmerich Gallery on Saturday September 23, 1978."[62]

I can hear the hiss coming out of the light—something deflating in the sculptor's vision having to be blown back up. The art doesn't seem to suffer as its creator does, not yet. The previous year, Wilmarth finished the largest work he would make in his life, *Days on Blue* (plate 77). Inspired by Brancusi's *Gate of the Kiss* (plate 76), which he'd gone to see in Târgu-Jiu in 1974, Wilmarth offered his most palpably architectural work. The sculpture's portal is large enough to fill its glass with a roomful of light. Yet it's also large enough to frustrate the viewer in a way none of his other works do: you want to walk through this luminous

STEVEN HENRY MADOFF

**ABOVE, PLATE 74**

*Invitation #1*, 1975–76. Etched glass and steel, 48 × 84 × 27½ in. (121.9 × 213.4 × 69.9 cm). Hirschl & Adler Modern, New York

**LEFT, PLATE 75**

*Invitation #1*, 1976. Graphite, graphite wash, and staples on layered translucent vellum paper, 22 × 23.6 in. (55.8 × 59.9 cm). Fogg Art Museum, Harvard University Art Museums, Cambridge, Massachusetts. Margaret Fisher Fund

doorway, but you're blocked. The viewer circles the work instead, observing mass and solid, which are joined to the air of translucency between. If *Days on Blue* offers its homage to Brancusi's *Gate* in broad, columnar forms, the stroll around it that viewers take evokes people walking under the trees in the park where the *Gate* stands. Wilmarth's pairing of steely solemnity and creamy whiteness has something of spare winter turning to spring, a darkness lightened by promise. There's another enlivening aspect here, too, a dramatic one. If someone happens to be behind the glass while you're in front, the hazy figure lives there in a way only implied by the shadows in the "Nine Clearings." The pictorial illusion in the great scrim of glass gives off a small shudder of the vaporous yet real, an energy of theater. It helps to dissolve the fact of weight—the glass alone is 557 pounds—while investing the work with sudden internal locomotion, a lightness of being and a different sort of evanescent presentness.

There is still the sense that you need the heavy materials of the world thinned and lifted to get beyond them, and many of the pieces in these last years of the seventies recapitulate the theme. Look at *Evers (When the Wind)* (plate 79): its steel sides are imposing but lift the eye; its angled steel behind the glass offers a wistful horizon line, so that the sides now

make their own transit into metaphor—tall trees, perhaps, or opened doors, the wind blowing through. But there's also an encroaching sense that if, as Simone Weil says, two forces rule the universe, then gravity is now slowly gaining the upper hand over light. Wilmarth keeps talking about the *use* of his art, how it's an instrument, about art that's useless because it's reft of the spiritual. It's around this time, in 1979, that he writes the high-blown statement that I quoted briefly at the start: "I don't really see my work as 'sculptures' but more as instruments: a matrix, receivers and senders—receiving light, instruments of evocation, intermediary objects serving as access to the non-physical," he writes. "I want them to engage more than their description. They are the visible elements of a greater phenomena [*sic*]. I make things that physically exist only to locate that which doesn't."

But whatever Wilmarth's aspiration, there's a paradox here that weighs. In order to get beyond the physical, he has to make something physical. He has to saw and grind and drill and hammer, construct and arrange. He has to put something between himself and the light: one sculpture after another, each with its relationship to the edge; its bends in the steel; the particular stain of a patina; the patterns on the glass from his acid-filled brush; the glass itself; the line of the steel cable; height, distance, scale, interval, weight. Nor can he get us to the precipice of time, to this absolute present, to this mystery of weightless merger with the landscape, without his instruments. Otherwise he would be a god. But he is all too human; the works are full of the human hand. As beautiful as he wants to make his art, it is still intermediary, as he says; it is still machinery. He's stuck on this side of the rainbow.

So it is that the forms of Wilmarth's sculpture now shift toward a marker of time that's far less a bubble, far less metaphysical presentness and more gravity's daily grind. He makes a new series. There are nine pieces, just as there were in the "Nine Clearings for a Standing Man," and the title he chooses is "Gnomon's Parade." A gnomon is the column or pin on a sundial whose shadow's progress shows the hour. What an odd and endless parade: the gnomon's shadow marching around the circle of time. To borrow a phrase from T. S. Eliot, the gnomon is "the still point of the turning world." But this isn't only a literary conceit contained within a title, and the gnomons in question are quite emphatically more than their shadows.

"With *Gnomon's Parade* spirit (flesh-spirit—symbol for figure) and place (reverie) are one in a way that has not occurred in my work before," the artist writes in his notebook in September 1980, two months before he unveils the series at the Studio for the First Amendment. "They draw on the *Platform Dream pieces* on WET 1966 (destroyed) and other anthropomorphized symbols in my work, but have come however briefly, to terms with containment with the help of the *Nine Clearings*. . . . Flesh is calling for its place as anchor,

BELOW, PLATE 78
*Street Leaf #1*, 1977. Etched glass and bronze, 54 × 30 × 4 in. (137.2 × 76.2 × 10.2 cm). Collection of Gail Fischmann, Saint Louis

OPPOSITE, PLATE 79
*Evers (When the Wind)*, 1976–77. Etched glass and steel, 84 × 96 × 48 in. (213.4 × 243.8 × 121.9 cm). Collection of Maxine and Stuart Frankel, Bloomfield Hills, Michigan

STEVEN HENRY MADOFF

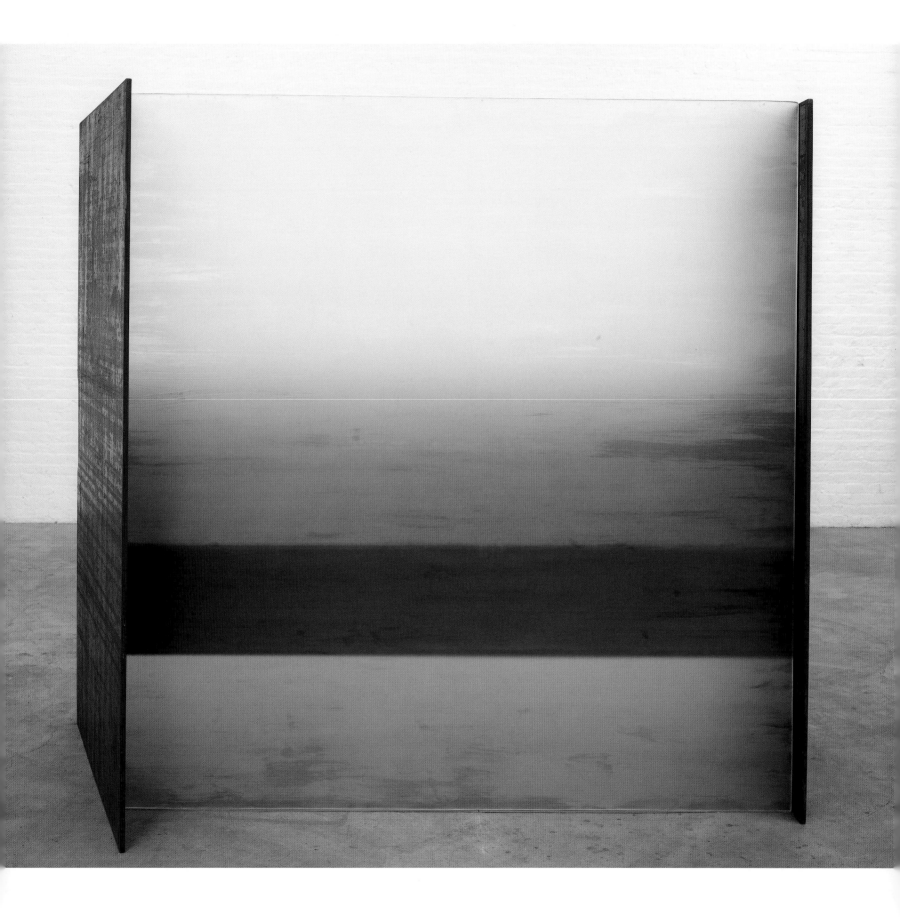

here, for wished-for-heavens, hopeful, varied, more like the days, sensual and imperfect, with more room to move." Then he makes a small and emphatic adjustment to his statement, writing below it in his notebook: "No longer is heavenly distance the preferred escape, the learning self defends."[63]

The first statement has hope about it, the pleasures of the fleshly world. Maybe he simply needs to be less abstract, less given to flight. He needs to be anchored to solid ground. Yet what he writes is also touched by a note of resignation, isn't it? Containment is all right. "Wished-for-heavens" with "room to move" are quickly put aside—the "learning self" is anchored to the earth; it defends its turf. There were earlier gnomon-inspired pieces, such as *February Gnomon* (plate 141), which clearly rose from the same ground as the "Nine Clearings." But now the clearing is narrowed to this proscribed, perhaps embattled, place, and it's one with the man. The figure in these works, usually evoked by an angle of steel jutting down from the wall like a leg, is no longer the meltingly amorphous shape caught in the mist of the glass but the other way around: the glass is subsumed, becoming part of the figure now thrust into the physical, just as "spirit" is instantly harnessed by those parentheses, made "flesh-spirit."

The position of the glass suggests various bodily roles—head, torso, full front—and a shield as well. Of course, the work still carries the profile of reduction, still has its Minimalist bones. But while the Minimalists assured the inaccessibility of the figure as an image by using geometric, simple, nonhierarchical forms, Wilmarth shapes his own Minimalist patois to say what he needs to. These are peregrinations outside the clearing to guide him back into the gravity of the world. His man attempts to stride forward, he doesn't simply stand, and here the artist reaches back again down the links of his modernist chain: first to Rodin's *Walking Man* (plate 80), so powerfully vertical, armless, headless, weight forward on the right leg, the terrain underfoot tilting down to imply movement, the legs rippled with muscles. There is Boccioni's *Unique Forms of Continuity in Space* (plate 81), more planar and driven to show the impact of thrusting force on a body—part Mercury, part machine—that shoots through the wind tunnel of the modern world, although that body, in Boccioni's philosophy, is anything but interested in the sublime. Then there is the truly sublime figure, most congruent with Wilmarth's, Giacometti's *Walking Man* (plate 82). He nods his delicate head to Rodin, but he's worn by the world's duress to almost nothing, as Giacometti said: "The form undid itself, it was little more than specks moving in a deep black void."[64]

The museum inside Wilmarth's series is rich, yet there's an austerity to his new figures—and unlike those of his predecessors, his are fixed to the wall; they're on a short leash.

Their tautness comes from that tension, and from the glass made dramatically narrow, as if it were saying, *Thinner*. Body, light, and time are all on a diet here, circumscribed; an angular astringency reigns. We focus on the leanness the sculptor offers: not so much imagination stinted as the determination to describe each figure as a lord of limits. In *Gnomon's Parade (Place)* (plate 1), the embedded picture plane of the glass leans out into space, yet its two steel boundary lines, right and bottom, are unyielding. They push the light away, toward the glass's unbound edges, squeezing, or pull it down into the metal plate behind. After all, the flesh is imperfect; it's sodden with gravity. The gnomon is immobile, secured to the center of the circle, contained.

The titles say as much: *(Place)*, *(Over)*, *(Noon)*, *(Parting)*, *(Late)*, *(Side)* . . . (plates 1, 83–87). They're about the spectator moving around the work's charged field, but the charge pulses with the negative: not arriving but going away; not straight on but seen indirectly; not present but catching up, expectancy in place of satisfaction; and, with the word *Noon*, we're in the hour between day and night, betwixt and between once again, but now it seems with less expansive promise. Dore Ashton, who has written often with fascination and

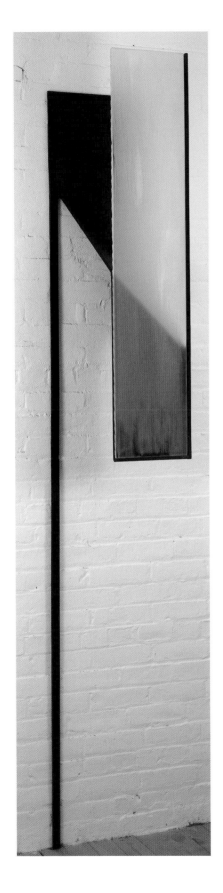

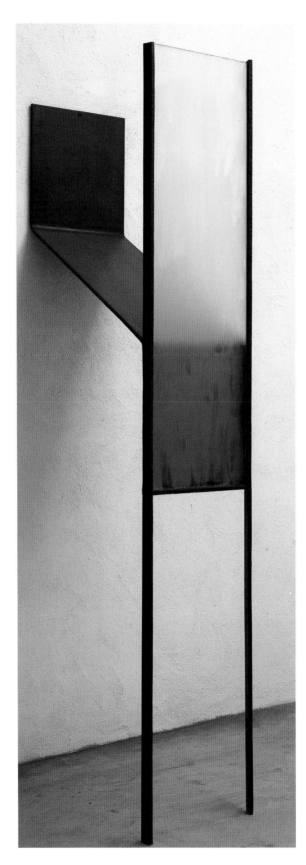

STEVEN HENRY MADOFF

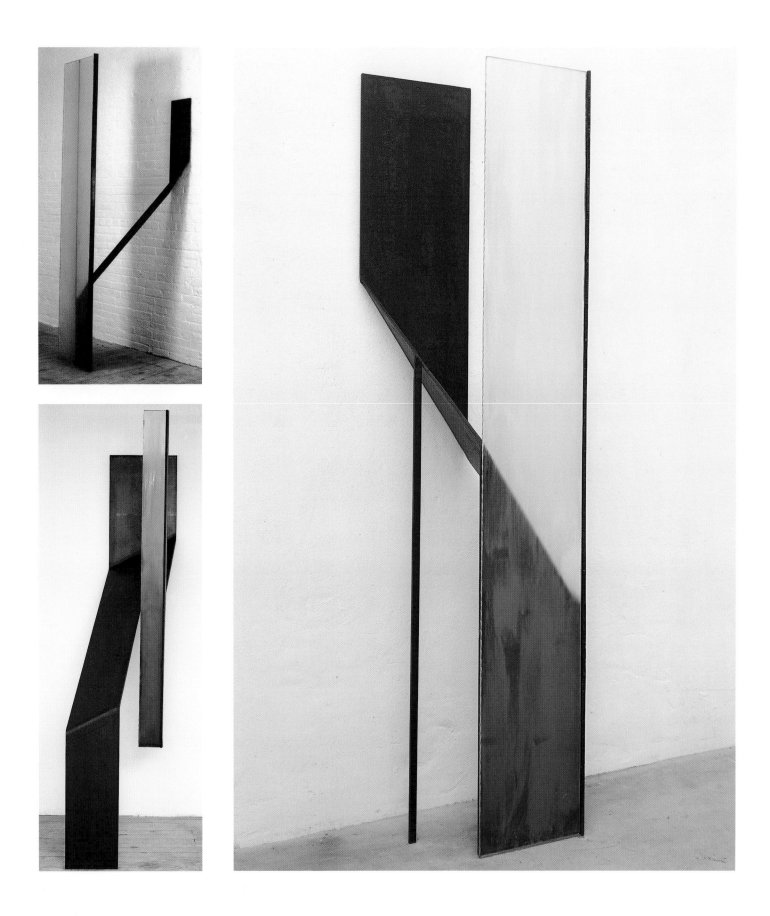

affection for Wilmarth's work, sees the series as far less brooding, even suggesting that the bend of steel stepping out in *(Place)* has the tight-limbed pose and brio of a tango step.[65] Yet her point rhymes with my own: the series appears more like a step-by-step illustration of movement; spry diagrams in which the light—once weightless and natural within the glass—is concentrated, constrained, earthbound; and the glass, held out as it is in many of these pieces, has the feel of an offering, of the clearing shrunk down to size, a reliquary object on exhibit, absolute presentness receded, a memory.

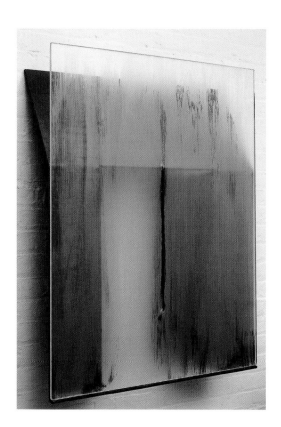

Wilmarth is pining for the fullness and fusion that he imagined he could hum into existence, whole on the other side of the glass. Now his unity has gone missing, and I think he yearns for it. He wants it remembered. The steel's lithe contortions get at the itch of his being. "They (these nine) have physically been the most difficult sculptures I have made," the sculptor writes in his notebook, "as they are each pulled from a single plate of steel to support a feeling of integral and generative form. All cutting, bending, & machining was done to retain a memory of the germ—the first shape—a simple rectangle, and endow the work with a sense of expectation, as if upon returning some time later they will have continued to evolve & move."

And then, just slightly below this in his notebook, he writes the oddest thing—or maybe not so odd, for someone whose instruments of evocation are, however briefly, objects of containment, not quicksilver but the imperfection of the flesh. "Given a choice would you choose not breathing over breathing?" Wilmarth asks himself. "My answer is no. And the reason I have decided to do what I have done in my profession, to be independent, is the same. I choose to breathe. For now." Then he draws a line, crossing out the words "for now."[66]

A relief, no doubt. Having grounded "Gnomon's Parade" in the world, Wilmarth now moves, once again, in the opposite direction. The "generative form," the "first shape," sound like Adam to me. But was he in the Garden or already evicted from it? Was the place of the "Gnomons" touched by "spiritual implications," as the sculptor said?[67] Well, he said so. Yet he also said that the flesh was imperfect, corrupted, which points a finger toward Eden's exit sign. And yet again, remember his phrase about containment in this post-Edenic world: "however briefly." Back and forth. He imagines his figures evolving, yet they move under the constraints of earthly weight. He chooses to breathe, appends death to his choice, then brushes its gravity away. Now he wants his wished-for heavens, that

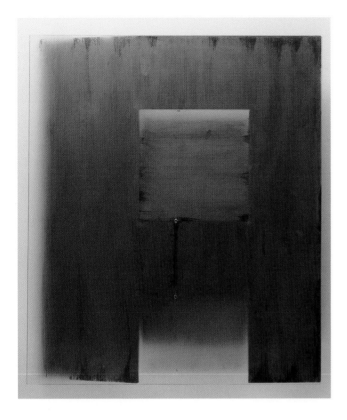

sense of wholeness restored with all the sweetness of a Proustian madeleine. He wants to be transported again, swung back up. Breath literally pulls the spirit of his next body of art out of the air.

At the same time that Wilmarth began his work on the "Gnomon" series in 1978, he was approached by his friend, the poet Frederick Morgan, with a handful of translations, seven in all, that Morgan made from the famously enigmatic poems of Stéphane Mallarmé, the nineteenth-century douanier of French literary Symbolism. Mallarmé's master, Baudelaire, wrote the title truest to Wilmarth's art, I think: "Anywhere Out of the World"; but it was Mallarmé who gave Wilmarth the words that most closely touched his sidling nature, always seeking the spiritual portage from matter to after-matter.[68] Across a century, we hear in both the poet's and the sculptor's works the leitmotif of longing for the other side: the same recognition of the pathos of art as encumbered by the physical and the deep desire to get beyond it—"to depict not the thing," as Mallarmé wrote, "but the effect that it produces."[69] Those words echo in Wilmarth's statement jotted down in 1979 as he pored over Mallarmé's poems, the statement I've quoted more than once as a shorthand for the artist's ambition: "I make things that physically exist only to locate that which doesn't."

With its elegant avoidance of direct statement and its emphasis on the inner life whose prism bends and changes the outer world, Mallarmé's poetry confirmed in Wilmarth the power of indirection, of the oblique, of things that transform in a glance into other things. Indirection is another way of describing the glimpse through the half-open door, with all its possibility, with its shadow figures merging and melting away the empirical. But indirection isn't only about the pleasure of cornucopian prospects. It aligns itself with the painful recognition of stuff always out of reach. Wilmarth said that he found in the poet's work "the anguish and longing of experience not fully realized"[70]—a comment sung in chorus with Mallarmé's own assertion, "This is what equals the act of creation: the notion of an object, escaping, that we need."[71]

It follows in Mallarmé's poetry that the haunting (or should I say taunting) condition of the ungraspable should find relief in the benefits of analogy, a literary tool forever prob-

ing and thrusting into the world to grab something else, to find one thing linked to an-
other in an endless collection of sensations, images, and objects perpetually changing their
skins. Analogy ties things together, but it also has the quality of the once-removed; its figures
take on a lightness, an evanescence. Mallarmé, in fact, wrote a prose poem called "The De-
mon of Analogy," in which he fastens on a phrase that mysteriously enters his mind, "The
Penultimate is dead." Translation: Things do get resolved and come to an end. But that, it
turns out, seems not to be the case, and the poet finds himself at the end of the poem star-
ing into a shop window, reflected, half transparent, figure melting into ground, as if to say
that analogy gains something and loses something else; nothing's complete or holds its
own weight or substance, and yet it has a second life on the other side of the glass. So
when we read "Sigh," among the bouquet of poems Morgan gave to Wilmarth, the over-
arching sense is of a breath exhaled, floating off, invisible to the eye and weightless:

> Towards your brow where an autumn dreams
> freckled with russet scatterings—
> calm sister—and towards the sky,
> wandering, of your angelic eye
> my soul ascends: thus, white and true,
> within some melancholy garden
> a fountain sighs towards the Blue!
> —Towards October's softened Blue
> that pure and pale in the great pools
> mirrors its endless lassitude
> and, on dead water where the leaves
> wind-strayed in tawny anguish cleave
> cold furrows, lets the yellow sun
> in one long lingering ray crawl on.

Morgan's translation teeters dangerously toward transcription at times, giving the
poem (and all the poems in the group) an antiquated air, the feeling of a museum piece
more than a legible reading in late-twentieth-century diction.[72] Precisely because of that, he
renders something that takes you out of the accustomed rat-tat-tat-tat of American En-
glish—a language with a train to catch—into the elaborately serpentine and drifting world
of the poem. A dreamy brow becomes an autumn that also dreams; a soul rises like a foun-

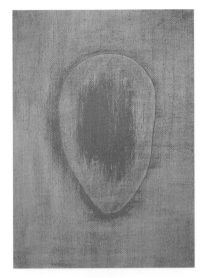

*Sigh*, 1979. Pastel and graphite, 26¼ × 19¼ in. (66.7 × 48.9 cm). Estate of Christopher Wilmarth, New York

CENTER, PLATE 91

*Sigh*, 1979–80. Etched glass, 13 × 7¾ × 6 in. (33 × 19.7 × 15.2 cm). Collection of Richard and Ronay Menschel

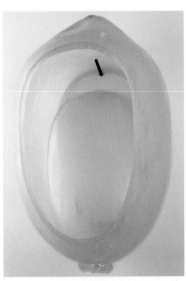

BOTTOM, PLATE 92

*Sigh*, 1981–82. Oil on wood and canvas, 25½ × 19⅞ in. (64.8 × 50.5 cm). Estate of Christopher Wilmarth, New York

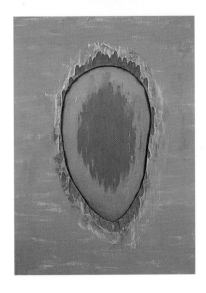

tain toward an eye that's a heaven, too. The poem divides at the middle, a mirror of soul and water, living and dead, earth and ether; one thing drawn out of another, analogy after analogy. Mallarmé once likened his poems to a handful of dust, but truer to his longing for ungraspable things, they're more like a handful of pollen blown everywhere to propagate, to bring him multiplicity in place of what is absent and to find in absence the imagined essence of what's missing in the world—as when he describes, in the sonnet Morgan titles "When Winter on Forgotten Woods . . . ," a sill that's "burdened with the weight of absent flowers."[73]

In the winter of 1979, Wilmarth taught at the University of California, Berkeley. One day, he was speaking with Peter Voulkos, another sculptor there, and Voulkos suggested that Wilmarth might like to meet his friend Marvin Lipofsky, a glassblower teaching nearby at the California College of Arts and Crafts in Oakland. Lipofsky was welcoming when he got Wilmarth's call. He invited him to come by, adding that his students would be happy to help if Wilmarth wanted to work with blown glass himself. Wilmarth demurred on the phone, but when he did go by, the lightness of breath transforming molten glass into a shell of matter captivated him.[74] From the figures of the "Gnomon" series, he now found a figurative logic, a material analogy, for Mallarmé's verses. He blew a simple glass orb that looked like an abstracted head and seemed almost lighter than air, like the cerebral abstractions of the poetry—an envelope for the mind of the poet, an exhalation from one body turning itself into the body of another. He called the series he now embarked on "Breath."

"Breath" is fundamentally literary, a bridge to the poet's words, and so I think Wilmarth turns again to a way of working that's illustrational, but even more so now that his source is wholly specific. In fact, graphic works outnumber sculptures many times over in the series. Of course, there's a delicious irony here. What physical source could be *less* specific than Mallarmé's immensely ethereal, elliptical poems? Nonetheless, they're an anchor and a frame for Wilmarth, and as well as pouring forth his bounty of graphics, he responds with the most pictorial sculptures he had ever made. The point of view is largely fixed: we stand in front of these heads—some of them attached to bronze plaques the size of a small easel painting, which only emphasizes their iconic aspect—and look. Our movement around them is minimal. The light captured inside the heads makes them appear jewel-like, as if the volume of illumination were a whisper. That is the whisper of Mallarmé's poems. And with this act of literary correspondence, a small but basic shift takes place, *however briefly*, in Wilmarth's art: he moves from a muscular expression of longing (all that bending and that tonnage of glass and metal sheets) to a plaintive air—something entirely lighter, winsome, necessitating the tiniest of movements. Though bound to the wall or to the bronze, these pieces are about their *float*, suggesting not so much their defiance of gravity as their indifference to it. With a stillness that approaches the idea of the gnomon, around which the world's daily circle of time grinds, these literary, pinched, plangent heads want to be anywhere else, anywhere out of the world.

A single smoke ring wafts from the poem "The Whole Soul Summed Up . . ." onto the wall in the Wilmarth sculpture (plate 93). What image could more effortlessly capture the poet's and the sculptor's fascination with the carnate dematerialized? A little puff of smoke with a hole in the middle; an absence at the core ringed by the slightest remnant of presence, of the body exhaled, expired, now lazily floating up. The head is etched and foggy, typically enough. It fits the image of a soul. But the choice of that Wilmarthian green for the ring is an expressly painterly decision, an issue of interest for the eye through contrast. It makes one think about color in his work, all the way back to his first fascination with ice glinting in the seaport's light. His palette is white, blue, green, the browns and blacks of steel, the gray-blacks of shadows. Primarily the colors of winter, cool watery depths, of ice and chill, of shade in place of light: the specifically not warm. Why the cool palette? For one, these are natural colors of the materials, in keeping with Wilmarth's residual Minimalist dedication to truth in materials, I suppose. Yet the lack of warmth hints at his taste, long-standing and obvious in his art, for the meditative over the hotly emotional—perhaps because his emotions could be so tempestuously heated outside his work. I'm reminded of T. S. Eliot's

PLATE 93

*The Whole Soul Summed Up . . .*, 1979–80. Etched glass, 17 × 12 × 5¼ in. (43.2 × 30.5 × 13.3 cm). Collection of Marlene Baumgarten, Winnetka, Illinois

comment, "But, of course, only those who have personality and emotions know what it means to want to escape from these things."[75] Escape is what Wilmarth's green oval (as much halo as a playful smoke ring from a postprandial cigar) is about. Its color is the cool of aloofness, a watchfulness that marks both the pleasure of the light and a discomfort with the world—the romance and the containment—and, as was so often seen in his life and work, of a willful calmness belying his intense desire to be apart, wanting to leave the body.

But Wilmarth wasn't aloof or alone in these dualities. Once again, he was kindred with his modernist elders. Consider Brancusi, whose *Sleeping Muse* (1909), *Sculpture for the Blind* (1916), and *Beginning of the World* (plate 95) are the sure precedents for Wilmarth's headlike orbs; particularly the two later Brancusis, whose featureless surfaces mirror the blown-glass skins of "Breath." That Brancusi's forms are often seen as eggs as well as heads may reflect (with a hopeful turn of mind) on Wilmarth's pieces, too: not only evoking the body left behind but also something being born. Brancusi thought of himself as a creature shifting between spheres, remarking once on his kinship with Milarepa, the Tibetan mystic torn between earthly temptation and spiritual release: "Moi aussi je me suis dédoublé" (Me as well, I'm divided in two).[76] The pathos of that double state also drew Wilmarth to Mallarmé. "Even there, in the presence of a woman," the sculptor said about the poet, "he is not there. . . . He is always in two places and of two minds at the same time."[77] For the poem "My Old Books Closed . . . ," Wilmarth found a way to join Brancusi's and Mallarmé's sense of bilocation, which weighed deeply on his own state of mind.

Wilmarth's image for the poem (plate 96) shows a second orb dreamily established on top of the first—a divided or doubled self that finds its shapely precedent in Brancusi's *Blond Negress II* (plate 97), alive in its own light of glinting brass at Wilmarth's beloved stomping grounds, the Museum of Modern Art.[78] The homage and transformation show wit. To take the negress's dainty bun and turn it into a sign of reverie, a second head like a thought balloon or pure emanation of the mind, is a wonderful, knowingly clever reading of the sculpture—though you get the feeling that Wilmarth's piece, like every other one in "Breath," is (even heartbreakingly) sincere. He enjoins the mystic aspirant in himself, so uneasy in the bustling commercial hive of SoHo's art scene and more so in the world at large, to reduce itself to this wisp, this head that opens itself, that treats inside and outside as a continuum or, more pointedly, as a trajectory. There's no mistaking the desire here. Nearly every work in the series has a hole or a wedge or a cut in it: little portals to leak away through. Even the variations he made—the gouged plaque for a version of *When Winter on Forgotten Woods . . .* (plate 99), the bronze grid like an open basket weave for *Saint (Doors Give Reasons)* (plate

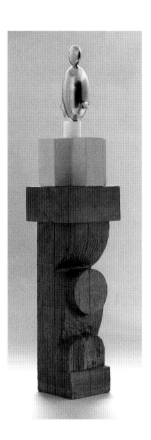
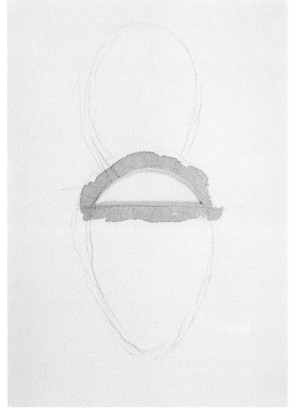

OPPOSITE, LEFT, PLATE 96

*My Old Books Closed . . .*, 1979–80.
Etched glass, 17 × 6½ × 5½ in.
(43.2 × 16.5 × 14 cm). Collection of
Marguerite and Robert Hoffman,
Dallas

OPPOSITE, TOP RIGHT, PLATE 97

Constantin Brancusi, *Blond
Negress II*, 1933. Bronze, height
15⅞ in. (40.3 cm). The Museum of
Modern Art, New York. The Philip
L. Goodwin Collection

OPPOSITE, BOTTOM RIGHT, PLATE 98

*My Old Books Closed . . .*, 1979.
Watercolor and graphite on paper,
6 × 4¼ in. (15.2 × 10.6 cm).
Collection of Richard and Ronay
Menschel

BELOW, PLATE 99

*When Winter on Forgotten Woods
Moves Somber . . .*, 1979–80. Etched
glass, 11½ × 6¾ × 6 in. (29.2 × 17.1 ×
15.2 cm). Estate of Christopher
Wilmarth, New York

100)—stick to his material analogy that the *something more* he's looking for is in fact the *something less:* to be removed from the clumsy, gravity-ridden world.

*My Old Books Closed . . .* is much in service to this vision, yet that's not to say that the ethereal is exclusively pacific. The sculpture's lower form has its front sheared away, alluding to the cruel image at the end of the poem, in which a dream of the triumph of ancient Greece gives way to a literal punch line that invokes the burned-off breast of a woman warrior. The brutality is in keeping with the poem's merciless pitting of fantasy against reality and with its flow of negatives qualifying positives that are negatively turned again. For example, Mallarmé writes, "My hunger feasts on no fruits," and then imagines their taste, only to shift into longing for the same fragrance "bursting forth" from flesh—a hunger that's sensual and sexual, with a kinky touch of the cannibalistic. But that double state of satisfaction and destruction, like analogy, gives and takes away. It describes the self-consuming act of art-making: the artist bears the fruit of his imagination and then devours himself. So Wilmarth's sculpture shows the head cut away, but above it the thought, the will of imagination, is left whole. After all, we're in the economy of matter and after-matter, where self-subtraction, or at least subtraction of the physical—terms that resound with Wilmarth's

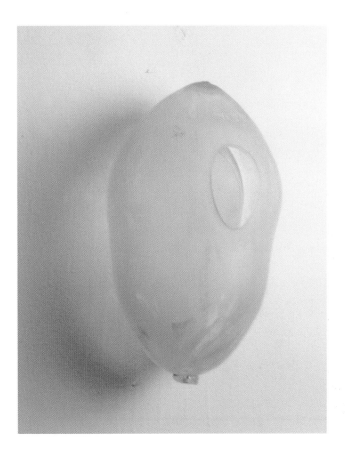

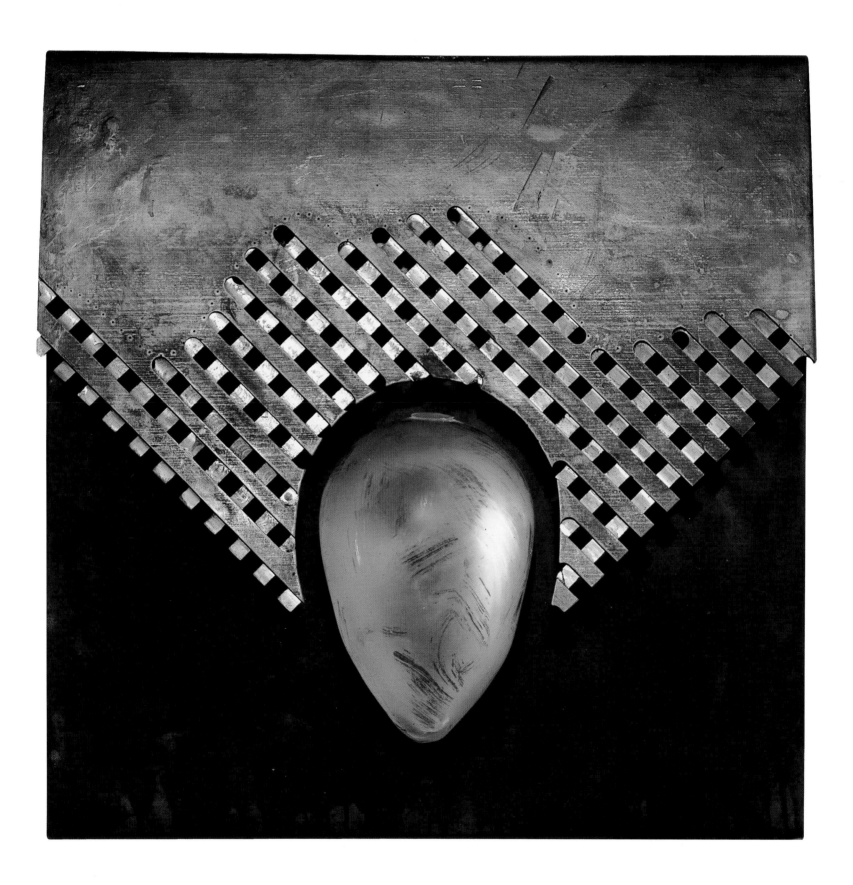

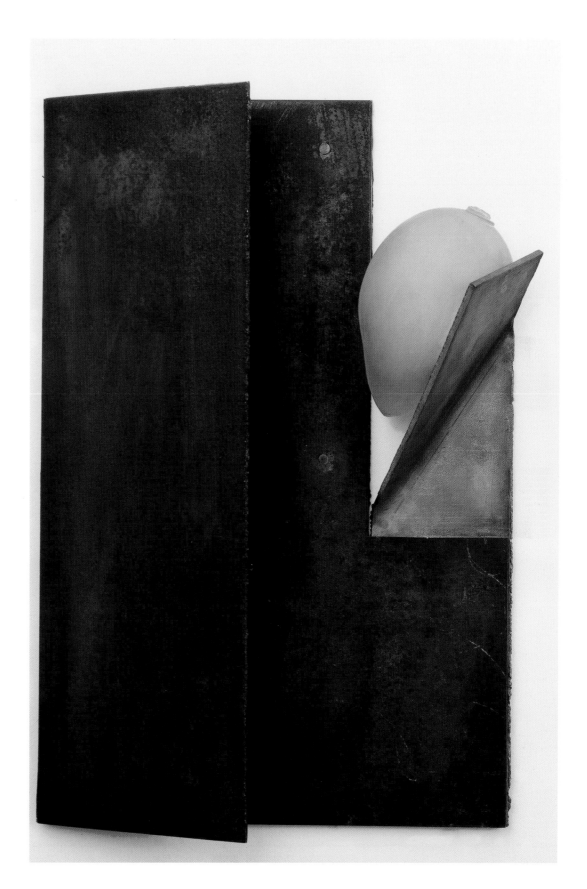

ABOVE, PLATE 102
*Insert Myself within Your Story . . . ,*
1980. Etching, soft ground, and
aquatint, 8½ × 12¾ in. (21.6 ×
32.4 cm). Estate of Christopher
Wilmarth, New York

OPPOSITE, PLATE 103
*Saint,* 1979. Charcoal, 26¼ × 19¼ in.
(66.7 × 48.9 cm). Estate of
Christopher Wilmarth, New York

end to come—aren't deficits, despite the pain. Looked at from this side of the mirror, getting out of the world by whatever the means is freedom and fulfillment.

Wilmarth may have traded roaming around the object for a fixed pictorial point of view, but his restlessness seems only to have shot up somewhere else, like crocuses in winter's thaw. His mobile temperament now shows itself in the sheer movement through mediums: drawings, etchings, charcoals, pastels, even paintings. Looking at the same seven images for "Breath" again and again, he sorts methodically, even obsessively, through expressive possibilities—lighter and heavier, elusive and overly specific—with what might be called serial intent. These works also mark a shift in Wilmarth's art that will stay with him to the end of his life, seven years away. His drawings were typically done after the sculptures, as I've said. They were a way of exploring the formal, spatial, and ambient possibilities that emerged. They were, you might say, on the road to other sculptures. But here the graphics are on an equal footing. They carry as much signifying power, have as much presence, are of equal size, and in their own right take the measure of Mallarmé's and the sculptor's metaphysical projects.

The charcoals and pastels in particular suggest the subtlety of matter unraveling. The etchings, on the other hand, have a weightiness to them, and the paintings, for all their vibrancy, feel almost frozen or congealed—their surfaces in wood and canvas are carved or

STEVEN HENRY MADOFF

pushed up from behind, looking hard or stuffed. Wilmarth's sculptures have an affecting painterliness to them, but it doesn't work as well the other way around. The outcome is the least otherworldly interpretation of Mallarmé, and we have to look elsewhere for the ethereal. In the dragged and rubbed charcoals, which have the milky, gray-dark gravitas of an X-ray, the voluptuous, almost guttural grain of matter is smudged and washed out, getting instantly at the dissolution of the flesh, at spectral being. In *Saint* (plate 103) a long, thin triangle pierces the head whose inspiration in Mallarmé's poem is Saint Cecilia, the second-century patron of church music, martyred with a sword. The triangular blade is also "an instrument of plumes," says the poem, that makes the music of silence. And here, emanating from the blade, a murky light seeps over the head's charcoal darkness, a violence softened—in the parlance of the text, musically resolved, lightening, quieted, rising.

The pastels seem to go at things the other way around. Their pale colors on the surface, which condense to form both outlines and the interiors of the heads, move downward or inward, from the spectral back toward the density of matter. There are two curious

pastels at the Fogg that are the closest Wilmarth ever came to getting Mallarmé in the flesh (plates 106 and 107). He didn't show them when he put up the "Breath" exhibition at the Studio for the First Amendment in May 1982. They must have been a private experiment, for the sheer play of things. Though they're based on "The Whole Soul Summed Up . . ." (Wilmarth wrote out two stanzas of the poem on the back of the second drawing), they make me think again of *My Old Books Closed.* . . . Although here the doubled forms aren't stacked. They mirror each other quite literally, this drawing and a rubbing from it.

The first sheet, just 10¼ by 7⅛ inches, shows a heavily worked tracing of the familiar head in black charcoal on nubbed paper, covered with an uneven pastel coating of apple green. There are darker bands of green away from the center of the sheet, which is lighter, with a narrow streak like a shaft of light coming down from the top of the head. The head is surrounded with other charcoal lines that roughly follow its oval shape, and they grow denser, weighting the picture to the lower left corner. The image is pressed into the paper so thoroughly that it seems, like Veronica's handkerchief, to be a portrait merged with the cloth; an iconic record of the flesh. Of course, here the head has no face; it's already an abstraction. Still, it has a heaviness to it; the working of the lines is almost baroque in feeling. The head emerges into the light, highlighted like a figure out of Gustave Doré.

Now comes the rubbing, an oddly dramatic rejoinder to this first head, so present in feeling. Centered on a larger sheet, 15½ by 11¼ inches, the green image is mirrored. What's left is a slightly oily afterimage, veil thin, with black lines made out and touches of green. This ghostly second head is a tannish yellow-green, with the white of the paper breaking through everywhere. There's hardly anything there at all, which suggests in its Mallarméan way the needed thing that's always escaping. To get it (if it can be got at all) takes a different sort of concentration—the indirection of the gaze that squints and sees at the corner of the real some essence, like the poet's absent bouquet. It's just in another room, hummed into being, or transformed by a musically elliptical phrase that's as insubstantial as breath. So this pale offset of a picture is like an exhalation, a residue or revenant that glides from material fact to a phantom mixture of stain and whiteness. It evokes what Matisse expressed when he did his own illustrations in the early 1930s for Mallarmé's verses, trying to get at that atmosphere of the ineffable caught like vapor in the poet's phrase from the poem "Salut," "the white care of our sail." Matisse notes: "Etchings done in an even, very thin line, without shading, so that the printed page is left almost as white as it was before printing."[79] Wilmarth's drawings for the series are like that, too. Pen and ink track the shape of the head and its variations so delicately that his line hardly touches the paper. Yet on the whole, I think, the

shading is as important as the white for Wilmarth. "Breath" is an analogy about lightness, with shadow and white and their implications mirrored and opposed. It's a double place—a place where the sculptor, in the abruptly shortened last decade of his life, still strained to be.

PLATE 108
*Street Leaf (Mayagüez)*, 1978–86.
Etched glass, bronze, and steel
cable, 48 × 72 × 9 in. (121.9 × 182.9 ×
22.9 cm). Collection of Mr. and Mrs.
Asher B. Edelman, New York
(destroyed)

After "Breath," in 1983, Wilmarth closed the Studio for the First Amendment. Not that it hadn't done well. It did almost too well. He sold enough art on his own to quit teaching entirely at Cooper Union, where he'd worked for eleven years. Yet the sales and the tasks of representing himself had slowly eaten up his creative time. And moving from Manhattan as he was (he and Susan sold their place in SoHo and bought a large factory building in the Red Hook section of Brooklyn), he still wanted a place for his art to be seen there. Now he began a new working relationship with the gallery Hirschl & Adler Modern, where he opened a small retrospective exhibition in 1984 to fine reviews. The times seemed promising, a newness in the air. He was on his second Guggenheim fellowship in 1983, lasting into '84, and that winter he went out to Seattle, with Marvin Lipofsky, to the Pilchuck School, where they were gratifyingly productive, making more blown-glass pieces.

Yet the sculptures show a different face, one that wears an unmistakable heaviness. *Street Leaf (Mayagüez)* (plate 108) is a work, in fact, that's Janus-faced; it bears the crossing from was to is. Begun in 1978 and not finished until 1986, it's a reprise of *Street Leaf #3* from 1977 (Whitney Museum of American Art, New York), with a coda that clearly comes after "Breath." On the left: glowing mist and shadow, angularity and rectilinear elegance. The luminosity has the substance—the gist of transformation and release—of the many works orbiting in the magnetic range of the "Clearings." Or I should say *had* the substance, since the sculpture's added poignancy is that it's truly historical: it was destroyed in transit. The image is all that's left, and what we see installed on the right side is like a blow to finish the fight. It dismisses the light. The glass is a mourner's head, a portrait affixed to a wall that has the craggy dolefulness of a Clyfford Still but is done in the weight of steel with a patina that weeps with the look of rust, of time's force of waste. Wilmarth transfers the painterly etching of his glass plates to the metal, but against that former lightness he uses the painterly for evidently heavy ends. The tension between the two sides grates, and it aches as well. It is what Simone Weil said in *Gravity and Grace:* "Suffering is nothing, apart from the relationship between the past and the future, but what is more real for man than this relationship?"[80]

So Wilmarth goes back and forth. He still thinks about the buoyancy of light, but his eye has turned retrospective. In 1985 he proposes a memorial, *The Spirit of the Roeblings*, to be sited by the East River and the Brooklyn Bridge, where "the light is special in its

variety and character and a sculpture placed there should engage it."[81] He's up and down in the tumult of his feelings; but the feeling is of wear, with a premonition that had come already in several versions of the sculptures done for "Breath." One rendition of *Insert Myself within Your Story* . . . (plate 109) has shallow ovals cut into the plates of bronze behind the head, as if they were shadows falling and this were a world with another physics in which light and shadow are no longer weightless but as weighty as bronze, pressing down with the graveness of mortality. From here on, any number of these shadows crop up in Wilmarth's work. They stay until the end of his art like signs, like the little stain of darkness I'm reminded of in *Pinkie*, Sir Thomas Lawrence's 1794 portrait of Sarah Moulton (Huntington, San Marino, California): all that fresh youth outdone by the smallest half-moon of shadow, moving as swiftly across her hat brim—impatiently, one imagines—as the wind pushing at her dress; such are the insignia of unseasonable death.

Now the light is changing. There had been portents of that, too. In the most disturbing entry found in any of the sculptor's notebooks, he writes a long and saddening self-

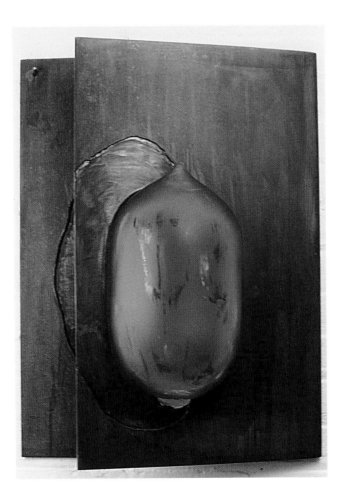

examination full of rage, dated April 25, 1976. It begins: "I have been extremely hostile & angry for 2 or three weeks and I must try to understand the origins as this anger is resulting in some self-destructive acts." The panic button was pushed by the early death from cancer of one of Wilmarth's students. A jag of tears leads to a night of heavy drinking, then an outburst of shouting on the street. The entry's morbid thoughts ramble. Insults, self-castigation. At the end: "The light has changed—how could the light have changed? The light in this place means so much to me—can the character of people on a street change the light? The light has become fitful and neurotic. The buildings and lots have become uncomfortable in their places. They shift and think of doom. The buildings don't trust anymore. Not here. Streets once loved (the) pressure of (from) the feet of dreamers. Now they can't afford to take the chance unarmed, dreamers die daily so now, as before, I take this sword in hand."[82]

But we know who doesn't trust, who is uncomfortable in his place. The light is the mirror of Wilmarth's mind, as it always has been, and what was once the bounty of floating presentness becomes his infected fitfulness, spreading. There's a sizzle of dangerous wires

PLATE 110
*Insert Myself within Your Story . . . ,*
1981–82. Oil and canvas on wood
panel, 25½ × 19⅞ in. (64.8 × 50.5 cm).
Estate of Christopher Wilmarth,
New York

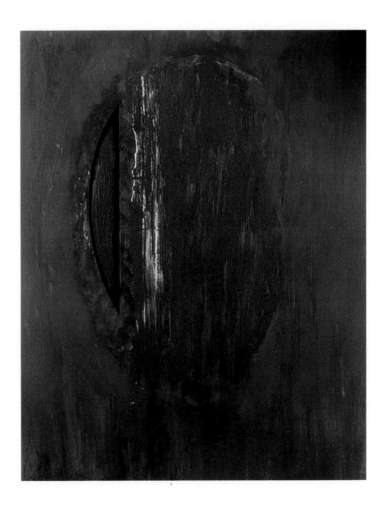

crossing in his rough, inflated fantasy of swords and buildings full of doom and dreamers dying; a long tear is made in the light as the pall of bad pantheism spills over the good. In the decade that follows this rueful entry in his notebook—a decade of elation and struggle, of good work and notices, of more drinking, alcoholism, AA, and a final diagnosis of manic depression—it's easy to track the hopeful lambency in his work crumbling, replaced by darkness. In a way, there was never enough light. But now, as things gather force and rush, tumbling toward a precipice, the question becomes: Could there be enough dark?

There is a long history of melancholy among artists as a sign of a specially burdened gift. In *Born under Saturn*, Rudolf and Margot Wittkower survey this strictly dismal history, noting how common it was by the late 1400s to associate melancholy and creative talent. They write: "Of Raphael, a contemporary reports, still during the artist's lifetime, that 'he is inclined to melancholy like all men of such exceptional talent,' and in *The School of Athens* Raphael gave his own interpretation of Michelangelo: he showed him wrapped in solitary thought in the traditional pose of Melancholy."[83] Fast-forwarding a few packed centuries of artists on the brink, we find Wilmarth following the profile of the classic vanguard modernist on the road to self-ruin: a utopian idealist and suffering soul troubled to a terrible end by the extremes of melancholy. Pushed by this vertigo of elation and depression, struggling with his volatile nature, he makes an art lodged at the omphalos of sensual delight, falling back into the flesh "calling itself as anchor" while shooting for the stars of metaphysical bliss. The contemporary profile of the artist in extremity is updated: a garret and poverty are no longer required in post-sixties America, with its robust art market. Yet Wilmarth's material success was based on an art devoted to passing through the portal of everything material.

The point isn't to throw him into the same miserable but brilliant circle of Raphael and Michelangelo, van Gogh or even Rothko, but to say how thoroughly Wilmarth's ambitions and expression were driven by the Saturnine spirit. It's what we see in the work, pressured by his wary sense of the world's inconstancy, and only the light—the way it fell at different times of day, the way it made colors live, how it sanctified a private sense of place—was constant, a fortress for his feelings, a clearing. This is what Susan Sontag notes in her essay on Walter Benjamin, "Under the Sign of Saturn": "The melancholic sees the world itself become a thing: refuge, solace, enchantment."[84] But what happens, finally, when the light isn't refuge enough, when there is always the sense of falling behind, of trying to catch up, as the titles of the "Gnomons"—those figures leashed to time—suggest? "The mark of the Saturnine temperament is the self-conscious and unforgiving relation to the self, which can never be taken for granted," Sontag writes. "The self is a text—it has to be deciphered. . . .

The self is a project, something to be built. . . . And the process of building a self and its works is always too slow. One is always in arrears to oneself."

Even as early as his class notes in 1961, Wilmarth admonishes himself, "Never be to [sic] easily satisfied with *the first* thing. Life is constantly shifting & one must realize that the shifting is of primary importance. . . . On any level if it comes too easy it can mean little or nothing." Everything is about concentration, dedication, hard work. During another class session, he writes: "YOU CANT [sic] PLAY ART BY EAR"; and then, just to make sure he's pummeled himself sufficiently, he adds: "If you depend on serendipity you are lost."[85]

In these last years, the world moves inexorably away from light and lightness toward the lost, and the self that Wilmarth built shifts even more; it swerves in extreme and curious ways. For instance, for his exhibition *Delancey Backs (and Other Moments)* at Hirschl & Adler Modern in November and December 1986, he decides to write the catalogue himself in the guise of a woman he calls Celadón, who happens to be from Mayagüez, Puerto Rico, a place he and Susan had visited. His leap of intellectual transvestism is funny in a Borgesian sort of way, even as it so obviously points out a new kind of divided self for Wilmarth: not, like Brancusi, pulled between earth and spirit, or between gravity and light, but all gravity all the time. Celadón conducts seven interviews, highly fictionalized, yet the subject is always the same: Who is Wilmarth? What's he about? The paths of the text fork. It is piled with much amusement—and it's not badly written, by the way—but it is studded with dismal thoughts. There are comments about art that's (literally) "shit"; a color that's "a *NOT blue, a NOT heaven*"; remarks like "God was not nice to Chris Wilmarth; first he gave him charisma, then he made him paranoid"; one interview subject dies; and there's the breakdown of Sartre and Giacometti's friendship thrown in for good measure. Transformation as escape is a constant theme. A female interviewee speculates that Wilmarth is none other than herself (which would make Wilmarth times three); he's referred to by the nickname "Inside Out"; and Celadón turns out to be a transsexual called the "So Long Man."

What is going on here? Amid the Grand Guignol humor of it all, no more profane sense of doubling (the spiritually minded artist and an emasculated former whore) could be envisioned, the bridge from one self to the other vibrating to the point of breaking apart. In fact, Celadón's last interview is about what happens when it all falls down. The text is just four lines long, a cautionary little riff almost lighter than air but for the ending thud, and the interview is with the artist himself: "And that's *all* you are going to say!? That's all. *If it's not magic it's merchandise?* If it's not magic—it's merchandise." Then you turn the page of the catalogue, and there is the first image: two heads separated on either side of a dark

metal edge, a look of death about them, with a graven shadow behind the head on the left, an acid patina dripping down like blood. The bronze plate on the right shows a lattice grid peeking through, as if the outside had worn terribly away. The title of the piece is *Her Sides of Me* (plate 112), yet there's nothing to suggest the romantic consummation on view in the first sculpture Wilmarth used that title for, back in 1964 (plate 6). In a letter to the art historian Maurice Poirier, dated January 25, 1985, the sculptor pokes around the subject of sexual duality, admitting that it had been there since 1960, saying that "sensuality, duality, its limiting and release" were more specific in early works like *Her Sides of Me*, before he began "to work the universal."[86]

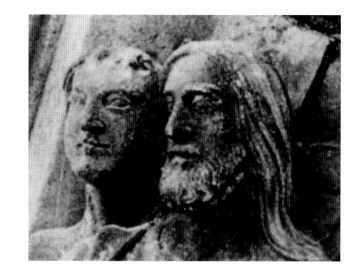

But now his abiding subject—the universal porosity of things, the merger of skin, identity, and matter—has given way; his endlessly wriggling nature made brittle by the toxicity of depression. The dual heads he creates have been said to take their cue from two figures on the north portal of Chartres Cathedral—God and Adam—that Wilmarth was struck by on a trip to France (plate 111).[87] But there's too little light left for that, I think. In words, he still argues the case of hope, continuing in his letter to Poirier that "love and imagination are united in my mind." Yet some part of love is mournful, and this case, too, can be made: Wilmarth's heads don't rise from the figures of God and Adam, which were, at most, spurs to his formal imagination. Nor, more significantly, do they have to do with Creation—or for that matter, given the higher and lower altitudes of the Wilmarth heads, are they an allusion to the Annunciation. No, they suggest the opposite: not union but division; not illumination and fruitful promise but what, after all, is in front of our eyes, the light being weaned away. Just as light once meant talking to the trees, a voluble conversation, an abundance, now its withdrawal signals release. It's the end of the conversation, what Sontag summarizes in a sentence: "Silence is the artist's ultimate other-worldly gesture: by silence, he frees himself from servile bondage to the world, which appears as patron, client, consumer, antagonist, arbiter, and distorter of his work."[88]

Wilmarth is on a course toward silence, he's starving himself of the light. So it was with a little shudder of recognition that I found before me, on a cart of the artist's early graphic works to examine in the Fogg's archives, a small object, some 12 by 10 inches, wrapped in white paper. Inside was a book that Wilmarth made as a student in 1963. He had decided, of all things, to illustrate Kafka's story "A Hunger Artist" (though he gets the title slightly

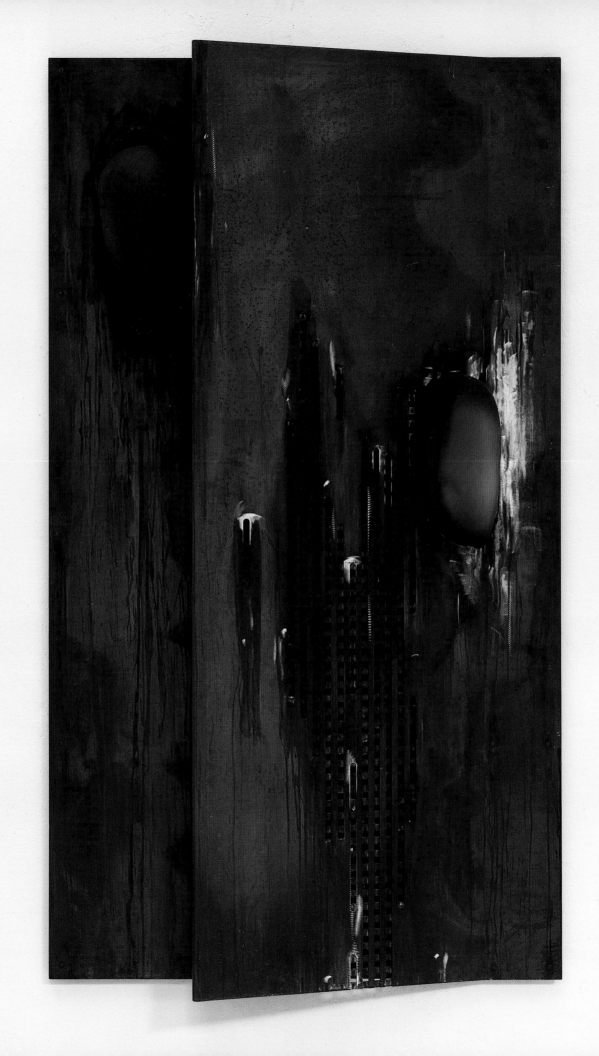

wrong), in which the artist's existentially freighted profession is to starve himself in front of the public. His ultimate triumph is his record-breaking fast—an accomplishment of precisely what Sontag describes, which leaves him, by his own choice and will, dead. The pencil drawings in Wilmarth's book are simple, realistic pictures: an apple; a wheel (presumably of the cage in which the hunger artist performed in the circus); a metal plate screwed shut (plates 113–15). The apple pulled me back to the shape of the late heads. The connections are surely whimsical, except for the strong suggestion of a penchant, an undertow tugging. Even if it's wise not to make too much of youthful predilections, we know that Wilmarth would spend the next two decades fancying himself on this side of the glass and the other, between form and formlessness, an imagined fullness and the thinness insinuating itself slowly, unstoppably.

Just before dying, the hunger artist whispers why he starved himself year after year: he could never find a food that he liked to eat! Does his death mean, then, that the gaudy dispensations of the world aren't enough? But the story ends in a, well, Kafkaesque way—the hunger artist is swept out with the trash, replaced by a panther for the crowd's amusement—and we're left to speculate if his martyrdom meant anything at all; whether spiritual dispensation, the ardor of the ascetic, is a better prize. To Kafka this was allegory, but to a world brought up on Kafka it sounds like pitch-black irony—a thing that seems to be one

thing and turns out, so horribly that it's comic, to be something else. To a young, romantically inclined artist in 1963, drawn to the possibilities of the light and also attracted to this off-kilter tale of sacrifice and death, its ambiguity was in sympathy with his youthful sense of life's slipperiness, which was implicit in that early note to himself: "the shifting is of primary importance." And this was the year that his brother Peter, three years his senior, age twenty-two, committed suicide.

It makes me think, watching this anorexia of light steal over Wilmarth's late works, that the two heads in *Her Sides of Me*—and those in *Baptiste Longing (Blue)* (plate 116), in *Emanation (for Enzo Nocera)* (plate 117), in *Delancey Backs* (plate 127)—are not only *not* sacred souls or souls united by love and imagination or matter floating upward into the plenty of after-matter, but a *"NOT heaven"* of the soul riven, doubled and haunted by the shadow of the brother. "One of my most intractable problems is dealing with loss," the sculptor writes in that wrenching notebook entry from 1976. Just as Andrew Solomon notes in *The Noonday Demon: An Atlas of Depression*: "One study suggests that three-quarters of completed suicides are committed by people who have been traumatized in childhood by the death of someone to whom they were close. . . . Inability to process this loss early in life leads to an inability to process loss generally."[89] So Wilmarth continues his grim reckoning, recalling his brother's suicide and the death of a former student: "These sad events are very difficult for me to accept. In fact I still haven't accepted them and so I look for someone to blame for the loss—for taking something or someone from my life that I love."

Yet for the melancholic always in arrears to himself, the blame is inevitably turned inward. It's hardly metaphorical to say that the light, so contiguous with the artist, is eating itself up. And the shadow we see in each of these pieces grinds down into the metal to tell us that this alternative physics is the physics of a night world, an inverted place in which darkness makes shadows, not the light—a world of catastrophic reversal. Because the light is being withdrawn, time as the possibility of absolute presentness, of plenitude, is also withdrawn. It deflates, drains away, which is what E. M. Cioran says, talking of self-destruction, "In a single second we do away with all seconds."[90] To imagine entering these shadows and the immense stillness of these last works is to pass into Nothing, the accelerated destination of the suicide.

Almost to the end, Wilmarth walks up gingerly to the light, finding its last traces like a deer feeding solemnly in a single clearing with houses all around. There is that feeling of unquenchable thirst and the smallness of the last resource. For instance, in *Baptiste Long-*

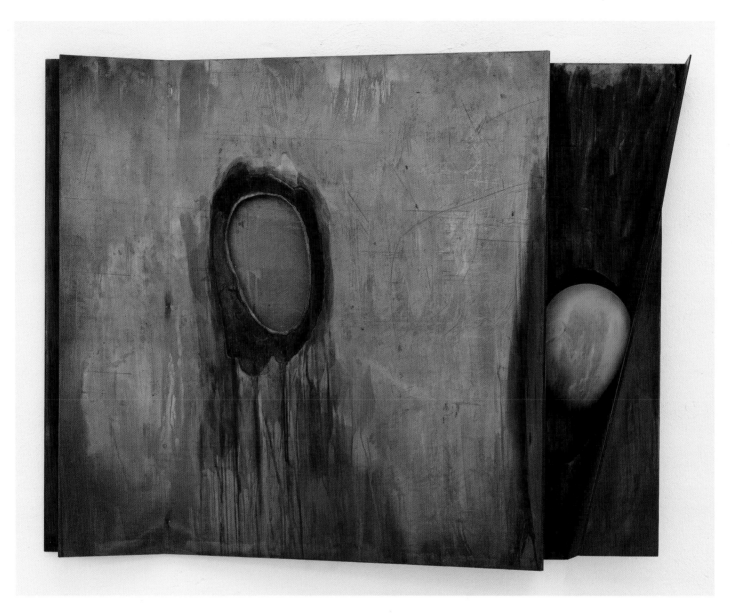

ABOVE, PLATE 116
*Baptiste Longing (Blue)*, 1983–86.
Etched glass and bronze, 40 × 52 ×
6½ in. (101.6 × 132.1 × 16.5 cm).
Private collection

OPPOSITE, PLATE 117
*Emanation (for Enzo Nocera)*, 1983–
86. Etched glass, bronze, and steel,
48 × 54 × 8 in. (121.9 × 137.2 × 46 cm).
Estabrook Foundation, Carlisle,
Massachusetts

STEVEN HENRY MADOFF

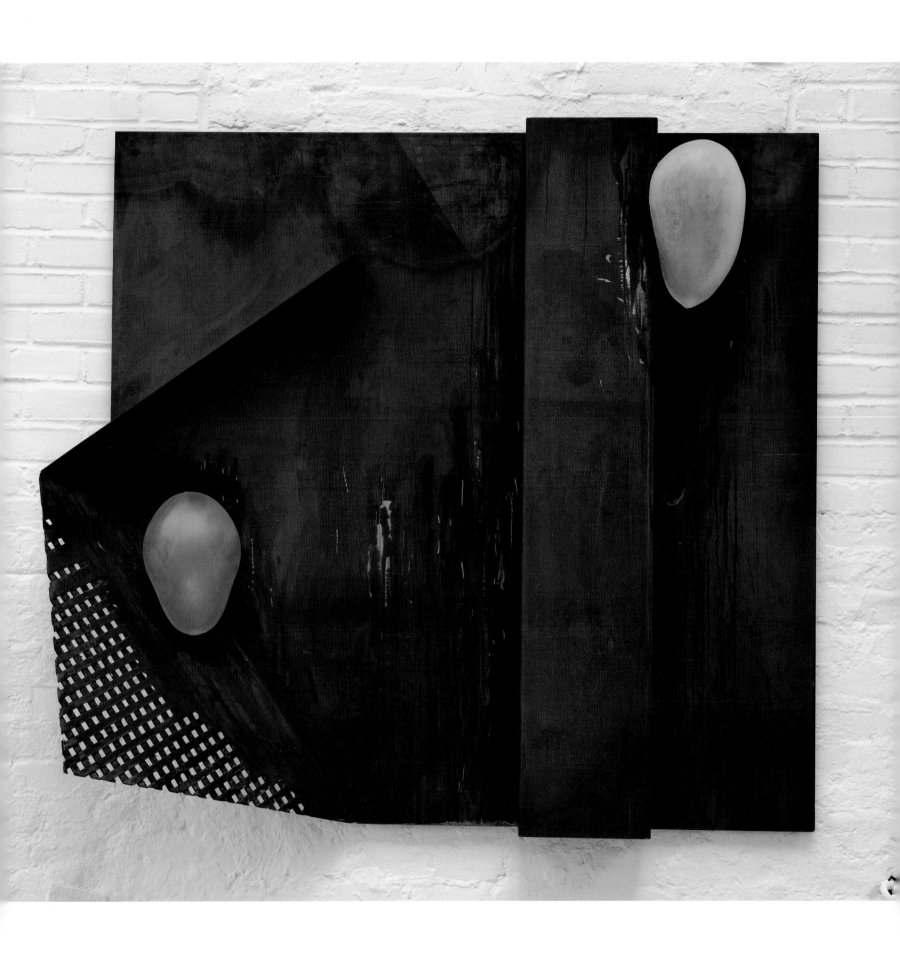

ing (Blue)—with its allusion to the old French movie *Les Enfants du Paradis*, whose hero Baptiste watches as his love, Garance, is swept away in a crowd, never seen by him again—one head is entirely gone, a scar left in the bronze, while the other glows its literal and figurative blue. *Emanation*'s title proposes ethereal possibilities, its pearlish heads still capturing their quotients of light. Glinting scrapes, read left to right from one head to the other, are like sparks, last bits of conversation, the light talking, summoning the world's affirmative *yes* that's nearly gone now—the world, for the depressed person, known by its *not*. The heads remain on opposite sides of their stout divider, yet the latticework shoots out into space, opening the solid weightiness, pointing like an arrow: *This way out.*

But against these remnants, I think, there's an awful load of black, coals to the Newcastle of the artist's final state. The last drawings, done in 1987, are shown to no one by Wilmarth. He keeps them hidden away. They have an evening, autumn light. You see it in the long strokes dragged downward that define place (in that notion of his of person-place) as fog and thickened shadow in some of the pieces. "Person" is a scumbled black hole of a

ABOVE, LEFT, PLATE 118

*Twelve Drawings from the Forty-fourth Year, #9: Moment*, 1987. Graphite, black and gray wash, gesso, and rabbit-skin glue on two layers of white wove paper, both layers cut and incised, 7 × 6⅛ in. (17.8 × 15.4 cm). Private collection

ABOVE, RIGHT, PLATE 119

*Untitled* [W321], 1987. Graphite and rabbit-skin glue on paper, 30 × 22⅜ in. (76.2 × 56.8 cm). Collection of Susan Wilmarth-Rabineau, Executor of the Estate of Christopher Wilmarth, New York

STEVEN HENRY MADOFF

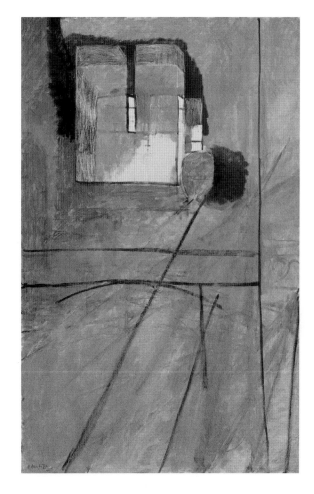

*Untitled*, 1987. Graphite and gesso on paper, 31 × 22⁵/₈ in. (78.7 × 57.5 cm). Collection of Naoto Nakagawa and Caroline Press, New York

Henri Matisse, *View of Notre-Dame*, 1914. Oil on canvas, 58 × 37¹/₈ in. (147.3 × 94.3 cm). The Museum of Modern Art, New York. Purchase, acquired through the Lillie P. Bliss Bequest, and the Henry Ittleson, A. Conger Goodyear, Mr. and Mrs. Sinclair Funds, and the Anna Erickson Levene Bequest given in memory of her husband, Dr. Phoebus Aaron Theodor Levene

head driven into the paper or a lighter, washed-out void. His love of his old masters is still here—even here, even now. He calls them back. Matisse's great painting from 1914, *View of Notre-Dame* (plate 121), is the patron of an untitled drawing with double heads (plate 120) that are placed in a rectangle much like the painting's window. The diagonal line, carried over from Matisse's picture to his own, seals the note of devotion; and suddenly, in the form of the green oval popping forward with a black shadow behind it in the master's work, another source for Wilmarth's heads appears obvious and true.

The museum inside his art is intact, alive in the twilight. The looking back is not a looking forward. This is the terminus where Wilmarth's own expression is merged with what he loved and understood of the expressive and the spare, the traits in the appearance of created things that so fully appealed to him. Giacometti is here, too. In fact, he's everywhere in the fine, dragged lines of the frail shoulders in another drawing (plate 122); in the curious, forlornly empty scaffolding looming in a drawing (plate 123) that evokes so many Giacomettis: the bronze sculpture called *The Cage (Woman with Head)* of 1950 or the paintings from the

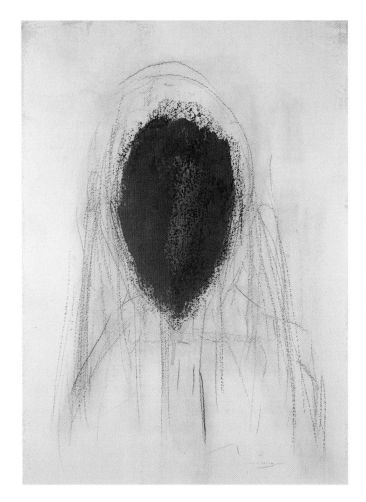 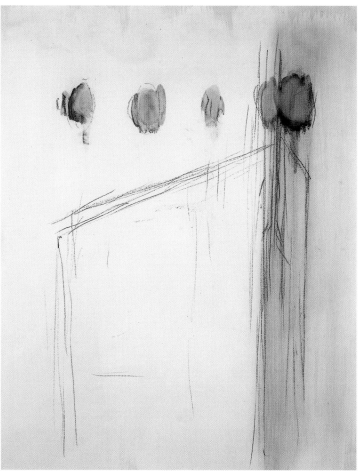

mid-fifties until the end of Giacometti's life—strikingly, *Woman and Head* (plate 125), with its exaggerated oval face, floating above a body that stands detached, scribbled over with paint, half painted out.

Yet here, in this one Wilmarth drawing (plate 123), there are four, perhaps five heads taking up their stations. Do they signify the various viewpoints of the sculptor looking down on a sculptural mass? Or are they alienated presences hovering? Or both at once? In any case, they have a sense of purpose, a gloomy, moving power that evokes the ache of consciousness on the edge of erasure, wholly masked in its private, troubled will. The work of Wilmarth's past seems kempt compared to these last drawings and sculptures. There was a primness, a refined delight in fluidity within geometric bounds; the polar play of hardness, the worldly, against the soft verges of the spirit. Now the grieving logic of self-abnegation, disavowal, bereavement of light, deprivation, silence, the permission of his brother's suicide, and disintegrating consciousness fill the work with the unkempt: dark surfaces rooted in the

ABOVE, LEFT, PLATE 122
*Untitled*, 1987. Graphite and gesso on paper, 22¼ × 15⅜ in. (56.6 × 39.1 cm). Estate of Christopher Wilmarth, New York

ABOVE, RIGHT, PLATE 123
*Untitled*, 1987. Graphite and gesso on paper, 21⅛ × 17 in. (53.7 × 43.2 cm). Collection of Betty and Rick Templeton, New York

STEVEN HENRY MADOFF

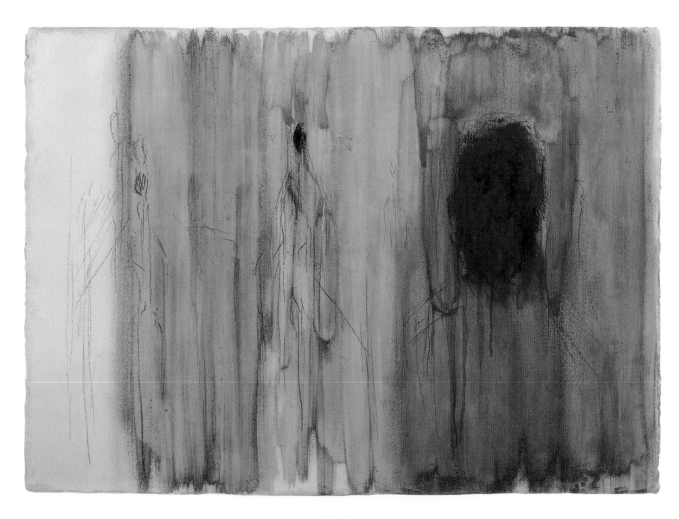

ABOVE, PLATE 124
*Untitled*, 1987. Graphite and
gesso on paper, 30 × 42 in. (76.3 ×
106.8 cm). Estate of Christopher
Wilmarth, New York

RIGHT, PLATE 125
Alberto Giacometti, *Woman
and Head*, 1965. Oil on canvas,
36¼ × 28¾ in. (92 × 73 cm).
Private collection

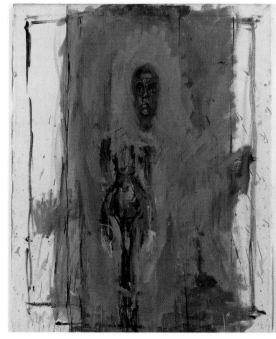

dirt of the grounded, unable to lift up, the unmetaphysical. In image after image, you can see the sense of purpose, spare and unyielding, the growing summary of pain. It began in the narrowed glass of the gnomons, then tried to right itself— but not entirely—in the pinched but luminous heads of "Breath." Then it fell back downward into these last works; the capaciousness of the clearing long gone, though not Wilmarth's sense of longing.

Now the longing is for the last thing. He spreads it like black butter among these drawings hidden away; a whole and intensely determined body of art singing its dirge. The sculptures rhyme with it. In *Delancey Backs* (plate 127), the heads face away from each other on opposite sides of a jagged plane. The shadow is vast, out of proportion to the oval's size, and it's scored in the metal, cut over and over into the plane. The plane itself is beat up, weathered and scarred. Wilmarth has found a way to recapture the physical tension of the gnomon figures pulling at the wall, the tension of the hybrid wall relief and the standing figure, but now the expression of loss in the deathly doubleness of the heads, in the wear of gravity, is explicit. Dark on dark, there is no internal strain, no argument any longer between materials. The play of things is coming to an end. There is no inside allowed. That has been relinquished; transparency giving way to the opaque, the occluded, the stopped. The light only glances off these blackened heads; it can't get in. They're the color of a deep bruise, which we see again in the sculptor's penultimate piece, *Do Not Go Gently* (plate 126). Everything here is reduced. The same configuration as *Delancey Backs* is concentrated, sucked into the wall as if it were being retrieved, taken back. The title (almost) quotes Dylan Thomas's 1952 poem, whose ending reads: "Do not go gentle into that good night / Rage, rage against the dying of the light." Which is what Wilmarth's work evokes, though nothing seems particularly good about the time of

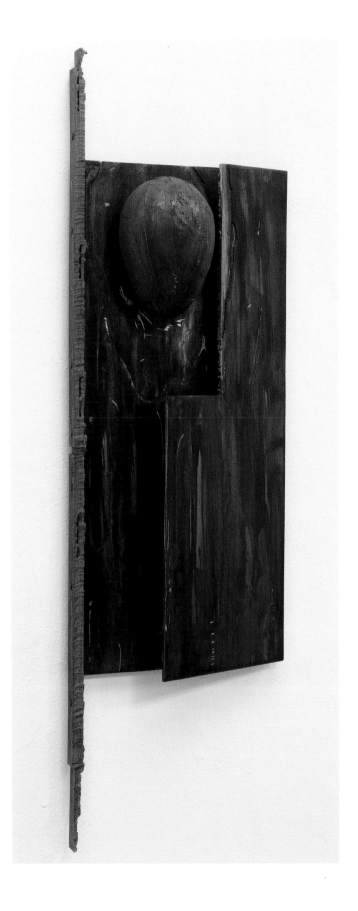

OPPOSITE, PLATE 126

*Do Not Go Gently,* 1987. Bronze and steel, 55¾ × 17⅛ × 7⅛ in. (141.5 × 43.5 × 18 cm). Hirshhorn Museum and Sculpture Garden, Smithsonian Institution, Washington, D.C. Gift of Robert Lehrman in honor of Agnes Gund, 1991

RIGHT, PLATE 127

*Delancey Backs,* 1983–86. Etched glass, steel, and bronze, 96 × 26 × 50 in. (243.8 × 66 × 127 cm). Estabrook Foundation, Carlisle, Massachusetts

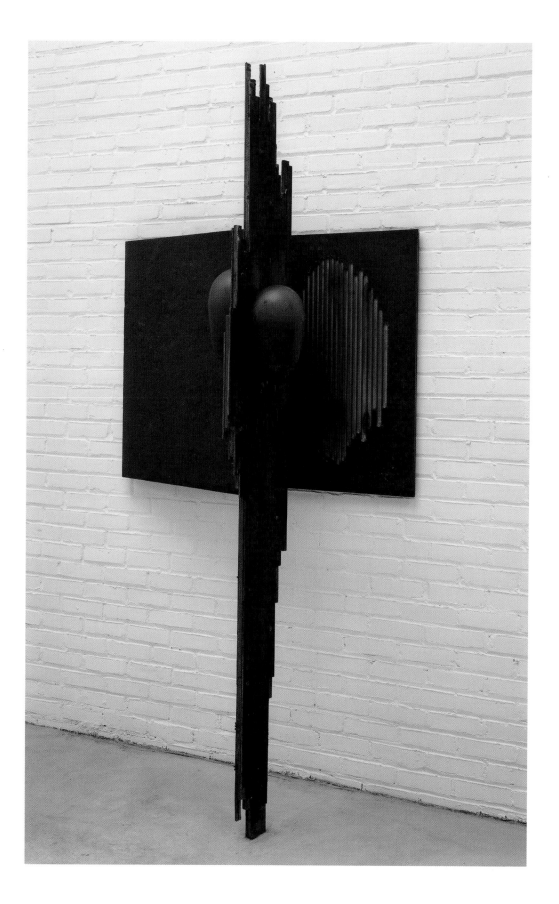

day—if anything, it's a bad night of the soul. There is only one head on view, and it's confined, framed, a picture for us to look at, with its graven shadow, a few last sparks of dying light nicked in the bronze, the patina like paint the color of wet mud poured down. His turbulent, willful grief is violently alive.

"Suicide is, after all, the result of a choice," A. Alvarez writes in *The Savage God*.[91] Didn't Wilmarth say as much? *I choose to breathe. For now.* In his final weeks, his depression thickening, the sculptor reverses his decision. His mood is of ultimacy, *despite* life, and you have no idea, unless you witness it, how strong the will of the body is to live. Many of us have seen it. When my sister was dying of cancer, all through her last night and into her final morning she didn't hear the pleas to let go, that she had done everything she could. The animal body fought. It wouldn't give up for hours, though everything inside it had failed or was in extremity. That mountain of the will is the body speaking to itself against itself; it is the ferocity of being pronounced in the local life of 100 trillion cells. So imagine the power of the suicide's will—how it overcomes the thrust of evolution, the code written into each one of those cells to survive; a self-destroying will that elects what nature protests at its core. This isn't helplessness. It's exhaustion and inexorable purpose combined.

There were good days still, days unmarked by depression. Yet what you hear in Wilmarth's last works is the elocution of the damned. And this despite the ethereal music that Mallarmé's poems had brought him. After "Breath," with its will to resolve earthly strain in a slow migration from matter to the dematerialization of all the world's weight, Wilmarth's despairing decisiveness, his choice not to breathe, gathers its awful gravity. It comes down with a terminal force. There's a final piece, of course, a final concerted act of expression, and the sculptor calls it *Self-Portrait with Sliding Light* (plate 128). It is almost a double of *Do Not Go Gently*—one last mirror of the divided self—yet the reflection presents something entirely crueler, more physically lacerated. He offers us a head of steel smothered with lead that performs its closing act of ventriloquism for the hopeless one. Wilmarth once protested, "Glass is only a vehicle. The medium is light." Now the glass is gone completely, and if light was once life and presentness, here it is lead and expired time.

Do you remember the Emerson quote, "Every moment instructs, and every object: for wisdom is infused in every form"? Well, here is the final object at the end of all moments for the artist, and the question strikes: What allocation of wisdom is given out in this lost stream of desire? It is hard to say. The two plates of the sculpture, opening out,

PLATE 128
*Self-Portrait with Sliding Light*, 1987. Bronze, steel, and lead, 53¼ × 17 × 7¼ in. (135.2 × 43.2 × 18.4 cm). The Museum of Modern Art, New York. Gift of Susan Wilmarth-Rabineau

STEVEN HENRY MADOFF

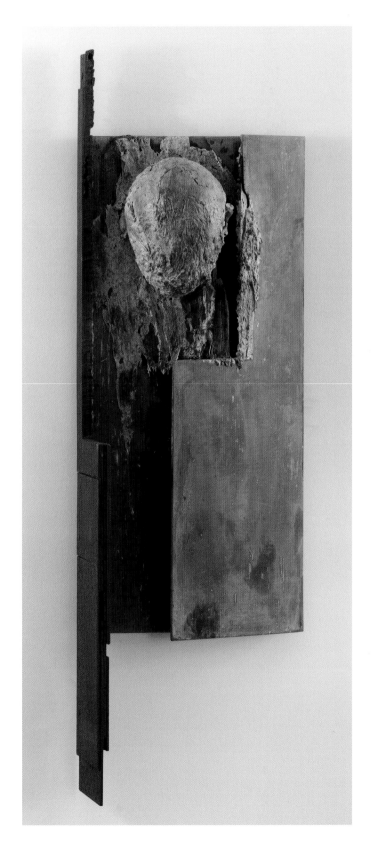

go back to "Breath," to the suggestion of a book's pages parted, which were meant for the Morgan translation of the Mallarmé poem beginning, "Insert myself within your story," and ending, "as though in purple death the wheel / of my sole twilight chariot." The wheel is the late sun, not unlike this last sphere of a head in *Self-Portrait with Sliding Light.* All the illumination has slid down under the horizon, the day's "purple death," where Wilmarth now, finally, looks. This is what Rilke said: "Works of art are always the product of a risk one has run, of an experience taken to its extreme limit, to the point where man can no longer go on."[92] On the pitted green of the bronze, the sculptor has laid down with last intent a ragged sheet of lead all around this head, his head—something burning that hardened to a whitish, ashen gray, not pliant, impermeable. In that gray was all of the lateness, all of the end of the day. It was the last of the light.

1. Christopher Wilmarth, quote from April 1979 notebook entry, Christopher Wilmarth Archive at the Fogg Art Museum, Harvard University, gift of Susan Wilmarth-Rabineau (hereafter cited as Wilmarth Archive).

2. For a survey of Pop art and its interpretations, see my *Pop Art: A Critical History* (Berkeley and Los Angeles: University of California Press, 1997).

3. Donald Judd, "Specific Objects," *Arts Yearbook* 8 (1965): 74–81. The attention to materials as an outgrowth of the postwar boom of American industry is not a new idea, and it is well summarized in James Meyer's superb account of Minimal art, *Minimalism: Art and Polemics in the Sixties* (New Haven, Conn.: Yale University Press, 2001).

4. Wilmarth was much taken with the invention of an American type of independence. He later reminisced wryly of his childhood romance with the tales of Huck Finn and Tom Sawyer, Mark Twain's two adventures of youthful exuberance, of hopeful and rueful self-discovery that mirrored the country, still mired in the contradictions of slavery. In an autobiographical essay entitled "Pages, Places, and Dreams (or The Search for Jackson Island)" that Wilmarth contributed to a special issue of *Poetry East* nos. 13 and 14, spring/summer 1984, 174–76, he wrote: "We had beautiful editions of *Tom Sawyer* and *Huckleberry Finn* with color illustrations and I would copy them. My favorite was 'Tom and Becky Lost in the Cave' but I loved them all. Everything I did or wanted to do was in those books. They gave me a place to dream." He goes on to recount that his stepfather burned his copies of the books page by page, when Wilmarth had taken to going around in bare feet, suspenders, with a corncob pipe. The anecdote is amusing and told with wry charm, but what is telling is the aftermath, as the artist recalls it in several lines of italicized free verse: *"And waited, and looked for safe places, / to dream / Found them sometimes outside / inside mostly / inside my work / inside poems / inside living / living inside."* Those sentiments of quiet rebellion through inward withdrawal underlie the imperative and locus of much of Wilmarth's most significant sculptures, with their clearings, their harbors of light surrounded by steel, their sense of enclosure and sanctuary as luminous dreaming spaces. Consider, for example, such series as the "Nine Clearings for a Standing Man" (plates 29, 30, 40, 48, 136) and the nine works of "Gnomon's Parade" (plates 1, 83–87), as well as individual pieces such as *Days on Blue* (plate 77), *Evers*

*(When the Wind)* (plate 79), *Susan Walked In* (plate 60), and *Long Leavers Gate* (plate 67).

Melville's *Moby-Dick* was a central text for Wilmarth as well; as how could a tale of water and light, of American virtue and hubris, of ports and natural bounty, not fascinate an artist whose work is described by summits and drops in mood and by the abstract representation of the ambience these locales engendered?

Then there is the Transcendentalist spirit as a subject worth considering in the context of Wilmarth's art, which I'll touch on but could no doubt be developed further. Essays by Emerson, such as "Nature" and "Self-Reliance," seem essential to Wilmarth's outlook. The quotation attributed to Emerson (see note 59 below) advertises how closely aligned Wilmarth's temperament was in many ways with that of the Transcendentalists.

5. Wilmarth, Cooper Union notebook, CW2001.775, inscribed in pencil in the artist's hand, "Christopher Wilmarth Sec. 2B1/2 Dimensional Design."

6. Wilmarth, red hardcover notebook kept apparently from 1974 to 1976, Wilmarth Archive, CW2001.786. The quote originally appeared in the interview that Guillaume Apollinaire conducted with Matisse and published as "Henri Matisse," *La Phalange* 11 (December 1907): 481; Jack Flam, trans., *Matisse on Art*, rev. ed. (Berkeley and Los Angeles: University of California Press, 1995), 212. Matisse, as we will see, was an enormous influence on Wilmarth throughout his life as an artist, from the master's drawings to the seminal impact of the "Back" series on the "Nine Clearings for a Standing Man" to the precedent of Matisse's illustrations for Mallarmé, which inspired Wilmarth's work for the "Breath" series.

7. Arthur Danto is particularly interesting on this point. In *After the End of Art: Contemporary Art and the Pale of History* (Princeton, N.J.: Princeton University Press, 1997), 28–29, he distinguishes in part between modernism and what he calls "Post-Historical" art—what is more usually referred to as postmodernism—in this way: "Each of the narratives—Malevich's, Mondrian's, Reinhardt's, and the rest—are covert manifestos, and manifestos were among the chief artistic products of the first half of the twentieth century, with antecedents in the nineteenth century. . . . It is a mere accident that some of the major movements of the twentieth century lacked explicit manifestos. . . . In terms of critical practice, the result is that when the various art

movements do not write their own manifestos, it has been the task of critics to write manifestos for them. . . . Modernism, overall, was the Age of Manifestos. It is part of the post-historical moment of art history that it is immune to manifestos and requires an altogether critical practice."

8. Early on, Hilton Kramer noted the Constructivist aspect of Wilmarth's art. Writing about the "Nine Clearings for a Standing Man" in an "Art View" column titled "The Delicate Touch of a Constructivist" in the *New York Times* on December 8, 1974, Kramer said that the work, in fact, had as much to do with Rothko and Matisse as with Gabo or Tatlin. He goes on to say, "While fully satisfying the taste for a radically simplified and completely visualized structure—for doing away with 'hidden' supports and disguised technical stratagems—that Constructivism introduced into modern sculpture, Mr. Wilmarth has yet managed to create an imagery of remarkable resonance and romance."

In the catalogue that accompanied the November 1974–January 1975 exhibition of the "Nine Clearings" at the Wadsworth Atheneum in Hartford, Connecticut, Joseph Masheck writes at length about the Constructivist influence, touching, for instance, on Gabo's use of glass. Masheck notes other interesting precedents, for example in the use of wire: Marcel Duchamp's employment of lead wire to frame lead foil in *Glider Containing Water Mill (in Neighboring Metals)* of 1913–15, as well as Picasso's and Alexander Calder's use of wire "as a literalized descriptive line in figurative sculptures of the 1920's." Also see Christina Lodder, *Russian Constructivism* (New Haven, Conn.: Yale University Press, 1983), 6 and 14, for the Constructivist precedents in the use of these materials and the way they were put together. Curiously, Laura Rosenstock's essay, "Christopher Wilmarth: An Introduction," in *Christopher Wilmarth*, exh. cat. (New York: Museum of Modern Art, 1989), the catalogue for the Wilmarth retrospective, never discusses Constructivism among the various historical influences the author cites.

9. El Lissitzky's jaunty rectangles and curved lines floating in empty space have a lightness to them that betokens their spiritual character. The "Proun" series was born in Vitebsk, Russia, in 1919, the year that Malevich came to teach at the public art academy where Lissitzky was also teaching. This was the year Malevich exhibited his series of white-on-white paintings, and the power of Malevich's art and Suprematist ideology converted Lissitzky to the geometric abstraction, with its architectural underpinnings, that we see in the "Proun" works. Many of these pieces have an energy and construction of

forms that are echoed in Wilmarth's art, especially pieces done in 1970 to 1972. *Late* (plate 13) is one obvious example; *Detroit* (1970) is another. *Fats* (plate 54), *Sonoma Corners* (1971), and *Tarp* (plate 19) are all evidence of the same influence. See *El Lissitzky* (Cambridge, Mass.: Busch-Reisinger Museum, Harvard University Art Museums, 1987).

10. Robert Hughes, "Poetry in Glass and Steel," *Time*, June 26, 1989, 88. T. S. Eliot, "Tradition and the Individual Talent," in *The Sacred Wood* (London: Methuen, 1960), 49.

11. Carter Ratcliff's elegant and informative book *Out of the Box: The Reinvention of Art, 1967–1975* (New York: Allworth Press, 2000) recounts the powerful presence of Conceptual art, for example, alongside Minimalism, as well as the rise of Earthworks. In her far-seeing essay, "Sculpture in the Expanded Field," and other pieces collected in *The Originality of the Avant-Garde and Other Modernist Myths* (Cambridge, Mass.: MIT Press, 1986), Rosalind Krauss advances the proposal that this work was not so much a terminus as a beginning of something else: postmodernism. What I find especially noteworthy in these accounts is their implicit, though not articulated, suggestion of formalism giving way to formlessness, the purity of certain modernist tenets for the formation of an artwork shifting to the impure. The formless is the subject of another work with Krauss's hand in it. She coauthored *Formless: A User's Guide* (New York: Zone Books, 1997) with Yve-Alain Bois. The notion of the impure bears significant relevance to the case of Wilmarth.

12. Bruce Glaser, "Questions to Stella and Judd," ed. Lucy R. Lippard, in *Minimal Art: A Critical Anthology*, ed. Gregory Battcock (New York: Dutton, 1968), 154.

13. Clement Greenberg, "Modernist Painting," in *Clement Greenberg: The Collected Essays and Criticism*, ed. John O'Brien, vol. 4, *Modernism with a Vengeance: 1957–1969* (Chicago: University of Chicago Press, 1995), 85–93.

14. Judd, "Specific Objects," 80.

15. Robert Morris, "Notes on Sculpture, Part I," *Artforum* 4, no. 6 (February 1966); reprinted in Battcock, *Minimal Art*, 224.

16. Lucy R. Lippard, "New York Letter: Recent Sculpture as Escape," *Art International* 10, no. 2 (February 1966): 50. Quoted in Meyer, *Minimalism*, 154.

17. Meyer, *Minimalism*, 185.

18. Maurice Poirier, "Christopher Wilmarth: 'The Medium Is Light,'" *Artnews* 84, no. 10 (December 1985): 72.

19. Wilmarth, letter to Hilton Kramer, January 29, 1979, Wilmarth Archive.

20. Gaston Bachelard, *The Poetics of Space*, trans. Maria Jolas (Boston: Beacon Press, 1969), 222.

21. Yve-Alain Bois, "Painting: The Task of Morning," in *Painting as Model* (Cambridge, Mass.: MIT Press, 1990), 238.

22. These are the very last words Wilmarth writes in the Cooper Union notebook from 1961, marked 1960 in the Wilmarth Archive.

23. Wilmarth, Strathmore drawing pad dated in the artist's hand December 12–31, 1972; this entry from December 15, CW2001.777, Wilmarth Archive.

24. Mel Bochner, "Primary Structures," *Arts Magazine* 40 (June 1966): 32. Quoted in Bruce Altshuler, *The Avant-Garde in Exhibition: New Art in the Twentieth Century* (New York: Harry N. Abrams, 1994), 220.

25. Morris, quoted in Meyer, *Minimalism*, 156.

26. Altshuler, *Avant-Garde in Exhibition*, 232, and 272 n. 29. Di Suvero went on the attack at a symposium held on May 26, 1966, for the exhibition *Primary Structures*. Meyer notes the differences in this context between Judd and Di Suvero in *Minimalism*, 135.

27. Wilmarth's comment is in a letter to Maurice Poirier, dated January 27, 1985, and now in the Fogg archive. It repeats Stella's remark made in the interview cited in note 12 above. Of course, Stella's resolutely antiillusionist paintings were replaced by more optically charged pieces shortly after he made the statement in 1964. Indeed, it would turn out that he couldn't have agreed less with himself. Still, the words became something of an easy summary for the Minimalist view of the essentialism of the object, and Wilmarth equated this Minimalist ardor for materials-in-themselves with a corrupt piety of materialism that permeated the art market, as several other written statements of his make clear. This romantic view of the art object as superior to the marketplace has the passion of the spiritual artist, though it grates against Wilmarth's reality as an artist made financially successful by the market.

28. Ralph Waldo Emerson, "Nature" (1844), in *The Essential Writings of Ralph Waldo Emerson*, ed. Brooks Atkinson (New York: Modern Library, 2000), 377.

29. Wilmarth, statement written for the exhibition *Private Images: Photographs by Sculptors*, Los Angeles County Museum of Art, December 20, 1977–March 5, 1977.

30. In his book *A Fine Disregard* (New York: Harry N. Abrams, 1990), 250–52, Kirk Varnedoe recounts Edwin A. Abbott's bizarre and wonderful allegorical tale, *Flatland*, first published in 1884. The story, as Varnedoe summarizes, "described a land where all movement and vision took place only in two dimensions, along a plane." He interprets the fiction ultimately as a lesson about vision in the modern world: "*Flatland* speaks of our bewilderment in the face of the dauntingly counterlogical, and wholly invisible, new world that modern science opens up. But the story is not just about the frustrations imposed by the narrow thresholds of what we can experience. It is also about the power of our imagination to conceive worlds beyond our ken, to put ourselves outside ourselves, and decenter our imaginations, in a way that lets us revolutionize our idea of the world, and of our place in it." Those words, as we'll see, shine an interesting light on Wilmarth's vision, most notably in the "Nine Clearings for a Standing Man," in which the figure is absorbed into a flattened Cubist space. Wilmarth did indeed put himself outside himself, imagining, as I've noted, his own invisibility, though the realm of his counterlogic was not of a physical bent but of a metaphysical one.

31. Umberto Boccioni, "Technical Manifesto of Futurist Sculpture 1912," in *The Documents of Twentieth-Century Art: Futurist Manifestos*, ed. Umbro Apollonio (New York: Viking, 1973), 63. Cited in Lodder, *Russian Constructivism*, 17.

32. In a document entitled *Studio for the First Amendment: Statement—Sept. 1980* (Christopher Wilmarth Papers, 1956–87, Archives of American Art, Smithsonian Institution, Washington, D.C. [hereafter cited as Wilmarth Papers], reel 4296), Wilmarth writes, "The ideal world in my work seemed to be a place to be with oneself. Oneself (the figure) was acknowledged as a state of mind, in the scale of the work, and as kind of a hybrid event: a person-place, but the sense of place predominated—in a quiet way, a reverie."

33. Jack Flam, *Matisse: The Man and His Art, 1869–1918* (Ithaca, N.Y.: Cornell University Press, 1986), 368.

34. John Elderfield, *Matisse in the Collections of the Museum of Modern Art*, exh. cat. (New York: Museum of Modern Art, 1978), 72–76.

35. Flam, *Matisse*, 265.

36. The links in the chain, by the way, go back slightly further, and very neatly, to Cézanne himself. Elderfield notes many precedents for the pose of the "Backs," from Rodin to Bartholomé, from Ingres's *Valpinçon Bather* of 1808 to Courbet's *Bathers* of 1853. But the closest source is a figure in Cézanne's *Three Bathers*, c. 1879–82, which Matisse happened to own. See Elderfield, *Matisse*, 74. Flam discusses Matisse's ownership of the Cézanne picture in *Matisse*, 265, while a detailed account of the precedents for the pose of the figure can be found in Albert Elsen, *The Sculpture of Henri Matisse* (New York: Harry N. Abrams, 1972), 174–82. Elsen also states his case here for the creation of what is called *Back o*, about which Elderfield and Flam are more than a little skeptical in their own discussions of the "Backs."

37. Elderfield, *Matisse*, 78.

38. Hilton Kramer, in his elegiac review of Wilmarth's retrospective at MoMA, published in the *New York Observer*, June 5, 1989, first noted the relation to Matisse's painting. He also refers to Richard Diebenkorn's "Ocean Park" series of paintings, which is equally relevant to think about—not only for the use of a Cubist-based, angled rectilinear motif but also for the sense of light that the Californian Diebenkorn shares with Wilmarth, who left the Bay Area but never forgot the quality of its light.

39. Kate Linker, in her thoughtful article "Christopher Wilmarth: Nine Clearings for a Standing Man," *Arts Magazine* 49, no. 8 (April 1975): cover, 52–53, speaks of "the eloquence of the edge." Linker also writes with insight about Wilmarth's use of cable. She calls the cable a "sign of extent" and elaborates: "It moves from the viewer's space, where it appears in its literal aspect as a unit of unequivocal length, to a quizzical course within the interior space, where its extension is inferred through allusion. The visibility of the line diminishes with the slow tapering of the plane until it emerges again to connect with the wall, linking up to the realm of the real." By describing the physical travel of the cable from clear visibility to diminished visibility, Linker digs deeper into a fine point that she made earlier in the same paragraph: "Wilmarth's juxtaposition of the literal and the experience engendered accentuates the illusionary nature of his art." Just so, the cable is an index of literal space and of the illusionistic space that stands in for the realm of reverie at the heart of Wilmarth's art. Later on the same page, she speaks of space in the "Nine Clearings" as a "dialectic of real and illusioned space."

40. Wilmarth, *Statement—Sept. 1980*.

41. Emerson, "Nature," *Essential Writings*, 365.

42. William Faulkner, *As I Lay Dying* (1929; New York: Penguin Books, 1975), 115 and 166.

43. Wilmarth, statement written for *Christopher Wilmarth: Nine Clearings for a Standing Man* (Hartford, Conn.: Wadsworth Atheneum, 1974), n.p.

44. Stephen Kern, *The Culture of Time and Space, 1880–1918* (Cambridge, Mass.: Harvard University Press, 1983), 145.

45. John Clarke, "Diligentia," in *Paraemiologia Anglo-Latina*, 1639. Cited in *The Oxford Dictionary of Quotations*, ed. Elizabeth Knowles (New York: Oxford University Press, 1999), 219.

46. Wilmarth, Cooper Union notebook entry, November 13, 1961, CW2001.775, Wilmarth Archive.

47. Wilmarth, quoted by Corinne Robins, "The Circle in Orbit," *Art in America* 56, no. 6 (November–December 1968): 63.

48. Letter to Jack Cowart at the Saint Louis Museum of Art, February 16, 1975, Wilmarth Archive.

49. See Meyer, *Minimalism*, 160–62. As Meyer deftly explains, Morris's thinking doffs its intellectual hat to Maurice Merleau-Ponty's book *Phenomenology and Perception*, which had been translated into English in 1962. With the absorption of Merleau-Ponty's ideas, Morris could renovate his previous thinking about Gestalt psychology to integrate the perception of gestalt shapes with the phenomenology of perception in situ, so that the viewer is in the world and of the world. As Meyer quotes Merleau-Ponty, "Our body is in the world as the heart is in the organism . . . it breathes life into it and sustains it . . . and with it forms a system." There is a curious relationship to the sort of pantheism I've discussed briefly. Though Merleau-Ponty's notion here doesn't explicitly describe a *paysage moralisé*, it nonetheless points logically toward a fellow-feeling with nature that leads to moral and spiritual questioning. Certainly painting as a labor of moral rectitude features in Merleau-Ponty's famous essay, "Cézanne's Doubt," in his book *Sense and Non-Sense*, which came out in an English version in 1964, and the whole of Cézanne's effort was entwined with his will to get as close as possible in his art to the trembling nuances of nature's light and shadow. For one reader of Morris's "Notes on Sculpture"—Michael Fried in his essay "Art and Objecthood," published in the June 1967 issue of *Artforum*—the spiritual transformation of an object's gestalt in

the theater of its space is crucial, and it is the final prod in his critique of Morris.

50. Wilmarth, *Addition to the Statement of Sept. 1980*, dated November 27, 1980, Wilmarth Papers, reel 4296.

51. Wilmarth, *Statement—Sept. 1980*.

52. Malevich, quoted in Altshuler, *Avant-Garde in Exhibition*, 90.

53. I think it is more than serendipity that Meyer notes Smith as anti-Minimalist in the complexity of his sculptures and that Wilmarth helped to build Smith's works for two very impressionable years not long after he had graduated from Cooper Union and was finding his own aesthetic way. Wilmarth understood the special value of the complex form as a more mysterious object, full of discovery. While it's also true that Morris begins the second part of his "Notes on Sculpture" with an amusing quote by Smith that launches Morris's argument about size, detail, intimacy, shape, and placement of a sculptural work, he also points specifically, as I say, to irregular polyhedrons—the geometric configuration that Smith was wont to use—as difficult shapes to grasp in the quest for a Gestalt experience. See Meyer, *Minimalism*, 158–59, and Morris, "Notes on Sculpture, Part II," in Battcock, *Minimal Art*, 228–35.

54. Smith, quoted in Michael Fried's seminal essay "Art and Objecthood," reprinted in Battcock, *Minimal Art*, 116–47. Fried's essay, in all of its complications, limitations, and reservations about the theatrical space of Minimalist (or as he called it, Literalist) art, bears directly on Wilmarth's intuitive sense of the sculpture's theatrical presence, but in a way that Fried seemed to hunger for and not find himself satisfied by in Morris's work—the spiritual. The votive aspect of Wilmarth's sculpture as a site of reverie and reverence (though not specifically Judeo-Christian) is significant, and it makes a case for a theater of grace that would have been fascinating to see addressed by Fried.

55. Rosalind E. Krauss, "Sculpture in the Expanded Field," in *Originality of the Avant-Garde*, 276–90.

56. Of course, there's the whole industry of art criticism, which is always running behind the artists, trying to catch up and explain. But interpretation, however comforting, is an unreliable intercessor, particularly for an art no longer grounded in accessibility. A voluminous literature argues over the unreliability of the critic as intercessor and of the author, from Jorge Luis Borges's short story "The Garden

of the Forking Paths" to such essays as Susan Sontag's "Against Interpretation" and Roland Barthes's "The Death of the Author" to the movie *Pulp Fiction* by Quentin Tarrantino. Software like Photoshop is a tool that collapses the role of the critic and the creator into one, melding fact and interpretation.

57. In an interview with Barbara Rose from 1971 to 1972, Judd said, "I don't think about what anybody else is going to think about the work." Quoted in Meyer, *Minimalism*, 158.

58. Wilmarth, "Clarification for the Statement of September 1980," dated November 26, 1980, Wilmarth Papers, reel 4296.

59. The quotation was attributed to Emerson by Barbara Haskell in her essay in the 1974 catalogue for the Arthur Dove exhibition that opened at the San Francisco Museum of Art and was on view at the Whitney Museum in November 1975 through January 1976. Wilmarth had the catalogue. No citation is given for the quotation in the essay, and no Emerson concordance or Web search unearths it. In Emerson's essay "Self-Reliance" (*Essential Writings*, 135), the author writes something close to the beginning of the Haskell quotation: "No law can be sacred to me but that of my nature."

60. Wilmarth, red hardcover notebook, 1974–76, CW2001.786, Wilmarth Archive.

61. Quoted in Yve-Alain Bois, *Painting as Model*, 234. Bois calls Courbet's counterexhibition "the first avant-garde act."

62. Wilmarth, "*Art in America* (or eat your 'meatball' hero)," unpublished statement, Wilmarth Papers, reel 4295.

63. Wilmarth, *Statement—Sept. 1980*.

64. Giacometti, quoted without citation on the Kunsthaus Zurich Web site.

65. Dore Ashton, "Christopher Wilmarth's Gnomic Sculpture," *Arts Magazine* 55, no. 4 (December 1980): cover, 93–95.

66. This quote and the one directly above are found in the same notebook pages with the *Statement—Sept. 1980*.

67. Wilmarth writes in the *Clarification for the Statement of Sept. 1980* (Wilmarth Papers, reel 4296), "I have the need to be in and of that imperfect world again and make my poems from its stuff (as in *Hague St. Memory*, 1963) [plate 138]. The *Gnomon's Parade* are sculptures which in their reference to the figure and movement

begin to approach this desire of mine while retaining the spiritual implications of 'place' exemplified by the *Nine Clearings for a Standing Man.*"

68. Wilmarth was inspired by Mallarmé's poems not only for his artwork but for his writing. In 1982, the year of the "Breath" exhibition, he self-published a small volume of poetry in an edition of 100 with the same title as the show. There are seven poems in the book, one for each of the Mallarmé poems translated by Morgan. The poems are brief and winsome; neither terribly demanding nor a match for the ambitions of his visual art. One of the poems, entitled "Doors" and inspired by the poem that Morgan translates as "Saint," in turn inspired a wall sculpture of 1982–83, *Saint (Doors Give Reasons)* (plate 100). The poem reads in its entirety: "Doors give reasons / then some don't / and now we're here / with all you know / and me so pleased / that no one ever told me."

Only in the first of these poems do I find something mordant and revealing of Wilmarth's turmoil. This poem is called "Was": "Because it was, / I'm now finding / a longer sweet / than yourself had been. / I blindly scrape, / and what was there / with chronic wisdom / moves aside." There's a bitter taste to this despite "longer sweet," and "chronic wisdom" effectively questions the use of knowledge. Yet perhaps I'm simply looking for one aspect of Wilmarth's personality, and what the poems reveal is a sentimentality that was obviously a trait, too.

In any case, Wilmarth took his writing seriously, and we see a lot of the same sentimentality in the songwriting that he threw great energy into. As suggested by the title of one of his glass drawings for the wall, *Six Clearings for Hank Williams* (plate 27), he was crazy about country music. He wrote songs copiously—there are more than 23 folders of his lyrics and music in the Fogg archives—and he hoped to have them performed by country music singers. The lyrics are full of down-home ache. One of them shares its title with the 1972 sculpture *Alba Sweeps* (plate 43), written during his stay in Italy, when he worked in Milan for his show at the Galleria dell'Ariete, which opened in April 1973. "And we made love in the sweet times, / at my funky place on West Broadway. / The front room always had sunshine, / the light drew pictures on our bodies as we lay. / Alba Sweeps the morning, / Antonio drinks his wine all day, / I'm upstairs thinking, / about Susan long ago far away." You get the twang, though the lyric, with its characteristic attention to light and its exact personal details, is too specific for the popular appeal a song has to have. On the other hand, a lot of the sculptor's songs are so generic that it is unlikely they would call out to a singer: "Too many times I hurt my baby, / Now I'm alone

on the range." Wilmarth made recordings of some of the songs, which were published by the artist's estate in 2000 on a CD titled *Christopher Wilmarth: California's Really Not to Blame,* for the occasion of a retrospective exhibition at New York's Robert Miller Gallery. One of the songs is called "Talking to the Trees"—an activity, or at least a fantasy, that revealed a great deal about the flight from the daily world at the heart of Wilmarth's art and an emblem of the stress that would bring about his end.

69. The quote, cited in Dore Ashton's essay "Mallarmé, Friend of Artists," for the "Breath" catalogue that accompanied Wilmarth's exhibition of the same name at the Studio for the First Amendment in May 1982, is from a letter Mallarmé wrote to his friend Henri Cazalis on May 14, 1867. In the original French, the poet uses the verb *peindre,* which I've translated as "to depict." Ashton translates it in her essay as "to describe." In a later essay, in the catalogue for *Christopher Wilmarth: Layers; Works from 1964–1984,* at Hirschl & Adler Modern in March–April 1984, she translates the verb as "to paint." Painting, of course, was essential to Mallarmé's world. His friendships with Manet, Morisot, Monet, Renoir, Degas, and others were a deep well of solace and imaginative thought for him. The double meaning "to paint" and "to depict or describe" is fortuitous, in any case, in the context of Wilmarth, as the act of rendering and the act of thinking about this nebulous state of presence in absence is crucial to the sculptor's mentality and art-making.

70. There are two main versions of this quote. In the May 14, 1982, issue of the *New York Times,* Grace Glueck quoted Wilmarth saying, "[Mallarmé's] imagination and reverie meant more to him than anything that was actually of this world. His work is about the anguish and longing of experience not fully realized, and I found something of myself in it." This quote was picked up by Hilton Kramer in the June 5, 1989, issue of the *New York Observer,* when he reviewed Wilmarth's retrospective at the Museum of Modern Art. But in Wilmarth's essay "Pages, Places and Dreams (or The Search for Jackson Island)," he breaks open the earlier quote and elaborates. At one point in the essay, he writes, "There have been times in my life when the work of writers and poets has changed the way I perceived myself and the world, or has provided an inspiration for my art as with seven poems of Stéphane Mallarmé. With Mallarmé understanding him was like a realization, an epiphany in that I found something of myself in them, but the first books that drove my imagination were *Tom Sawyer* and *Huckleberry Finn* and indirectly they have been a source for what I

have done ever since." Below, he adds: "*Living inside myself*—When I realized that for Mallarmé his reverie and imagination were more real than the world outside, than even the woman beside him; that in his work is a sense of longing for experience not fully realized; when I recognized this, I found another place, in pages, for dreams." Yet a third variation in part appears in Dore Ashton's essay in the "Breath" catalogue, in which she quotes Wilmarth saying, "Even there, in the presence of a woman, he is not there." (Evidently, Wilmarth was as given to serial reformulations of his thoughts as he was to his formal reconfigurations of his sculptures.) In any case, I find the difference between the two main versions noteworthy: he backs off from "anguish" and talks instead of presumably happy dreaming. It's as if, at that moment, the satisfaction of the "Breath" series has lightened his mood.

71. Stéphane Mallarmé, "Music and Letters," trans. Rosemary Lloyd, in *Mallarmé in Prose*, ed. Mary Ann Caws (New York: New Directions Books, 2001), 37.

72. Compare Morgan's translation with the beginning of Henry Weinfield's, for example: "My soul, calm sister, ascends toward your brow / Where an autumn that's scattered with russet dreams now, / And toward your angelic eye's wandering heaven / Ascends, as in a melancholy garden." Weinfield's version in fact *is* a translation: he carries the poem over into sense for the contemporary reader. I need the Weinfield, in a way, to make the Morgan understandable. But the Morgan, however poor its legibility can sometimes be, gives off a stronger scent of the exotica, of the mandarin intricacy of Mallarmé.

73. This phrase is in Henry Weinfield's translation, *Stéphane Mallarmé: Collected Poems* (Berkeley and Los Angeles: University of California Press, 1994), 70.

74. Anecdotal history based on my interview with Marvin Lipofsky, December 2, 2002.

75. Eliot, "Tradition and the Individual Talent," in *Sacred Wood*, 58.

76. Brancusi, quoted in Sandra Miller, *Constantin Brancusi: A Survey of His Work* (New York: Oxford University Press, 1995), 230.

77. Wilmarth, quoted in Ashton. She elaborates perceptively on this point. See "Mallarmé, Friend of Artists," in *Christopher Wilmarth: Breath*, exh. cat. (New York: Studio for the First Amendment, 1982), 20.

78. Another precedent is his own *Fontella* (plate 55), with its two overlapping circles of etched glass joined by a square of cable. And yet the Brancusi, for its striking similarity in shape and Wilmarth's deep devotion to the master, seems more likely a source than his own work. Of course, there is the possibility that the *Blond Negress* inspired *Fontella*.

79. Ashton discusses in detail Matisse's illustrations for Mallarmé's poetry and the painter's Symbolist affinity to the poet. The quote from Matisse is also there. See "Mallarmé, Friend of Artists," 15–17.

80. Simone Weil, *Gravity and Grace*, trans. Emma Craufurd (London: Routledge, 1987), 73.

81. Wilmarth, proposal for memorial entitled *The Spirit of the Roeblings*, Wilmarth Archive.

82. Wilmarth, red hardcover notebook, 1974–76, CW2001.786, Wilmarth Archive.

83. Rudolf and Margot Wittkower, *Born under Saturn: The Character and Conduct of Artists: A Documented History from Antiquity to the French Revolution* (New York: W. W. Norton, 1969), 104.

84. Susan Sontag, "Under the Sign of Saturn," in *Under the Sign of Saturn* (New York: Farrar, Straus, Giroux, 1980), 125. The following quote, 117.

85. Wilmarth, Cooper Union notebook, entries for September 25, October 2, October 9, 1961, Wilmarth Archive.

86. Wilmarth, letter to Maurice Poirier, January 25, 1985, Wilmarth Archive. In this same letter Wilmarth repeats his old grudge against Minimalism, referring to Frank Stella's "What you see is what you see" quote as evidence of a perceived tie between materiality and materialism: dwelling on the material aspect of art leads directly to art as commerce. Of course, the prejudice wasn't Wilmarth's alone. For example, Meyer's book discusses Minimalism's harsh European reception in 1968, the time of Enno Develing's exhibition *Minimal Art* at the Gemeentemuseum in The Hague. Minimalism was identified as a capitalistic, imperial American art form—an art form entwined irrevocably with a monolithic military-industrial empire, so much the mantra of the Left in the late '60s. See Meyer, *Minimalism*, 264.

For his own reasons, as we've seen, Wilmarth shared this same antipathy toward Minimalism, perceived as an art that turned away from any spiritual tone. And of course, what was the Studio for the First Amendment if not a protest against the art market and the art object as mere commodity? Yet even here, Wilmarth proves to be

a creature of duality. During the time of the Studio, he simply took on the role of the merchant, selling his spiritually oriented art himself. He was essentially torn, and the double self of Wilmarth/Celadón is only the most graphic, egregious, and weirdly comic sign of Wilmarth's divided self.

87. See Rosenstock, *Christopher Wilmarth*, 17. Her source for the anecdotal notion of the Chartres Cathedral figures as an influence on Wilmarth's double heads was the sculptor's wife, as noted in the essay's endnotes.

88. Susan Sontag, "The Aesthetics of Silence," in *Styles of Radical Will* (New York: Delta, 1981), 6.

89. Andrew Solomon, *The Noonday Demon: An Atlas of Depression* (New York: Scribner, 2001), 257.

90. E. M. Cioran, *A Short History of Decay*, trans. Richard Howard (New York: Viking, 1975), 36.

91. Quoted in Solomon, *Noonday Demon*, 280, from A. Alvarez, *The Savage God: A Study of Suicide* (London: Weidenfeld and Nicolson, 1971), 75. The word *ultimacy* in this context is taken from a phrase of Sontag's in "The Aesthetics of Silence": "Silence in this sense, as termination, proposes a mood of ultimacy antithetical to the mood informing the self-conscious artist's traditional use of silence" (6).

92. Rainer Maria Wilke, in a letter to Clara Wilke, cited in Giorgio Agamben, "The Most Uncanny Thing," in *The Man Without Content*, trans. Georgia Albert (Stanford, Calif.: Stanford University Press, 1999), 5.

# RAY

## Nancy Milford

---

*How is the yellow piece, for Pittsburg coming along. Did you decide on a title? ... I know what your doing Tony with this big yellow in a sunless grey city. Some hope I guess for someone there. Anyway coming home from seeing you last I got very involved with your search for a title RAY was the best I could do because I figured that's what it was going to be.*

— CHRISTOPHER WILMARTH TO TONY SMITH, 1973

That sounds just like Chris—direct, a little colloquial, and generous. He was making something of this sculpture, assuring Smith he could count on Chris to be thinking of his work. He was also nailing his relationship with one of the great Minimalist sculptors of the 1960s, for whom he'd worked as studio assistant. There's almost no greater compliment a young man can give an older artist than that. It's as if a son were giving deference to a father, a mentor. But this young artist has a request; his dealer was preparing a catalogue "and asked me if I knew of someone who could write something in the way of a short introduction. I thought of you & some of the things you have said about my work. If you have time & would like to write something it would be great."[1]

**1.** I met Chris in the late 1960s. I'm pretty sure it was 1967, because my son, Matthew, was in Susan Wilmarth-Rabineau's wonderful class "Red, Yellow, Blue & Glue" at the 92nd Street Y. It was for three- to five-year-olds, and Matt was two months shy of three. But we lived across the street, and anyone who has ever tried to pull a snowsuit on a toddler knows that across the street is an advantage not to be missed. So I lied about his age, and across the street he went. That would have been the fall of 1967, when Chris had begun working for Tony Smith.

PLATE 129
Wilmarth in Milan steel factory,
1973

123

Within a couple of years Chris was teaching at Cooper Union, where he and Susan had met as students, and one spring he invited us to a show of his students' work out on a pier near the Fulton Fish Market in New York Harbor. It was one of those prime cold sunny days, clearer than memory, and there he stood, all six foot two of him, with his full dark beard and lips as red as rubies smiling like a sun god. He was twenty-seven years old.

What was it his friend, the artist Forrest Myers, said about him then? "He was movie-star good looking and he knew it. Look how he dressed. That's a California thing."[2] He and Frosty were both from California. Susan and Chris were living at 144 Wooster Street, where they had the third and fourth floors, and Bernie Kirschenbaum, a sculptor who'd worked for Buckminster Fuller and built his own dome in Stony Creek, Connecticut, had the floor below them. They were all hardworking, talented, and young at a time when New York was just pulling out of the Minimalist movement. Actually, Chris was the youngest. "He made this great impression early," Ingrid Schaffner says now.[3] She was an archivist for the estate and knew his work well. "There was something spooky about how carefully he kept his collection," she said. "I don't think he was a Minimalist. You might call his work post-Minimalist." These artists had careers to build and works to create, and curators and galleries to win to their side. Chris was a handsome charmer, which didn't hurt.

Frosty says, "I think his big contribution as a sculptor was making steel transparent. The art of sculpture is every bit as illusional as painting. It was about light—glass and dark, shadow and clearings—steel is this impenetrable dark thing. And he melded them. When you can transcend your materials, well—" Frosty pauses and says, "We are what we do."

The tough part for any artist in New York is to keep focused enough to do the work and yet wily enough to secure the interest of those who can be useful to you and not be harmed by their interest. I knew Chris was ambitious; I didn't know he was angry and sly and vulnerable. I didn't think of it then, but he was a sort of Harlequin figure—just as Hemingway, whom he physically resembled, had been—playful, intense, and brutal. He was a man I admired and didn't want to get too close to. Susan was his ideal wife.

But I liked him. Maybe that's a good enough reason to write about anyone you've admired when you were both young. I've written this piece as I remembered him. I thought it was a chance for me to write about someone I'd actually known, about someone who wasn't dead. Except Chris was. I knew he'd committed suicide almost seventeen years ago, but I didn't want his death to shadow his life or his work, even though I knew there's the risk that it will, does, has. Even for me.

**2.** One night in 1971 I was invited to dinner at their loft. Chris, who had supported them with his woodworking in the first years of their marriage, had made their handsome long table, and Susan cooked beautifully. Henry Geldzahler was there with his friend, a slender young man wearing a brown monk's cape, who withdrew fairly early in the evening to make his own food. I recall an abundance of greens steaming in a wok. Henry was chunky and balding, the first curator of the Metropolitan Museum's Department of Twentieth-Century Art. At one point in the evening, when Susan and I were talking together in the kitchen, Henry came over and began to explain to Susan that Chris was an extraordinary artist with a magnificent career ahead of him. It was pretty heady stuff he was saying, and I knew Geldzahler was a crucial figure in their world. He was praising Chris's work when suddenly he began to tell Susan that having a child was not the thing to do right now. It would be a deflection from Chris's career; it was not the right time; it was not . . . and here I can't remember what else he said. He'd said enough. It was done deftly, with only their best interests at heart. I don't think I even looked at Susan.

Susan is a beautiful woman with flawless creamy skin and sorrowful brown eyes, like a Jewish Madonna. As early as 1964 Chris made a charcoal drawing of Susan in which he called her Shifrah, her Hebrew name. She had the perfect posture of a dancer, erect and slender. She wore her long dark hair down straight in the style of the sixties. I remember she played the recorder with a group of friends, whereas Chris played the guitar and sang songs he'd written that I've only recently heard—a lost boy in the country driving his beat-up old truck. Some years ago William Kittredge wrote, "Country music, all that worn-out drifter syncopation, turned out to be another lie, a terrific sport but a real thin way of life."[4] I think he was on the money, and Chris knew that at his best he sounded like a cross between Bob Dylan and Hank Williams, only more forlorn and uncertain. But in 1972, when he did *Six Clearings for Hank Williams* (plate 27), he made that green etched glass certain and precise, as if cowboy sentimentality would be controlled and transformed into art. I noticed that he kept a photograph he'd taken of Susan's breasts pinned above the high-top desk where he did his songwriting on Wooster Street. I thought it was his antidote against hokum.

**3.** It was about this time when I got an invitation to Chris's first solo show at Paula Cooper's gallery at 100 Prince Street. The invitation was just perfect, a photograph of him standing in front of Fanelli's, a restaurant and bar that's still on Mercer but was then a working-man's bar, "and Chris saw himself as a worker," Frosty says. He's wearing a long white

coat, like a painter's smock from the 1920s, and he's standing with two men who look as if they had just stepped out of a butcher's shop; the owners of Fanelli's are standing in front of Chris, who towers above them, grinning. You can just make out a menu written in chalk offering "Barley Soup, Spaghetti Meat Balls, $1.50." Betty Cuningham, who had the gallery above Fanelli's from 1972 to 1982, remembers that "one of the things about that picture for me, and about Chris, was his attraction to the underside, to the worker, to the Italian family that Fanelli's provided to all of us, far away from the business of art."[5]

At Chris's show there were sheets of steel and squares of glass, sometimes etched and curved, or laced as if drawn with what looked like steel string. Some pieces were leaning against the wall or carefully braced by it, and the glass was not transparent but glowed with green light as if from within. Where the glass was thicker, it was like looking through a porthole at some wild green sea caught there. It was meticulous work, chilly and precise. I'd never seen anything like it, and I didn't know what to say.

They came to dinner at our apartment with another couple we'd invited, a poet whose first novel was about to make her famous, and her husband, who was an analyst. Her husband fell asleep almost at once. While the woman was talking intensely, she gazed at Chris. Pretty soon Chris asked if I'd come outside with him to have a cigarette. We all smoked in those days, but it wasn't polite to leave your own dinner party. Still, I did. When we were outside, he said, "Did you see what she was doing?" I had no idea what he meant. "Didn't you see the ring she was wearing?" I hadn't noticed. "It's got this silver prong sort of thing sticking up on it and she's rubbing it up and down." "Oh, come on, Chris," I said, "maybe her finger itches." "She's stroking the prong, not her finger."

In 1970 Chris got his first Guggenheim, and I was astonished when he recommended me for one the following year. I'd published *Zelda* the year before, and though I'd needed the money then, I didn't feel I needed it now. I was even a little surprised that he'd suggested me. He and Susan seemed like kids to me, although we were only four and five years apart. But his career had taken off—by 1980 he'd receive his third National Endowment for the Arts Fellowship, in 1983–84 his second Guggenheim. Our lives were changing, and we lost track of each other for a while.

But one day we reconnected, and they invited me to the opening of an exhibition at the Brooklyn Museum called *Sculptors Working in Brooklyn*. Susan and Chris had recently bought a large warehouse on Sackett Street in Red Hook, which they were in the process of renovating. We went back to the warehouse afterward for a little celebration and to see

the new place, which was in a great location. It faced New York Harbor and had huge white open spaces, perfect for his sculpture. Susan was laughingly reduced to cooking salmon steaks in a toaster oven while we toasted them for having found such a splendid spot. For even though the renovation was trying—it took endless patience and handfuls of permits; it also took nerve and daring to turn an old warehouse into a studio and a home—neither one of them seemed to mind. They'd found their paradise, and like all Edens it came with a snake.

In September 1985 Chris explained:

> My move to Brooklyn was a matter of nourishment. In Manhattan I had begun to starve, slowly, in an environment that increasingly oppressed my dreams. Invasions of self-consciousness and trivial consumption were altering the shape of that wonderful island. A kind of psychic landfill was absorbing the special edges; the possibilities of discovery. To exist in the present became an encounter with marketing strategies. . . . From my studio in the Hook I can search around the world.[6]

And he did. He learned to scuba dive in Bonaire, he and Susan bought a house in Spain, he had grand notions, and some of them were fun, provocative, imaginative, even if they didn't all work out. For example, we both liked secrets, and we made a bargain. I would tell him a secret place I knew, and in return he would tell me one of his. I went first. I had found an old wooden staircase leading down into the bowels of the New York Public Library, below the Main Reading Room, where all the books were stored, floors of books below the ground floor of the library itself. Chris had discovered immense stone vaults built into the supporting bases of the Brooklyn Bridge, where there were storage rooms and even studios. We never actually got a chance to take each other to our secret places, for Chris began to plot a project he called *Harmonica Breakdown*. It would be a dance performance, choreographed by Jane Dudley, with sculpture by Chris and a written piece documenting it by my elder daughter, Kate. "I remember meeting Jane Dudley," Kate says, "and I did go to the Lincoln Center Performing Arts Library to hear a recording of the blues singers Brownie McGhee and Sonny Terry. But nothing came of it."[7] She doesn't remember much about it now. "He gave me a little job, and maybe he paid me. He wanted to be helpful. But I think it was that he had this desire, which didn't have much to do with me, and therefore it was like he was trying to save my life. And while life isn't easy—it wasn't that

we had a rich relationship to draw on—it was an idea he had that he wanted to swoop down and save me. And he couldn't." What she did remember was seeing orbs of glass clustered around the floor of his studio on Sackett Street.

**4.** As early as November 1978, the poet Frederick Morgan sent Chris his translation of Mallarmé's poem "Insert Myself within Your Story . . ." and asked him if he knew someone who would illustrate the poem. "Of course illustrations were second fiddle," Morgan says now. "I should have said *images*."[8] But by January 1979 Chris was beginning his own astonishing drawings for the Mallarmé. "In April I sent him another new translation." By July 1980, "I wrote, Here are the seven poems in their finished form."

"It was," Frederick Morgan says, "a very happy collaboration." Chris was making not only drawings but etchings and sculptures. "He had the most wonderful sense of humor. And that helps. I would tell him a joke—or a true-life experience. I'd walk around the neighborhood. There was a coffee shop on the corner, and in comes this foursome. A good-looking blond wife with a wall-eyed husband. And two dopey boys who look just like him. I said to Chris, 'It's a wise man who knows his own father,' and he just laughed his head off!"

By April 1982, there is a clear sense of exhilaration in Chris's note.

Dear Fred,
Here they are! I hope you are pleased with the results. This whole project
has been one of the great events (continuing) of my life and it is thanks to your
translations and your belief in me that it all came about.[9]

Chris's work was completely transformed, or at least my own ability to see it was. Instead of those remarkable walls of steel and bronze, of glass that seemed to deny its own fragility even as it was bent to Chris's vision, now there were orbs, these floating shapes of breath. For Chris had learned to blow glass, and it was literally his breath made manifest, ovals and eggs and orbs, heads of glass, like nothing I had ever seen before. They were buoyant with life. Frosty white, like the breath one leaves on a mirror when one has exhaled upon it. Like *Breath*, which was the title of his next show.

In the catalogue published in 1982, Chris publicly acknowledged what Morgan had done for him: "For Frederick Morgan, who gave me his Mallarmé, who gave me more of myself."[10] But the astonishing thing was, as Forrest Myers says now, "it was almost a reversal of the way one worked at that time. No one went from Chris's degree of success with abstract

work, to figurative work. No one!" Well, in fact, others had—Philip Guston, for one—but the point is that Christopher Wilmarth, at the peak of his career, took his own mysterious leap into the thin air of breath and made glass his own.

**5.** But by the fall of 1986 something alerted me that trouble was in the air. Late in the afternoon, before a grand opening of his most recent sculpture at Hirschl & Adler Modern, Chris stopped by my apartment on Washington Square. He hadn't called first. He said he wanted me to have the catalogue for his new show, *Delancey Backs (and Other Moments)*, which he had written. Then he asked if he might change into his tux at my apartment before his opening. I had that flush of feeling when something isn't right, but I was caught between a sort of pleasure that he was treating me as an old friend—someone he could drop in on—and my discomfort at wondering, What is going on here? I'm pretty sure I let him change. But when he asked if I'd like to go to the opening with him, I wondered where Susan was, and I said no.

Chris borrowed a book from me the following spring, 1987—a collection of memoirs. He was curious about it because in his own *Delancey Backs* he had invented a character

named Celadón, who conducted interviews about him with a variety of people, Susan included. I didn't know quite what to say to him about his writing. I thought his interviews were mannered and oddly self-serving, but I didn't want to tell him that. And maybe the book would be useful. I had found one of the essays, "Reflections on the Death of John Gardner," riveting for what it revealed about the author—not Gardner, but Terrence Des Pres. We talked a little about memoir, and he left with my book.

That summer I was visiting friends on Fire Island who knew people who were collectors of Chris's work. They told me a story about him that was disturbing. He'd been invited to visit them, he came hours late, and he left almost immediately. There was something about Susan being in Spain without him. I didn't want to hear the rest. But I must have called him when I returned to the city, because he left the book at a restaurant we used to go to. Not a note, just the book.

Months later, entirely by chance, I opened the book to the essay on the death of Gardner. There was a faint pencil sketch on the top of the page. It shows the bend in the road where John Gardner had been riding the motorcycle from which he fell to his death. In the sketch his body lies on the road, his motorcycle having raced on without him. There was no reason for him to have fallen, no skid marks, nothing. He was an experienced rider. It was an accident.

I don't know why Chris made the sketch—or even truly if he did, although no one else had ever had the book. Maybe drawing it was just his way of understanding something puzzling: an artist falling to his death. What I need to remember of him are those moments when our lives crossed, when I was lucky enough to recognize the exacting romance of his achievement. It's the work that lasts. People don't.

# Notes

1. Christopher Wilmarth to Tony Smith, winter 1973.

2. Nancy Milford, interview with Forrest Myers, December 2002.

3. Nancy Milford, interview with Ingrid Schaffner, January 20, 2003.

4. William Kittredge, "Drinking and Driving," in *The Graywolf Annual Three: Essays, Memoirs, Reflections*, ed. Scott Walker (Saint Paul: Graywolf Press, 1986), 170.

5. Nancy Milford, telephone interview with Betty Cuningham, June 16, 2003.

6. Christopher Wilmarth, "A Statement for the Occasion of the Exhibition *Sculptors Working in Brooklyn*," Brooklyn Museum, October 1985.

7. Nancy Milford, interview with Kate Milford, February 24, 2003.

8. Nancy Milford, interview with Frederick Morgan, January 21, 2003.

9. Christopher Wilmarth to Frederick Morgan, April 21, 1982.

10. Christopher Wilmarth, *Breath: Inspired by Seven Poems by Stéphane Mallarmé, Translated by Frederick Morgan* (New York: privately printed, 1982), dedications, n.p.

# A Place for Reflection: Writings by Wilmarth

## Edward Saywell

Throughout his life, Christopher Wilmarth found in writing not only a means to explore ideas in absolute privacy but also, in the form of his occasional artistic statements, an opportunity to express publicly his deeply felt spiritual and poetic sensibility.[1] Just as Wilmarth's working drawings and maquettes provide the most intimate access and insight into his creative process, so his writings underline his originality while also shedding further light on his artistic practice.

Wilmarth loved words, and he embraced the beauty and sensuousness of language in his eloquent letters, poems, songs, and statements.[2] The statements are succinct and focused, but their allusive, evocative imagery resonates with his unabashedly romantic vision of his painterly glass and steel sculptures. Rarely polemic, or manifesto-like,[3] his statements and other writings engage with his art in a fascinating dialogue. In a number of instances, for example, the titles of his poems and songs mirror those of his drawings and sculptures.[4] In other cases, his writing encapsulates all that he strove to accomplish in three dimensions. Many of his statements emphasize the significance to him of the subtlest nuances of light and shadow, the importance of capturing a sense of place and spirit, and his search for a human presence within his work.[5] Perhaps most interesting of all are the series of interviews—all but two of which are fictional—that he wrote under the pseudonym Celadón for the catalogue of his 1986 exhibition at Hirschl & Adler Modern in New York.[6] The astonishing frankness and intensity of the interviews at the least prefaced, if not indeed facilitated, the making of his deeply affecting and haunting drawings from the following year, which are similarly uninhibited by emotional or personal limitations.

PLATE 131

*When Winter on Forgotten Woods Moves Somber . . .* , 1979–80. Etched glass and bronze, 18½ × 12 × 6 in. (47 × 30.5 × 15.2 cm). Collection of the Maxine and Stuart Frankel Foundation for Art, Bloomfield Hills, Michigan

The powerful sense of release conveyed by these interviews is also evident on a more intimate, and private, level in the many unpublished songs and poems that Wilmarth wrote throughout his lifetime.[7] Inspired by other songwriters, especially the country singer Hank Williams, he found in songwriting an alternative means to explore both his emotions as well as many of the poetic concerns that he sought to express within his art.[8] Dissatisfied with his early wooden sculptures, he began songwriting at the same time that he started to experiment with the creative and compositional possibilities of glass.[9] From 1968 to 1973 he wrote profusely, noting that "the lyrics were about the same thing that my sculpture is about, a celebration of the imagination, of the ability to dream. . . . They were really about longing, the impossibility of the ideal, the unattainable."[10]

The casual observations and candid notes that Wilmarth never expected to be published or scrutinized are often wonderfully illuminating. His scribbled annotations on a draft of Joseph Masheck's essay "Wilmarth's New Reliefs,"[11] for example, are especially enlightening and help bring us closer to understanding Wilmarth's perception of his own work. In his response to Masheck's text, Wilmarth deleted a passage about the connection of his work to that of Richard Serra's sculptures. Instead, he emphasized a parallel between the relationship that the sculptures in his series "Nine Clearings for a Standing Man" (1973) have with the wall they rest against and Henri Matisse's monumental "Back" series of bronze reliefs (plates 35–38). Writing in the margins of the essay, Wilmarth goes on to stress: "Where is Matisse? Where are Matisse's beautiful charcoal drawings and their lovely light quality? / Where's Rothko? / Where's Brancusi? Where's Torso of a Young Man / Where's Joseph Paxton? Where's the glass and steel structures of 19 cent. England?" Two pages later, he scrawls: "Where's Edward Hopper with Nighthawks?, Light in an Empty Room? / Where's Tony Smith?"[12] The text is an open window into the artist's innermost thoughts.

Although Wilmarth professed that literature was not specifically influential upon his work (with the exception of certain poems by Stéphane Mallarmé), a dialogue with literature is evident throughout his career.[13] In 1984, for example, in an issue of *Poetry East*, Wilmarth discussed the first books that had driven his imagination: *The Adventures of Tom Sawyer* and *The Adventures of Huckleberry Finn*.[14] Mallarmé's melodious Symbolist poetry also had a profound impact on his work. Wilmarth's illustrations for Frederick Morgan's translations of seven of Mallarmé's poems are among the most subtle and profound works of his career, reflecting his search for an ever-greater sense of quiescence and spiritual reverie.[15] The seven poems also inspired Wilmarth to write and publish seven of his own poems under the title *Breath*.[16] He even described the continually evolving connection between his older and

newer work as resembling Honoré de Balzac's creation of the ninety-five novels that make up *La comédie humaine*. Although each of Balzac's books exists independently, they share an exhaustive and scrupulously detailed array of characters (some two thousand in all) and are unified by events and stories that link the novels—often volumes apart—together.[17] In a similar way, Wilmarth would return to a sculpture, sometimes years after its completion, to explore again, through drawings, ideas manifest within the original work.

Nobody would claim that Wilmarth's writings are of great independent literary merit, but his words function in many ways; they not only provide insight into his most private musings and speculations, but they also emphasize the strength of his conviction and the depth of his yearning for a state in which the "survival of spirit, of enthusiasm, wonder, curiosity, passion, [and] love"[18] could be expressed.

PLATE 132

*Blue Long Tangle*, 1972. Etched glass, 16 × 48 × 1 in. (40.6 × 121.9 × 2.5 cm). Collection of Richard and Ronay Menschel

Within the notes below and the writings that follow, citations of archival material have been made to the original manuscript when available. In some instances, the original manuscript is not located in the Archives of American Art at the Smithsonian Institution or in the Christopher Wilmarth Archive at the Fogg Art Museum, but a photocopy of the material resides in the Christopher Wilmarth Archive. In those cases, the copy has been cited.

1. The statements that Wilmarth published in exhibition catalogues and journal articles are listed in the bibliography. Among his most important other statements, which were either unpublished or circulated as exhibition handouts, are the statement for the exhibition *Private Images: Photographs by Sculptors*, Los Angeles County Museum of Art, December 20, 1977–March 5, 1978 (Christopher Wilmarth Papers, 1956–87, Archives of American Art, Smithsonian Institution, Washington, D.C. [hereafter cited as Wilmarth Papers], reel 4296), and the *Studio for the First Amendment: Statement—Sept. 1980*, along with its accompanying *Clarification for the Statement of Sept. 1980* and *Addition to the Statement of September 1980* (Wilmarth Papers, reel 4296).

2. In November 1984 Wilmarth started to convert a large warehouse on Sackett Street, Brooklyn, to house living and working spaces for both himself and his wife, Susan Rabineau. Part of his plan was to create a room specifically for writing. I would like to thank Susan Wilmarth-Rabineau for this information.

3. The key exception is Wilmarth's manifesto, *Are Resale Royalties to Artists Destructive to Our National Cultural Heritage, the System of Free Enterprise, and to Artists Themselves? An Open Letter to the Public from Christopher Wilmarth, on the Occasion of Contemporary Art, Part I, Sothebys, New York, May 4, 1987* (Christopher Wilmarth Archive, gift of Susan Wilmarth-Rabineau, Fogg Art Museum, Harvard University Art Museums [hereafter cited as Wilmarth Archive], CW2001.1681). In the document, Wilmarth introduces what he called the "Muse for Youth Clause," a plea that each time a work of art is resold after the original sale, the seller should donate 5 or 7 percent of the profit to a nonprofit cultural institution focused on the education of children and young adults.

4. In a letter to Maurice Poirier, Wilmarth wrote, "I've always thought the only way with words is to create as parallel a shared source in a poem, story or song" (letter to Maurice Poirier, January 27, 1985, Wilmarth Archive, Box 70). For example, Wilmarth used the titles *Alba Sweeps* and *Susan Walked In* for both sculpture and lyrics.

5. See especially Christopher Wilmarth, [Statement], in Joseph Masheck, *Christopher Wilmarth: Nine Clearings for a Standing Man*, exh. cat. (Hartford, Conn.: Wadsworth Atheneum Museum of Art, 1974), n.p.; [Statement], in Peter Marlow, *Christopher Wilmarth: Matrix 29* (Hartford, Conn.: Wadsworth Atheneum Museum of Art, 1977), n.p.; and the statement written for the exhibition *Private Images: Photographs by Sculptors*, but never published (Wilmarth Papers, reel 4296).

6. Christopher Wilmarth, "Seven Interviews by Celadón," in *Chris Wilmarth: Delancey Backs (and Other Moments)*, exh. cat. (New York: Hirschl & Adler Modern, 1986), 6–33.

7. The original manuscripts for many of these songs and poems can be found in the Wilmarth Archive. See especially CW2001.1625–29 and CW2001.1675–76. Wilmarth recorded many of his songs, the tapes of which are also in the Wilmarth Archive (CW2001.1583–1624).

8. The titles of a number of Wilmarth's sculptures from the early 1970s attest to his love of country music—for example, *Shady Gibson* (1971), *Six Clearings for Hank Williams* (plate 27), *Layout for Bobby Bare* (plate 41), *Little Bent Memphis* (plate 56), *Clear Blue for Hank Williams* (1972), and *Long Memphis* (1973).

9. Wilmarth was to remark later that at this point, "Sculpture was not allowing me to express everything I wanted." See Maurice Poirier, "Christopher Wilmarth: 'The Medium Is Light,'" *Artnews* 84, no. 10 (December 1985): 71.

10. Ibid., 68.

11. The essay was later published in Joseph Masheck, *Christopher Wilmarth: Nine Clearings for a Standing Man* (Hartford, Conn.: Wadsworth Atheneum Museum of Art, 1974), n.p. Wilmarth's revealing comments on Masheck's essay are first discussed in Edward Saywell, *Christopher Wilmarth: Drawing into Sculpture*, exh. cat. (Cambridge, Mass.: Fogg Art Museum, 2003), 30 n. 21.

12. Wilmarth Papers, reel 4296.

13. Roland Hagenberg, "The Sun Is Just a Square upon the Wall," *Artfinder*, spring 1987, 62.

14. Christopher Wilmarth, "Pages, Places and Dreams (or The Search for Jackson Island)," *Poetry East*, nos. 13 and 14 (spring/summer 1984): 171–73.

15. The most important discussion of Wilmarth's Mallarmé-inspired work remains Dore Ashton's essay "Mallarmé, Friend of Artists," in *Christopher Wilmarth: Breath*, exh. cat. (New York: Studio for the First Amendment, 1982), 9–23.

16. Wilmarth's poems were privately published in 1982 in a limited edition of 100, under the title *Breath: Inspired by Seven Poems by Stéphane Mallarmé, Translated by Frederick Morgan*. The poems were reprinted in Christopher Wilmarth, "Pages, Places and Dreams," 174–76.

17. See Paula Dietz, "Constructing Inner Space," *New York Arts Journal*, no. 9 (April/May 1978): 27.

18. Wilmarth, *Statement—Sept. 1980* (Wilmarth Papers, reel 4296).

# WRITINGS

## Christopher Wilmarth

**WHY** I like the circle has to do with the fact that it is probably the most paradoxical shape. It is a nondirectional shape, yet it is the fastest, speediest form you can use. A circle to me is a portent of activity. It belies itself in a way—in the sense that it is moving so fast and yet suffers from a kind of stasis in that it cannot ever move. It is totally without direction at any one point, and everything is possible within a circle—which isn't true of the square or rectangle. When I finish a piece, because of the fact that it is a circle, it never stops moving. *Lit* looks on-the-go to me—if you came back in ten minutes it would be moving in a relentless direction. In this sense it isn't an object. For one thing, it's very much involved with time; and, also, in that connection, it's very much involved with movement. It's the movement within the form that becomes almost magical. For example, the two glass circles seem to be sliding through the wood. It makes me feel that I haven't really created the piece, but rather discovered it. In a way these wood-and-glass pieces are my first light pieces, because they have a lot to do with light without containing light sources within themselves.

Christopher Wilmarth, quoted from Corinne Robins,
"The Circle in Orbit," *Art in America* 56 (November–December 1968): 63.

PLATE 133

*The Whole Soul Summed Up . . .*,
1979. Watercolor and graphite on
layered off-white wove paper, 10¼
× 7⅛ in. (25.9 × 18 cm). Estabrook
Foundation, Carlisle, Massachusetts

## ALBA SWEEPS 1973

Alba Sweeps the morning,
Antonio drinks his wine all day,
I'm upstairs thinkin',
about Susan long ago far away.

Dreamin' bout New York City wandering,
hanging on with everything we had,
Every other shadow had a song to sing,
sometimes were sweet and some were sad.

And we made love in the sweet times,
at my funky place on West Broadway,
The front room always had sunshine,
the light drew pictures on our bodies as we lay.

Alba Sweeps the morning,
Antonio drinks his wine all day,
I'm upstairs thinkin',
about Susan long ago far away.

Dreamin' bout New York City wandering,
hanging on with everything we had,
Every other shadow had a song to sing,
sometimes were sweet and some were sad.

Christopher Wilmarth, *Alba Sweeps*, Milan, 1973 (Wilmarth Archive, CW2001.1634).
The song was recorded and released, with slightly altered lyrics, on the compact disc
*Christopher Wilmarth: California's Really Not to Blame*,
Robert Miller Gallery, New York, 2000.

## THE TRUE STORY OF THE GIFT OF THE BRIDGE

C. Wilmarth

Written in Milan, in 1973. Rewritten New York 1977.

I was going to be twenty, or rather I was twenty, and Susan was coming over to my old place on West Broadway and North Moore to give me my birthday present. I never liked birthdays much, probably because my mother was always angry when we mentioned hers, but Susan loved them. Always about two months beforehand she would say, "Did you know that Leonardo da Vinci died on my birthday?" See what I mean? I felt that those two months had to show in my choice of her gift. Still, I submitted to her enthusiasm.

Susan had been giving me the, "just wait till you see what I'm giving you," look for days and I was getting curious. About twenty minutes before she was supposed to arrive I started repainting my loft, or ripping out a wall or something so I wasn't looking too terrific when she showed up, but Susan looked great and acting all animated and bright, suggested that my gift was "elsewhere" so I got really curious and cleaned up.

I wasn't surprised when we headed downtown, not that I had any idea what or where my gift was, but downtown was sacred turf in those days. It was like an old city forgotten by everyone except the vegetables, the fish, and twenty-seven artists. We felt like we were explorers in a frontier paradise, so downtown always seemed a natural turn to take.

I was born on June eleventh, and June eleventh, nineteen sixty-three, at five to seven in the evening was beautiful! The light was long, yellow-red, and low and it streamed through the cross-streets to the east, stopping up against red brick walls and green tin cornices making them glow that way against the blue sky behind. Susan was wearing a light muslin blouse, and when we passed a cross-street, walking into the sun coming from over by the river, her breasts would show so sweet and golden inside her blouse. I stayed east of her the whole way downtown.

There were two ways to get to the Brooklyn Bridge on foot: through the I.R.T. subway station past the old bronze plaque that said it was the first subway, and by going up the stair's from William Street. I always preferred the William Street way because the bridge would bounce into view as I climbed the steps, and I could hum things to myself and mostly no one was around to hear.

When we got there (to the William Street stairs) Susan was grinning and chuckling and hurrying me up onto the bridge but I was in the dark. I really didn't think that any substantial gift could be hidden on the bridge and not be found by someone passing by.

When we had walked to the middle of the bridge where the expansion joint is, near the police phone, Susan made a gesture of presentation and triumph. I looked thick and stumbly so she said to me "Don't you see it?" and then—I did! Right in the middle of the bridge, under the railing on the uptown tips of the footwalk planks so you would hardly notice them, were painted one letter to a plank end, the words: FOR CHRISTOPHER ON HIS BIRTHDAY LOVE SHIFRAH. It was great! I loved that bridge so much and here Susan had gone and given it to me. It said so! Right there in the middle.

Every so often after that I'd go down for a walk on the bridge alone, or with Susan, and we would see how my birthday card was doing. If there were other people around we would never let on about the letters, just check them out and not say anything. After a while a board would go bad and be replaced, so a letter or two would disappear or the railing would be painted and the drips would fuzz the words. Slowly over the years the inscription would become more and more cryptic. By the end of September nineteen seventy-one all the letters had gone.

| 1963 | FOR | CHRISTOPHER | ON | HIS | BIRTHDAY | LOVE | SHIFRAH |
|------|-----|-------------|-----|-----|----------|------|---------|
| 1964 | F R | CHRI   OPH | R   N | IS | BIRTH  A | LOVE | SHIFR |
| 1965 | F R | CHRI   OP | R   N | IS | BIRT   A | L VE | SHIFR |
| 1966 | F | C RI   P | R   N | IS | BIR    A | VE | SHIFR |
| 1967 | F | C RI   P | N | IS | BIR | VE S | IFR |
| 1968 | | C RI   P | | I | BIR | E S | IF |
| 1969 | | C R    P | | | IR | E S | IF |
| 1970 | | C      P | | | IR | E | IF |
| 1971 | | P | | | R | | F |

OCT. 1971

Christopher Wilmarth, "The True Story of the Gift of the Bridge," in Peter O. Marlow, *Christopher Wilmarth: Matrix 29,* exh. cat. (Hartford, Conn.: Wadsworth Atheneum, 1977), n.p.

LIGHT gains character as it touches the world; from what is lighted and who is there to see. I associate the significant moments of my life with the character of the light at the time. The universal implications of my original experience have located in and become signified by kinds of light. My sculptures are places to generate this experience compressed into light and shadow and return them to the world as a physical poem.

Art exists for a reason. The reason is simple and often forgotten. Art is man's attempt to communicate an understanding of life to man. To give in a sculpture what I understand; to imbue concrete things with parallels to human feelings; to do this in a real way; to be believable is my purpose.

In my attempt to make believable art I make sculptures in which the forms seem to have evolved of themselves. They exist and imply change. The personality of the piece is self-generated and not imposed in an illustrative way. It is not narrated. In their autonomy my sculptures are real. Certain formal limitations support this sense of self generation. The sculpture is given a first form which is finite. The finite is established by cutting the basic shape of the material with no sense of touch. The material is flat and the shapes are geometric. The memory of the first form is retained in the completed piece giving the sculpture a history. All subsequent working of the material is done with respect to the identity of the material, its first form, and to celebrate touch.

For years I have been concerned with the complex problem of implying the human presence in a non-objective art. The concept of the self-generated form approaches a solution in that the sculpture attains a living presence. The layering of material has organic implications but it was the feeling of people in places and the special energy certain places have long after the people have gone that provided insight into my concern with the figure. The configuration,

PLATE 136
*Nine Clearings for a Standing Man #5*, 1973. Etched glass, steel, and steel cable, 60 × 80 × 4 in. (152.4 × 203.2 × 10.2 cm). Collection of the Maxine and Stuart Frankel Foundation for Art, Bloomfield Hills, Michigan

CHRISTOPHER WILMARTH

scale and proportion of place can evoke human presence. These are the places I speak of when I say my sculptures are places to generate experience. The feeling is intimate. You are acknowledged.

Christopher Wilmarth, [Statement], in Joseph Masheck,
*Christopher Wilmarth: Nine Clearings for a Standing Man,*
exh. cat. (Hartford, Conn.: Wadsworth Atheneum, 1974), n.p.

---

## STATEMENT

Written for the Exhibition
*Photographs by Sculptors*
The Los Angeles County Museum, 1977

Most of these photographs were made when I was nineteen and with the exception of *Alley off Crosby Street*, 1963, which I printed then, all remained on the contact sheet until this year. That most of the photographs I've taken, that I consider works in their own right, occurred in the years 1962–1964, and that I abandoned the medium until recently, is relevant to thoughts I've had about artistic sources, superstition, epiphanies, the erosion of dreams and linear thinking.

For as long as I remember I would tell stories to myself and make magic. Only I didn't think of it that way: I never thought that I lived in my head. I was always on the lookout for a place with the light just so and the colors right (red and yellow almost never seemed right) and if I was quiet, or hummed a long time just one or two notes, that I would become transparent and be a part of the place I was in. Then I could talk to the trees or a special corner. It felt nice so I did it a lot.

In 1960 I came to New York to go to school and found some new places so in 1962 when I began to use a camera, without really thinking about it I attempted to make photographs that were like the feelings I had in my places. Some of my paintings and drawings felt like places, but like the places in my head. They didn't look like anything outside.

I was too superstitious to try to photograph a place where these experiences had happened, besides, I knew it couldn't be done. When I was feeling that way in a place, the light would change as if another layer of brightness had bloomed around me, and that couldn't happen with the camera in between. Besides, I didn't want to take a chance on ruining my dream.

Still, I was taking so many photographs that by late 1963 I was suffering from kid [*sic*] of a "malaise of the frame." I was beginning to see everything framed in the shape of a 33 millimeter negative. Things that used to just happen I had to think about and try to make happen. Something was getting between me and that feeling I like to have, so I stopped using the camera so much and after a while the frames went away.

Although I haven't taken many photographs since then I do want to thank the camera for causing me to become more conscious and protective of that part of my mind where the places happen and the words don't come in lines.

Nothing else looks like being alive.

<div align="right">Christopher Wilmarth</div>

<div align="center">© Copyright 1977 Christopher Wilmarth</div>

<div align="center">Christopher Wilmarth, statement for the exhibition *Private Images: Photographs by Sculptors*,
Los Angeles County Museum of Art, Los Angeles, December 20, 1977–March 5, 1978
(Wilmarth Papers, reel 4296).</div>

---

## JANUARY 17, 1978

The structure of most dealer-artist relationships is decidedly feudalistic. A dependent position may be agreeable to some artists but it's not to me.

Personally I don't like being diminished, especially in my own estimation: Serf is not my scene.

<div align="right">Christopher Wilmarth</div>

<div align="right">Wilmarth Papers, reel 4295.</div>

---

## STATEMENT

For the Exhibition: Eight Artists, The Philadelphia Museum of Art

I was asked to address myself to two questions, one in two parts, in writing a statement for this exhibition. The questions are: what is my reltionship [*sic*] to my materials and how did it evolve? and what are the sources of my art? Although I understand the need behind these questions, I have always found them distressing, and at those times when I have attempted to provide answers I have subsequently experienced feelings akin to shame, as if I had dishonored my work and my history.

Can one say on this day for that reason came glass? And if answered what purpose would be served, what conclusions drawn? The sources of my art are complex, as is living this life. There are markers on some days; occasional clear signals, but when one assigns a sentence to a wonder, how inconsequential it seems compared to the dream. Is it possible to summarize a soul?

If I said that as a child I would watch the trees moving in the wind outside my room, with my face pressed against the window, my breath fogging up the glass, and that I would dream in this other vision and light: Would that be a reasonable explanation of why I use etched glass? It may or not be true. I *would* do those things, every child does but then one child *sees* something. Maybe the trees were really the beautiful woman who would sunbathe behind our house. Would that be as acceptable an explanation? Will the reader now say "I see"—the written word blocking the evocation of experience?

Words are easy to make and often carelessly used. Poems take longer. The mind in my art is yours to explore. The mind in me is mine.

Christopher Wilmarth, Chicago, April 8, 1987 [*sic*]

© Copyright 1978 Christopher Wilmarth

Christopher Wilmarth, unpublished statement,
written April 8, 1978, for the exhibition
*Eight Artists*, Philadelphia Museum of Art, April 29–June 25, 1978
(Wilmarth Papers, reel 4296).

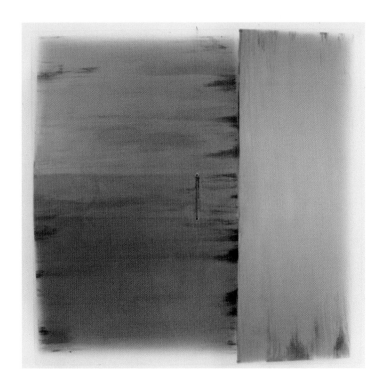

PLATE 137

*City Willows #2*, 1977. Etched glass, steel, and steel cable, 48 × 48 × 4 in. (121.9 × 121.9 × 10.2 cm). Collection of Larry and Cindy Meeker, Lake Quivira, Kansas

## ART IN AMERICA

(or eat your "meatball" hero) © by Christopher Wilmarth

America is a culture that values possessions more than people. When art is Art (and not all art is) it is of the spiritual. It is a place where the feelings of a people are gathered and manifested in a physical existence. The American people are no different from any other in that we do have spiritual needs. We are very different in our abilities to acknowledge that we have those needs. But the need, unrecognized, remains, for the most part suppressed and converted into a neurotic, relentless consumption of material things. Although the need for much of what is consumed is artificially stimulated through advertizing [*sic*] and is essentially useless, there is an attitude among most of the population that it is Art that is useless. Art is suspect. One of the ways that Art can be accepted in a market culture is by bringing it into that system and treating it as a commodity. If an artist collaborates in this they remain an artist in title only. Light manufacturing and market manipulation become their modus operandi. Their art becomes truly useless, a clone of Art, as the spiritual sinks beneath the greed.

It is because I refuse to enter this arena of spiritual death that I picketed the resale exhibition of my sculpture at the Andre Emmerich gallery on Saturday September 23, 1978.

Christopher Wilmarth

©1978 Christopher Wilmarth all rights reserved.
This essay must be printed in full or not all.

Christopher Wilmarth, unpublished statement (Wilmarth Papers, reel 4295).

---

## Studio for the First Amendment

*Statement—Sept. 1980*

- For me, life's effort concerns survival.

- Survival of spirit, of enthusiasm, wonder, curiosity, passion, love.

- Life's crisis is the repression of these things.

- My work is directly concerned with issues of survival of the spirit and resistance to its containment; by self, by other than self.

- I have at times in my life experienced realizations, a heightened feeling of being alive and connected in this world at which times a vision of ideal existence was presented to me.

- I have always wanted to find a place, or make a place or a thing that by its nature, its energy, its EMISSIONS, would render ineffective the confining power of the Group, places or things that were inviolable as they would work with just one of us at a time towards release and realization.

- With some of my work I have returned this ideal vision in a physical poem in which the romance surmounts its containment. Epiphanies.

- The sculptures, *Nine Clearings for a Standing Man,* are the most complete in this feeling.

- In other works, especially earlier ones, the crisis, the containment, the repressive elements are stronger and in some cases predominate. They are angrier works, the most extreme of which I have destroyed because they were negative and graphic, ungenerous and overly self-involved.

LEFT, PLATE 138

*Hague Street Memory (for the Old Man Who Spoke with Me),* 1962. Mixed media, 64¼ × 50⅛ × 2½ in. (163.2 × 127.3 × 6.4 cm). Estate of Christopher Wilmarth, New York

CENTER, PLATE 139

*Platform Dream #8,* 1962. Graphite and gesso on paper, 20¼ × 26⅜ in. (51.4 × 67.6 cm). Estate of Christopher Wilmarth, New York

RIGHT, PLATE 140

*Filter (for Trouble),* 1963. Mixed media, 24½ × 18 × 1½ in. (62.2 × 45.7 × 3.8 cm). Estate of Christopher Wilmarth, New York

- Usually the image would be of flesh-spirit in mechanical confinement.
- *The Platform Dream*, *Filter for Trouble*, and *Hague St. Memory* are the works of this period I retained along with *Twenty Two Drawings from the Platform Dream*. *Hague St. Memory* is the most successful, in my mind, as there is in it a sense of hope. The drawings at times are hopeful.
- The ideal world in my work seemed to be a place to be with oneself. Oneself (the figure) was acknowledged as a state of mind, in the scale of the work, and as kind of a hybrid event: a person-place, but the sense of place predominated—in a quiet way, a reverie.
- The figure or symbols for figure and sensuality that were present in *Hague St. Memory* for example showed too much anxiety and I was unable to evolve that image to support my dreams.
- With *Gnomon's Parade* spirit (flesh-spirit—symbol for figure) and place (reverie) are one in a way that has not occurred in my work before. They draw on the *Platform Dream* pieces, on *Wet* 1966 (destroyed) and other anthropomorphic symbols in my work, but have come, however briefly, to terms with containment with the help of the *Nine Clearings*.
- Flesh is calling for its place as anchor here, for wished-for heavens, hopeful, varied, more like the days, sensual and imperfect, with more room to move.

NOTE. A gnomon is that part of the sundial that stands up for the light to make the shadow that tells the time.

About the sculptures—

These nine works are the most recent in a family that began in 1974 with *Gnomon*, *Second Gnomon* 1975, *February Gnomon* 1976, *Gnomon's Parade #1* 1977, *Gnomon's Parade #2* 1978.

They (these nine) have physically been the most difficult sculptures I have made as they are each pulled from a single plate of steel to support a feeling of integral and generative form.

All cutting, bending, and machining was done to retain a memory of the germ—the first shape—a simple rectangle, and endow the work with a sense of expectation, as if upon returning some time later they will have continued to evolve and move. And the glass that is light that was flesh-to-be-again is now presented by the steel that was so mean

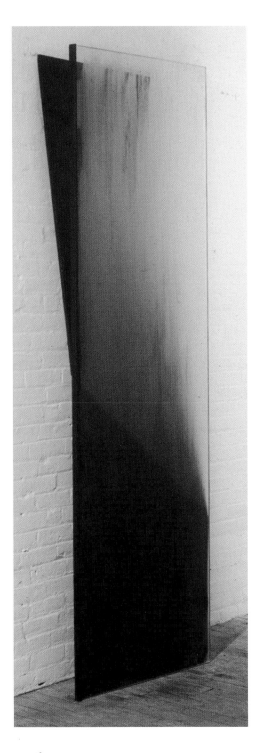

PLATE 141

*February Gnomon*, 1976–77. Etched glass and steel, 96 × 30 × 11 in. (243.8 × 76.2 × 27.9 cm). The Edward R. Broida Collection

CHRISTOPHER WILMARTH

before, and now shares the flesh and is the flesh and is the strength. No longer is heavenly distance the preferred escape. The learning self defends.

<div align="right">Christopher Wilmarth</div>

## CLARIFICATION FOR THE STATEMENT OF SEPTEMBER 1980

November 26, 1980

"No longer is heavenly distance the preferred escape. The learning self defends."

What I am trying to say here is that with my work of the past eight years I have tried to make sculptures that evoke a spiritual disembodied state close to that of reverie; the kind of perfection that I have found during my "revelations" or "epiphanies." I have avoided in my recent sculpture poetry directly tied to the imperfect world of flesh and matter. I have the need to be in and of that imperfect world again and make my poems from its stuff (as in *Hague St. Memory*, 1963). The *Gnomon's Parade* are sculptures which in their reference to the figure and movement begin to approach this desire of mine while retaining the spiritual implications of "place" exemplified by the *Nine Clearings for a Standing Man*.

<div align="right">Christopher Wilmarth</div>

## ADDITION TO THE STATEMENT OF SEPTEMBER 1980

For those without an interior life or without an access to it my work, at best, remains on the level of "beautiful" and can give no more. The rest, which is the most, is not released. For those with an "inside" it can go deeper, for my work does not spell out, nor does it illustrate, meaning. It is an instrument of evocation and requires as catalyst the soul of a sensitive person to engage its process of release, its story, its use. These "requirements" in themselves do not contain prerequisites of exposure to nor education in art. If you can dream, whoever you are, dream with me.

<div align="right">Christopher Wilmarth<br>November 27, 1980</div>

<div align="center">Christopher Wilmarth, <em>Statement — Sept., 1980, Clarification for the Statement of September 1980,</em><br>and <em>Addition to the Statement of September 1980</em> (Wilmarth Papers, reel 4296).</div>

OVER the years I have assiduously avoided exhibitions whose focus is glass. I do not wish to have my art explored in material terms. The materials I use are a vehicle for poetic metaphor, the medium is light, and the subject is experience.

I feel that museums that mount exhibitions of this nature do a disservice to their public by drawing attention away from the true purpose of art which is spiritual, by elevating "style," "technique," and "material" to the level of subject.

Letter from Christopher Wilmarth to Sherry Lang, acting curator of the DeCordova Museum, Lincoln, Mass., dated May 10, 1981, declining her invitation to participate in the exhibition *Glass Routes*. (Object file for Christopher Wilmarth, *Grey-Blue for Hank Williams, No. 2*, 1973.104, Department of Modern and Contemporary Art, Fogg Art Museum, Cambridge, Mass.)

---

## CHRISTOPHER WILMARTH

Pages, Places, and Dreams (or The Search for Jackson Island)

There have been times in my life when the work of writers and poets has changed the way I perceived myself and the world, or has provided an inspiration for my art as with seven poems of Stephane Mallarmé. With Mallarmé understanding him was like a realization, an epiphany in that I found something of myself in them, but the first books that drove my imagination were *Tom Sawyer* and *Huckleberry Finn* and indirectly they have been a source for what I have done ever since.

Ever since was 1950 in Palo Alto, California. I was seven and my concerns were turning the handlebars on my bike upside down and earning a living. Most of my income was from selling tracings I'd made from my step-father's book *How to Draw the Female Nude* which I sold for a dime apiece in the schoolyard until my brother told on me and my step-father gave me a lecture on the sanctity of sex. After that the only employment of interest was bottles. Empty quart beer bottles were worth a nickel each and the best place to get them was the creek down by the railroad bridge in the bushes where the bums lived. The best time for a raid was the afternoon because no one was there usually but sometimes there was and then we would sneak up through the bushes on our bellies ever so slow and pass the bottles back. "We" were myself and Gunny Hefta and Sergei Herlein and we called ourselves the San Francisquito Creek Gang.

My other concern was getting out of the house. I didn't know it then but years later when I saw the movie *Suddenly, Last Summer* I realized that we were living a Tennessee Williams

play and I was supposed to be Elizabeth Taylor only it didn't work out that way. Mark Twain saw to that. We had beautiful editions of *Tom Sawyer* and *Huckleberry Finn* with color illustrations and I would copy them. My favorite was "Tom and Becky Lost in the Cave" but I loved them all. Everything I did or wanted to do was in those books. They gave me a place to dream. The creek became the Mississippi (on the few days of the year it had water in it). We built rafts and hid them from Jim Brody's gang and made forts. Until Beverly came along we all swore in blood never to take anyone to the fort. Then Gunny was there with Beverly and Sergei and I found out because our sacred altar of stones and glass was messed up and believe me this fort was secret, so we grabbed Gunny and said we'd throw him in the poison oak unless he confessed, which he did, and we banished him. Then I got banished and Sergei would have except he couldn't banish himself and that started me making my own forts. These political arrangements were interfering with my dreams.

One day my parents had the idea that they could make a lot of money selling chickens cooked right on a truck and ordered by radio-phone so we moved to San Francisco to an apartment in Jackson Street that we couldn't afford. My brother worked on the truck and I delivered papers in Pacific Heights. I worked in bare feet, suspenders, and corn-cob pipe and my customers called me "the Barefoot Contessa" and reported my parents to the Department of Children's Welfare. The embarrassment was too much so my mother consulted with the principal of my school and my teachers to find out how to stop me from thinking I was Huckleberry Finn.

They decided on a book burning and clay steamboat smashing. One day my stepfather took me into the living room, lit a fire, and page by page burned *Tom Sawyer* and *Huckleberry Finn*. It didn't work. Inwardly I mean. Outwardly it was a great success. I stopped wearing floppy hats and suspenders, got rid of my pipe, put on shoes and became a successful juvenile delinquent.

> *And waited, and looked for safe places,*
> *to dream*
> *Found them sometimes outside*
> *inside mostly*
> *inside my work*
> *inside poems*
> *inside living*
> *living inside.*

*Living inside myself*—When I realized that for Mallarmé his reverie and imagination were more real than the world outside, than even the woman beside him; that in his work is a sense of longing for experience not fully realized; when I recognized this, I found another place, in pages, for dreams.

Author's note: Seven Poems by Stephane Mallarmé, translated by Frederick Morgan, inspired a group of sculptures, drawings, pastels, a book of etchings, paintings, and a book of my own poems, *Breath*.

. . .

## Edges (from Toast)

An edge was breached
and just became
the back of something else.
We are at the best and better
part of up to now.
So dance! let's dance in resting airs
and take one long sweet taste:
hair down behind our faces
in a breeze of final joy.

ABOVE, PLATE 142
*Toast,* 1979. Ink on paper, 8¼ × 5¼ in. (21 × 13.3 cm). Collection of Susan Wilmarth-Rabineau, Executor of the Estate of Christopher Wilmarth, New York

RIGHT, PLATE 143
*Toast,* 1979–80. Etched glass and steel, 10 × 7 × 7 in. (25.4 × 17.8 × 17.8 cm). Collection of Robert and Loretta Lifton, New York

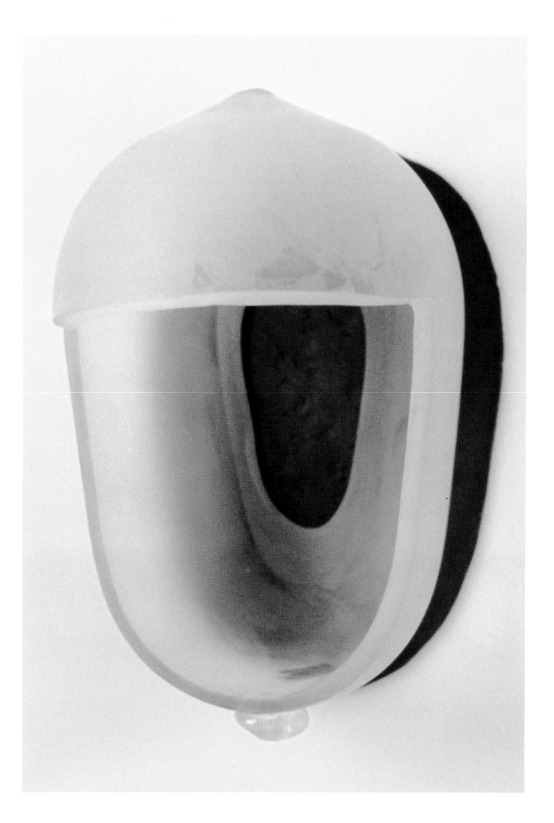

## WINE AND STONES (FROM "THE WHOLE SOUL SUMMED UP . . .")

All that's been

has floated down

and settled here

long ago

beneath times near

found a place

below the nows

in dimming light

from nows above

drifting down

to wine and stones

waiting

to be found.

Christopher Wilmarth, "Pages, Places and Dreams (or The Search for Jackson Island),"
*Poetry East*, nos. 13 and 14 (spring/summer 1984): 171–76.

---

THE observation your friend made at The Neuberger about the male/female reference surprised me to the point of denying them. No one has focused on this aspect which is there and has been since 1960. Sensuality, duality, its limiting and release was much more specific in works of 1962–63 like *Hague Street Memory*, *Filter for Trouble*, *The Platform Dream* and in 1964 *Her Sides of Me*. Duality is clearest in *Her Sides of Me* and my 1982 poem *You*. The specific which I felt confined the work became less so later as I tried to work the universal. Maybe less *literal* is a better word to express the change. I've never been much on discussing this aspect of my work, not wanting to attach a literal [crossed out] linear progression of words to what I felt could only be sensed and absorbed. I think there's some superstition going on here, as if words would floodlight a personal story and bleach the meaning. I've always thought the only way with words is to create a parallel a shared source in a poem, story or song. The survival of imagination (preservation of) has been my preoccupation. Imagination is my life and love and imagination are united in my mind.

We talked a lot about glass Maurice and you've got me a bit nervous. It's obvious I love the material but I must insist that glass has nothing to do with what I'm trying to say other

than serving as a vehicle with its identity and truths respected. I would try to apply this to any material. I'm leery of material as subject. It's a disease, this materialistic "what you see is what you see" denial of the spirit (but a perfect vehicle for trade).

<div align="right">

Christopher Wilmarth, draft of letter to Maurice Poirier, January 29, 1978
(Wilmarth Archive, CW2001.1791).

</div>

---

**MY** move to Brooklyn was a matter of nourishment. In Manhattan I had begun to starve, slowly, in an environment that increasingly oppressed my dreams. Invasions of self-consciousness and trivial consumption were altering the shape of that wonderful island. A kind of psychic landfill was absorbing the special edges, the possibilities of discovery. To exist in the present became an encounter with marketing strategies.

And Brooklyn? "Brooklyn is the Universe."* Brooklyn can't be known; it is the experience of the nourishing present. From my studio in the Hook I can reach around the world.

<div align="right">

Christopher Wilmarth, Red Hook, Brooklyn 9/11/85

</div>

*Bernard Malamud in conversation at the home of Dore Ashton and Matti Megged 1984

<div align="right">

Christopher Wilmarth, [Statement], in Charlotte Kotik, *Working in Brooklyn/Sculpture*, exh. cat. (New York: Brooklyn Museum, 1985), 26.

</div>

---

**INTERVIEW #7**

Chris Wilmarth, Brooklyn, New York, August 20, 1986

"And that's *all* you are going to say!?"

"That's all."

*"If it's not magic it's merchandise?"*

"If it's not magic—it's merchandise."

<div align="right">

Christopher Wilmarth (writing under the pseudonym Celadón), "Interview #7" in *Chris Wilmarth: Delancey Backs (and Other Moments)*, exh. cat. (New York: Hirschl & Adler Modern, 1986), 33.

</div>

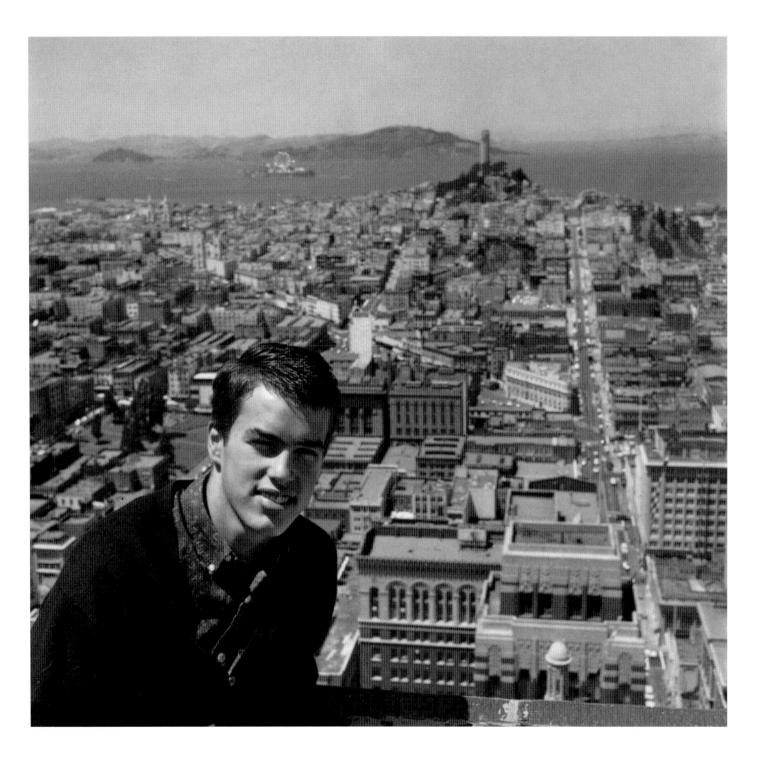

PLATE 144

Wilmarth at age seventeen in San Francisco

# Chronology

## Edward Saywell

**1943**

Born Christopher Mallory James on June 11, in Vineburg, Sonoma County, California. His father, William Mallory James, and mother, Stephanie Stefanssen James, divorce when he is very young. Shortly thereafter, his mother marries Charles M. Wilmarth. Christopher and his brother, Peter, take their new father's last name.

**1956–60**

Attends the Wilmerding School of Industrial Arts, San Francisco. The curriculum of the school places particular emphasis on technical and fine arts courses.

**1960**

Moves to New York City to attend the Cooper Union for the Advancement of Science and Art. Enrolls in classes that include calligraphy, world literature, three-dimensional design, and visual communication. Among his teachers are Adja Yunkers, Robert Hassa, Tony Candido, Paul Seide, Nicholas Carone, and Ruben Kadish. Meets Susan Rabineau, his future wife.

**1962**

In September, following his brother's suicide, he takes a year off from college. For a brief period he uses a camera in an attempt to "make photographs that were like the feelings I had in my places."[1] He abandons photography in 1964.

**1963**

Produces a number of painted wall pieces and the "Platform Dream" series of twenty-two drawings.

As recorded by Wilmarth in *The True Story of the Gift of the Bridge* (see pages 141–43), Susan Rabineau "gives" him the Brooklyn Bridge for his birthday.[2]

In September, he returns to classes at Cooper Union.

**1964**

Inspired by the figurative drawings of Matisse, he makes a series of charcoal drawings of Rabineau. Marries Rabineau on September 20, at Valhalla, New York.

Awarded a Scholastic Achievement Prize by Cooper Union in November.

Begins making furniture on a commission basis.

**1965**

Graduates on June 9 with a bachelor of fine arts degree.

Begins work on a series of sculptures made from painted wood.

**1966**

Exhibits *Wet*, a painted-wood sculpture, at the Whitney Museum of American Art's Annual Exhibition.

Commissioned by Jane Dudley to make a glass and wood cabinet— the first time he uses glass.

**1967**

Works as studio assistant to Tony Smith (to 1969).

Introduces sheets of glass into a number of his sculptures, such as *Cirrus* (plate 12) and *Panoply's Angel* (plate 58). The sculptures combine sheets of tempered glass with cylinders and wedges of polished birch. Becomes increasingly fascinated by the sculptural possibilities of glass. Starts to visit glass manufacturers to study the properties of different kinds of glass as well as to observe how the material could be shaped.

## 1968

First solo exhibition at Graham Gallery, New York, October 26–November 23, at which six sculptures are shown. Later, he destroys three of the all-wood sculptures, an assertion of his discovery that only glass could capture the qualities of light and shadow and the sense of place and spirit that he had been seeking in his work.

Inspired by songwriters, especially Hank Williams and Bobby Bare, he starts to write numerous song lyrics. Many of his early sculptures, such as *Six Clearings for Hank Williams* (plate 27) and *Little Bent Memphis* (plate 56), bear names that attest to his love of country music.

PLATE 145
Wilmarth with Susan and Morris at Fanelli's in 1971, before the opening of his first solo exhibition at Paula Cooper Gallery

## 1969

Receives a National Endowment for the Arts Fellowship.

In February, appointed adjunct instructor in art (three-dimensional design) at Cooper Union; continues to teach there for eleven years (until 1980).

Completes his first works, such as *Gye's Arcade* (plate 11) and *Go* (no longer extant), that are made entirely from sheets of glass.

## 1970

Starts to use small, thick planes of glass as a drawing support. At first, he uses graphite to mark and hydrofluoric acid to etch the glass, in order to control its transparency by blurring its surface. After only a few works, he abandons the use of graphite and instead introduces Roebling steel cable into the works as both a structural and calligraphic element.

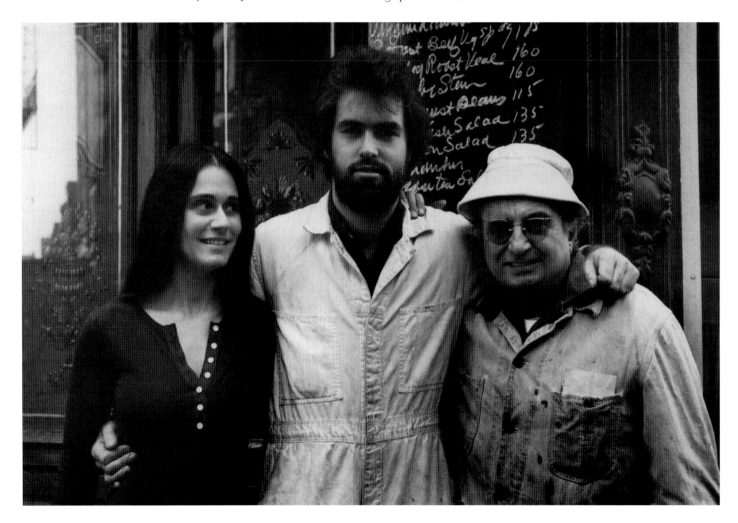

In what Wilmarth later describes as the "first use of an 'alternative space' in New York,"[3] he initiates the "Pier Project" and "Reo" with his first-year three-dimensional-design students at Cooper Union. The two projects use the vaults under the Brooklyn Bridge, as well as buildings, lots, and piers in the adjacent Fulton Street Fish Market, for the display of student work.

Awarded a John Simon Guggenheim Memorial Foundation Fellowship.

## 1971

First solo exhibition at Paula Cooper Gallery, New York, at which Wilmarth exhibits a group of glass-and-steel-cable drawings, including works such as *Half Open Drawing* (plate 24).

In a breakthrough collaborative piece with Mark di Suvero, Wilmarth incorporates steel plate into his sculpture for the first time. Combining the artists' last names, the sculpture is called *Di-Wil-Vero* (plate 25).

## 1971–72

Visiting artist, Yale University, New Haven.

## 1972

Awarded the Norman Wait Harris Award in the Seventieth American Exhibition at the Art Institute of Chicago for *Clear Stream.* Awarded a Howard Foundation Fellowship, from Brown University, Providence.

## 1973

From January until April, works in Milan, Italy, producing fifteen sculptures. An exhibition of the works opens on April 3 at Galleria dell'Ariete, Via S. Andrea, 5 Milan.

Writes *The True Story of the Gift of the Bridge*, later rewritten in New York and published in Peter O. Marlow, *Christopher Wilmarth: Matrix 29* (Hartford, Conn.: Wadsworth Atheneum, 1977, n.p.).

Completes the series of sculptures "Nine Clearings for a Standing Man."

PLATE 146
Wilmarth standing next to Constantin Brancusi's *Endless Column*, Târgu-Jiu, Romania, in 1974

## 1974

In the summer, travels to Târgu-Jiu, Romania, to visit Brancusi's public sculptures.

In November the exhibition *Christopher Wilmarth: Nine Clearings for a Standing Man* opens at the Wadsworth Atheneum before traveling to the Saint Louis Art Museum.

Submits proposal to the Iowa City Sculpture Project for installing *Blue Release* on the Civic Center Sculpture Site.

Invited by the Society of the Four Arts, Palm Beach, to submit a proposal for a sculpture to be placed on their grounds. He proposes the juxtaposition of *Calling* and *First Light* to "create a sense of *place*."[4] Neither proposal is accepted. Invited to submit sketches for a mural to be commissioned by the City College of the City University of New

York, to be located in the recently completed Science Building at 137th Street and St. Nicholas Terrace. The mural is to fill a space at the head of a staircase leading from the entrance hall on St. Nicholas Terrace to the plaza-level hall immediately above. Wilmarth proposes a wall sculpture, *Second Roebling,* to be 8 feet wide by 10 feet high by 5½ inches deep. In February 1975 Wilmarth is chosen as the winner of the competition. A wave of controversy ensues over the $50,000 expense of the commission, which results in Wilmarth's withdrawal from the project in February 1976.

"We believe that of the projects proposed for the commission, Mr. Wilmarth's is the most unique and innovative, one whose spirit of adventurousness and rigorousness is singularly well-suited to the site and to the need of the community that will have contact with the piece. It is visually and intellectually provocative, and we feel that it will continue to sustain itself on many levels over a period of time."[5]

## 1976

Submits a proposal, again not accepted, for the installation of three sculptures, *Calling, Days on Blue,* and *Evers,* in the grassy court at the Kimbell Art Museum, Fort Worth, Texas.

Visiting artist, Columbia University, New York (to 1978).

## 1977

Receives his second National Endowment for the Arts Fellowship.

*Christopher Wilmarth: Matrix 29,* the second solo exhibition of his work at the Wadsworth Atheneum, opens in February.

Greatly inspired by the formal purity, sense of place, and scale of Brancusi's *Gate of the Kiss* (plate 76) and *Endless Column* at Târgu-Jiu, Wilmarth completes the largest sculpture that he will ever make: *Days on Blue* (plate 77).

## 1978

Greatly frustrated by the relationship with one of the galleries that represents his work, Droll Kolbert, Wilmarth establishes the Studio for the First Amendment. With the slogan "Support your local independent artist," the exhibition space opens in his studio at 144 Wooster Street, New York, on January 7. The first exhibition, which opens

January 10, is *Christopher Wilmarth: Recent Sculpture.* It is held in conjunction with the exhibition *Christopher Wilmarth: Sculpture and Drawings,* at the Grey Art Gallery and Study Center, New York University.

Pickets the André Emmerich Gallery on Saturday, September 23, 1978, in protest at an exhibition of his work at the gallery. Wilmarth alleges that the gallery has both inflated the prices of his work and not stated clearly enough that they do not represent him.

The poet Frederick Morgan asks Wilmarth to suggest an artist to illustrate his translations of seven poems by the French Symbolist poet Stéphane Mallarmé (1842–1898). Greatly inspired by the poems, he asks Morgan whether he can undertake the task himself. Morgan agrees, and Wilmarth begins work on what becomes known as the "Breath" series.

Selected as one of five finalists by the Forty-second Street Redevelopment Corporation to submit plans for the installation of public art on two sites on Forty-second Street between Ninth and Tenth Avenues, Wilmarth proposes a sculpture called *Dream Arbors Light.*

Begins work on the Harmonica Breakdown Project. The project was to consist of a dance performance *Harmonica Breakdown,* choreographed by Jane Dudley, with sculpture by Wilmarth inspired by the performance and documentation in the form of a written piece by Kate Milford. Although the project continues to interest Wilmarth throughout the 1980s, the work is never realized.

## 1979

Spends the winter semester (January 8–March 17) as visiting lecturer in the Department of Art Practice, University of California at Berkeley.

Realizing that blown glass would express sculpturally the images he had drawn for Morgan's book, Wilmarth learns glassblowing from Marvin Lipofsky at the California College of Arts and Crafts, Oakland, in order to create a series of blown-glass, Mallarmé-inspired works.

Invited by the city of Corpus Christi, Texas, to propose a sculpture in the Bayfront Plaza. The project is not realized.

PLATE 147

Wilmarth with his guitar
(a photo of his wife, Susan,
is in the background),
Vineyard Haven,
Massachusetts, mid-1970s

**PLATE 148**
Wilmarth at the beach in Catalunya, Spain, a few miles north of the house that he and his wife purchased in Monells during the early 1980s

## 1980

Receives his third National Endowment for the Arts Fellowship. Awarded a New York State Council on the Arts Creative Artists Public Service Program Grant.

In November, opens *Christopher Wilmarth: Gnomon's Parade* at the Studio for the First Amendment.

Resigns from Cooper Union on December 20.

## 1982

In May exhibits the "Breath" series for the first time, at the exhibition *Christopher Wilmarth: Breath*, in the Studio for the First Amendment. The exhibition travels to the Institute of Contemporary Arts, Boston; the University Art Museum, Berkeley; and the University Art Museum, Santa Barbara.

Publishes seven of his own poems entitled *Breath: Inspired by Seven Poems by Stéphane Mallarmé, Translated by Frederick Morgan* in a limited edition of one hundred.

Visits Chartres Cathedral, France, over the summer. One sculpture on the portal of the cathedral representing God and Adam, their heads almost together, has a tremendous impact on Wilmarth and leads to the double-headed forms in his late drawings and sculptures.

## 1983

Following the death of the owner of the Wooster Street building that houses the Studio for the First Amendment, Wilmarth is forced to close the gallery on January 7.

Receives his second John Solomon Guggenheim Memorial Foundation Fellowship, "To continue developing the concepts which began with the sculptures that were inspired by Mallarmé's poems."[6]

## 1984

In March, Hirschl & Adler Modern, New York, opens *Christopher Wilmarth: Layers*, a small retrospective of his career to date.

In an issue of *Poetry East*[7] devoted to poetry and the visual arts, Wilmarth writes about the influence of literature on his art. He publishes "Pages, Places, and Dreams (or The Search for Jackson Island)," in which he describes the importance to him as a young boy of *The Adventures of Tom Sawyer* and *The Adventures of Huckleberry Finn*.

The Spencer Museum of Art, University of Kansas, commissions a sculpture and reflecting pool for a site on campus. Wilmarth has to decline the commission later in 1985 due to time constraints.

Appointed artist in residence at the Pilchuck Glass School, Seattle, for the first week of June.

In September, starts to convert a large factory in Sackett Street, Brooklyn, into living and studio spaces for both himself and Susan. He joins Hirschl & Adler Modern to ensure continued representation of his work in Manhattan.

## 1985

Proposes a memorial, *The Spirit of the Roeblings*, in celebration of John, Washington, and Emily Roebling, all three of whom were instrumental in the engineering and building of the Brooklyn Bridge. The site envisioned for the sculpture is the Promenade in Brooklyn Heights, a walkway on the East River just south of the Brooklyn Bridge, where "the light is special in its variety and character and a sculpture placed there should engage it."[8]

**1986**

Appointed adjunct professor of painting and sculpture, Columbia University, New York.

In November, exhibits eight of his most recent sculptures at Hirschl & Adler Modern, New York. Many of the sculptures took over three years to complete, due to the complexities of renovating the Sackett Street factory. The exhibition is accompanied by a catalogue, *Chris Wilmarth: Delancey Backs (and Other Moments)* credited to a woman called Celadón. The catalogue consists of interviews with six people about Wilmarth, and a seventh with Wilmarth himself. What Wilmarth did not reveal was that Celadón was, in fact, his pseudonym and that all but two of the interviews were fictional.

Resigns from a New York City arts panel, organized by the Department of Cultural Affairs, after it rejects his proposal to use children's art in a permanent art display at the Brooklyn zoo.

Commissioned to propose an installation in front of the town hall in Greenwich, Conn.

**1987**

Enters a competition for the American Merchant Marines Memorial. Publishes, in a limited edition of twenty copies, *Remembrance: A Memorial to Those American Merchant Marines Who Lost Their Lives in Peaceful Commerce and in Wars against Foreign Foes, in Defense of the Freedom This Nation Now Enjoys.*

In response to the "Visual Artists Rights Amendment of 1986," which was presented at the second session of the Ninety-ninth Congress, writes the pamphlet, *Are Resale Royalties to Artists Destructive to our National Cultural Heritage, the System of Free Enterprise, and to Artists Themselves? An Open Letter to the Public from Christopher Wilmarth, Artist, on the Occasion of Contemporary Art, Part I, Sothebys, New York, May 4, 1987.* Wilmarth is concerned about the provision to pay "to the artist or artist's agent a royalty . . . equal to seven percent of the difference between the seller's purchase price of the fair market value of any property received in exchange for the work." Instead, he argues for what he calls the "Muse for Youth Clause": each time a work of art is resold after the original sale, the seller should donate 5 or 7 percent of the profit to a nonprofit cultural institution that would focus on the education of children and young adults.

Creates two groups of drawings. The intimately scaled *Twelve Drawings from the Forty-fourth Year* (the title refers to the artist's age) precedes a second group of large portraitlike drawings that Wilmarth was working on immediately before his death in November. He also starts on a series of sculptures that were to be in an exhibition entitled *Lead* at Hirschl & Adler Modern. The last sculpture he completes, *Self-Portrait with Sliding Light* (plate 128) features a haunting molten-lead-covered bronze head.

Suffering from clinical depression, on November 19 Wilmarth commits suicide by hanging himself in his studio.

## NOTES

1. Christopher Wilmarth, statement for *Private Images: Photographs by Sculptors*, Los Angeles County Museum of Art, December 20, 1977–March 5, 1978 (Christopher Wilmarth Papers, 1956–87, Archives of American Art, Smithsonian Institution, Washington, D.C. [hereafter cited as Wilmarth Papers], reel 4296).

2. See Christopher Wilmarth, "The True Story of the Gift of the Bridge," in Peter O. Marlow, *Christopher Wilmarth: Matrix 29*, exh. cat. (Hartford, Conn.: Wadsworth Atheneum, 1977), n.p.

3. Letter from Wilmarth to Lee Ann Miller, October 14, 1983 (Christopher Wilmarth Archive, gift of Susan Wilmarth-Rabineau, Fogg Art Museum, Harvard University Art Museums [hereafter cited as Wilmarth Archive]).

4. Christopher Wilmarth, "Proposed Sculpture for the Grounds of the Society of the Four Arts" (Wilmarth Papers, reel 4295).

5. *Statement*, dated February 26, 1975, and signed by Henry Geldzahler, Jennifer Licht, and Marcia Tucker (Wilmarth Archive, CW2001.1653).

6. Quoted from Wilmarth's application form to the John Solomon Guggenheim Memorial Foundation (Wilmarth Archive).

7. *Poetry East*, nos. 13 and 14 (spring/summer 1984): 171–73.

8. Christopher Wilmarth, *A Statement about My Proposed Sculpture, "The Spirit of the Roeblings"* (Wilmarth Archive, CW2001.1660).

# EXHIBITIONS

## Edward Saywell

### SOLO EXHIBITIONS

#### 1968

*Christopher Wilmarth*, Graham Gallery, New York, October 26–November 23.

#### 1971

*Chris Wilmarth: Sculpture*, Paula Cooper Gallery, New York, March 14–April 7.

*Chris Wilmarth*, Janie C. Lee Gallery, Dallas, opened November 20.

#### 1972

*Chris Wilmarth*, Paula Cooper Gallery, New York, March 11–April 5.

#### 1973

*Chris Wilmarth Sculpture*, Galleria dell'Ariete, Milan, opened April 3.

#### 1974

*Chris Wilmarth: Drawings and Small Sculptures*, Rosa Esman Gallery, New York, February 2–28.

*Chris Wilmarth: Recent Sculpture*, Daniel Weinberg Gallery, San Francisco, March 5–30.

*Christopher Wilmarth: Nine Clearings for a Standing Man*, Wadsworth Atheneum, Hartford, Conn., November 13, 1974–January 12, 1975, and tour to Saint Louis Art Museum.

#### 1975

*Chris Wilmarth*, Galerie Aronowitsch, Stockholm, April–May.

#### 1977

*Christopher Wilmarth: Matrix 29*, Wadsworth Atheneum, Hartford, Conn., February 8–April 17.

#### 1978

*Christopher Wilmarth: Recent Sculpture*, the Studio for the First Amendment, New York, January 10–February 4.

*Christopher Wilmarth: Sculpture and Drawings*, Grey Art Gallery and Study Center, New York University, January 10–February 10.

*Chris Wilmarth: Recent Sculpture and Drawings*, Daniel Weinberg Gallery, San Francisco, opened September 11.

*Christopher Wilmarth: Sculpture, 1972–1973*, André Emmerich Gallery, New York, September 12–October 4.

#### 1979

*Christopher Wilmarth*, Seattle Art Museum, January 25–March 25.

#### 1980

*Christopher Wilmarth: Gnomon's Parade*, the Studio for the First Amendment, New York, November 8–December 6.

#### 1982

*Christopher Wilmarth: Breath*, the Studio for the First Amendment, New York, May 1–29, and tour to Institute of Contemporary Arts, Boston; University Art Museum, Berkeley, Calif.; and the University Art Museum, Santa Barbara, Calif.

#### 1984

*Christopher Wilmarth: Layers, Works from 1961–1984*, Hirschl & Adler Modern, New York, March 17–April 19.

**1986**

*Chris Wilmarth: Delancey Backs (and Other Moments)*, Hirschl & Adler Modern, New York, November 1–December 3.

**1989**

*Christopher Wilmarth/Days on Blue 1977*, Neuberger Museum, Purchase College, State University of New York, Purchase, N.Y., January 21, 1989–January 7, 1990.

*Christopher Wilmarth*, the Museum of Modern Art, New York, May 25–August 22.

*Christopher Wilmarth: Drawings, 1963–1987*, Hirschl & Adler Modern, New York, June 1–July 28, 1989.

**1992**

*Christopher Wilmarth*, Hirschl & Adler Modern, New York, dates unknown.

**1993**

*Christopher Wilmarth: Sculpture and Works on Paper*, Nielsen Gallery, Boston, October 2–November 13.

**1994**

*Christopher Wilmarth*, DIA Center for the Arts, Bridgehampton, N.Y., June 25–September 18.

**1995**

*Christopher Wilmarth*, Sidney Janis Gallery, New York, February 18–March 25.

**1996**

*Christopher Wilmarth: Sculpture*, Hirschl & Adler Modern, New York, January 5–February 10.

**1997**

*Christopher Wilmarth: Sculpture and Painting from the 1960s and 1980s*, Sidney Janis Gallery, New York, March 18–April 19.

**1998**

*Christopher Wilmarth, 1943–1987: Layers, Clearings, Breath*, Nielsen Gallery, Boston, April 8–May 9.

**2000**

*Christopher Wilmarth: Every Other Shadow Had a Song to Sing*, Robert Miller Gallery, New York, April 7–May 6.

**2001**

*Christopher Wilmarth: Living Inside*, University Gallery, University of Massachusetts Amherst, February 3–March 16, April 1–May 18.

*Christopher Wilmarth*, the Arts Club of Chicago, September 20–November 3.

**2003**

*Christopher Wilmarth: Gift of the Bridge, Related Drawings and Sculpture*, Nielsen Gallery, Boston, March 29–May 3.

*Christopher Wilmarth: Drawing into Sculpture*, Fogg Art Museum, Harvard University Art Museums, Cambridge, Mass., April 5–June 29.

*Christopher Wilmarth: Inside Out*, Robert Miller Gallery, New York, October 17–November 15.

### GROUP EXHIBITIONS

**1966**

*Invitational Exhibition*, Park Place Gallery, New York, June 12–30.

*Annual Exhibition 1966: Contemporary Sculpture and Prints*, Whitney Museum of American Art, New York, December 16–February 5, 1967.

**1967**

Graham Gallery, New York.

**1968**

*Cool Art—1967*, the Aldrich Museum of Contemporary Art, Ridgefield, Conn., January 7–March 17.

*Cool Art: Abstraction Today*, Newark Museum, N.J., May 27–September 29.

*1968 Annual Exhibition: Contemporary American Sculpture,* Whitney Museum of American Art, New York, December 17, 1968–February 9, 1969.

### 1969

*The Big Drawing,* Graham Gallery, New York, April 8–May 3.

*Superlimited: Books, Boxes and Things,* the Jewish Museum, New York, April 16–June 29.

*Highlights of the 1968–1969 Art Season,* the Aldrich Museum of Contemporary Art, Ridgefield, Conn., June 22–September 14.

Paula Cooper Gallery, New York.

### 1970

*Tom Clancy and Chris Wilmarth,* French & Co., New York, June 20–August 31.

*L'Art vivant aux Etats-Unis,* Fondation Maeght, Saint Paul-de-Vence, France, July 16–September 30.

*Art for Peace,* Paula Cooper Gallery, New York, September 19–26.

*Small Works,* the New Gallery, Cleveland, Ohio, opened December 4.

*1970 Annual Exhibition: Contemporary American Sculpture,* Whitney Museum of American Art, New York, December 12, 1970–February 7, 1971.

Janie C. Lee Gallery, Dallas.

### 1971

*Twenty-six by Twenty-six,* Vassar College Art College, Poughkeepsie, N.Y., May 1–June 6.

*Highlights of the 1970–1971 Art Season,* the Aldrich Museum of Contemporary Art, Ridgefield, Conn., June 27–September 19.

*Recent Acquisitions IX,* the Museum of Modern Art, New York, October 7–14, October 27, 1971–January 2, 1972.

*Drawings by New York Artists,* Utah Museum of Fine Arts, University of Utah, Salt Lake City, November 28, 1971–January 12, 1972, and tour to Henry Gallery, University of Washington, Seattle; Arizona State University, Tempe; Georgia Museum of Art, University of Georgia, Athens; Finch College Museum of Art, New York; Hayden Gallery, Massachusetts Institute of Technology, Cambridge.

Windham College, Putney, Vt.

### 1972

*New York '72,* Paula Cooper Gallery, New York, January 7–29.

*Painting and Sculpture, 1972,* Storm King Art Center, Mountainville, N.Y., April 8–June 11.

*Painting and Sculpture Today, 1972,* the Indianapolis Museum of Art, April 26–June 4.

*Seventieth American Exhibition,* the Art Institute of Chicago, June 24–August 20.

### 1973

*1973 Biennial Exhibition: Contemporary American Art,* Whitney Museum of American Art, New York, January 10–March 18.

*New American Graphic Art,* Fogg Art Museum, Harvard University, Cambridge, Mass., September 12–October 28, 1973.

*The Albert Pilavin Collection: Twentieth-Century American Art II,* Museum of Art, Rhode Island School of Design, Providence, October 23–November 25.

*Drawings and Other Works,* Paula Cooper Gallery, New York, December 15, 1973–January 9, 1974.

### 1974

*Twentieth-Century Art Accessions, 1967–1974,* the Metropolitan Museum of Art, New York, March 14–April 24.

*Questions Answers,* Sarah Lawrence College Art Gallery, Bronxville, N.Y., April 16–26.

*Painting and Sculpture Today, 1974,* the Indianapolis Museum of Art, May 22–July 14, and tour to the Contemporary Art Center and the Taft Museum, Cincinnati.

*Sculpture Now*, New York, inaugural exhibition, November 1974–
January 1975.

**1975**

*The Conditions of Sculpture*, Hayward Gallery, London, exhibition
organized by the Arts Council of Great Britain, May 29–July 13.

**1976**

*Two Hundred Years of American Sculpture*, Whitney Museum of
American Art, New York, March 16–September 26.

*Projects Rebuild*, Grey Art Gallery and Study Center, New York
University, August 11–27.

**1977**

*A View of a Decade*, Museum of Contemporary Art, Chicago,
September 10–November 10.

*Drawings for Outdoor Sculpture, 1946–1977*, John Weber Gallery,
New York, October 29–November 23, and tour to Mead Art Gallery,
Amherst College, Mass.; University Art Museum, Santa Barbara,
Calif.; La Jolla Museum of Contemporary Art, Calif.; Hayden Gallery,
Massachusetts Institute of Technology, Cambridge.

*Private Images: Photographs by Sculptors*, Los Angeles County
Museum of Art, December 20, 1977–March 5.

**1978**

*Eight Artists*, Philadelphia Museum of Art, April 29–June 25.

*Dialogue: Shapiro, Wilmarth*, Huntington Museum of Art, W. Va.,
September 29–November 26.

**1979**

*Places to Be: Unrealized Monumental Projects*, Rosa Esman Gallery,
New York, January 9–February 3.

*1979 Biennial Exhibition*, Whitney Museum of American Art,
New York, February 6–April 8.

*Eight Sculptors*, Albright-Knox Art Gallery, Buffalo, March 17–
April 29.

*Contemporary Sculpture: Selections from the Collection of the
Museum of Modern Art*, the Museum of Modern Art, New York,
May 18–August 7.

*The Decade in Review: Selections from the 1970s*, Whitney Museum of
American Art, New York, June 19–September 2.

*Recent Acquisitions from the Department of Twentieth-Century Art*, the
Metropolitan Museum of Art, New York, October 16, 1979–January 30,
1980.

**1980**

*Perceiving Modern Sculpture: Selections for the Sighted and Non-
Sighted*, Grey Art Gallery and Study Center, New York University,
July 8–August 22.

*Arte americana contemporanea*, Comune di Udine, Civici Musei e
Gallerie di Storia e Arte, Udine, Italy, September 20–November 16.

**1981**

*Contemporary Artists*, the Cleveland Museum of Art, October 21–
November 29.

**1982**

*Made in New York,* City Gallery, New York City Department of
Cultural Affairs, February 1–17, and tour to the Bronx Museum of
the Arts.

*Prints by Contemporary Sculptors*, Yale University Art Gallery,
New Haven, Conn., May 18–August 31.

*1982 Carnegie International*, Carnegie Institute, Pittsburgh, October
23, 1982–January 2, 1983, and tour to Seattle Art Museum. Australian
tour, June–November 1983: Art Gallery of Western Australia, Perth;
National Gallery of Victoria, Melbourne; Art Gallery of New South
Wales, Sydney.

*Androgyny in Art*, Emily Lowe Gallery, Hofstra University, Hempstead,
N.Y., November 6–December 19.

**1983**

*Minimalism to Expressionism: Painting and Sculpture since 1965
from the Permanent Collection*, Whitney Museum of American Art,
New York, June 2–December 4.

*American Accents*, the Gallery/Stratford, Ontario, June 6–August 7,
and tour to College Park, Toronto; Musée du Québec; Art Gallery
of Nova Scotia, Halifax; Art Gallery of Windsor, Ontario; Edmonton
Art Gallery, Alberta; Vancouver Art Gallery, British Columbia;
Glenbow Museum, Calgary, Alberta; and Musée d'Art Contemporain,
Montréal, Québec.

*The Permanent Collection: Highlights and Recent Acquisitions*,
Grey Art Gallery and Study Center, New York University,
November 8–December 10.

## 1984

*An International Survey of Recent Painting and Sculpture*, the Museum
of Modern Art, New York, May 17–August 19.

*American Sculpture: Three Decades*, Seattle Art Museum, November
15, 1984–January 27, 1985.

## 1985

*A New Beginning, 1968–1978*, the Hudson River Museum, Yonkers,
N.Y., February 3–May 5.

*Image and Mystery*, Hill Gallery, Birmingham, Mich., April 21–
May 30.

*Working in Brooklyn/Sculpture*, the Brooklyn Museum, October 18,
1985–January 6, 1986.

*Transformation in Sculpture*, Solomon R. Guggenheim Museum,
New York, November 22, 1985–February 16, 1986.

## 1986

*Cy Twombly, Christopher Wilmarth, Joe Zucker*, Hirschl & Adler
Modern, New York, May 21–June 27.

*American Sculpture: A Selection*, Arnold Herstand and Company,
New York, June 4–July 31.

*Sculpture and Works in Relief*, John Berggruen Gallery, San Francisco,
October 9–November 29.

*The Purist Image*, Marian Locks Gallery, Philadelphia,
November 1–30.

## 1987

*Three Sculptors: Chris Wilmarth, John Duff, Peter Charles*,
the Corcoran Gallery of Art, Washington, May 9–August 16.

*Beyond Reductive Tendencies*, Michael Walls Gallery, New York,
September 12–October 3.

## 1988

*Sculpture since the Sixties: From the Permanent Collection of the
Whitney Museum of American Art*, Whitney Museum of American Art
at Equitable Center, New York, August 18, 1988–August 9, 1989.

## 1989

*Repetition*, Hirschl & Adler Modern, New York, February 25–
March 25.

## 1990

*The Transparent Thread: Asian Philosophy in Recent American Art*,
Hofstra Museum, Hofstra University, Hempstead, N.Y., September 16–
November 11, 1990, and tour to Edith C. Blum Art Institute, Bard
College, Annandale-on-Hudson, N.Y.

## 1991

*The Contemporary Drawing: Existence, Passage and the Dream*,
Rose Art Museum, Brandeis University, Waltham, Mass., March 17–
April 28.

## 1994

*In a Classical Vein: Work from the Collection*, Whitney Museum of
American Art, New York, October 18, 1993–April 3, 1994.

## 1995

*Matrix Is 20!*, Wadsworth Atheneum, Hartford, Conn., January 28–
April 9.

## 1996

*Minimalism: Its Aftermath and Affinities*, Seattle Art Museum,
March 27–August 25.

*Still Life/Still Alive*, Nielsen Gallery, Boston, June 15–August 15.

**1997**

*A Decade of Collecting: Selected Recent Acquisitions in Modern Drawing*, the Museum of Modern Art, New York, June 5–September 9.

*Drawing Is Another Kind of Language: Recent American Drawings from a New York Private Collection*, Arthur M. Sackler Museum, Harvard University Art Museums, Cambridge, Mass., December 12, 1997–February 22, 1998, and tour to Kupferstichkabinett, Akademie der Bildenden Künste, Vienna; Kunstmuseum Winterthur, Switzerland; Kunst-Museum Ahlen, Germany; Akademie der Künste, Berlin; Fonds Régional d'Art Contemporain/Musée de Picardie, Amiens, France; Parrish Art Museum, Southampton, N.Y.; Lyman Allyn Art Museum, New London, Conn.; Mary and Leigh Block Museum of Art, Northwestern University, Evanston, Ill.; and the Contemporary Museum, Honolulu.

*Recent Glass Sculpture: A Union of Ideas*, Milwaukee Art Gallery, September 5–November 2.

*Modern Masters: The Last Decade at Janis*, Sidney Janis Gallery, New York, April 11–May 16.

*Sculptors against the Wall*, Sidney Janis Gallery, New York, May 3–June 14.

*Modern and Contemporary Masters: Paintings, Sculpture, Works on Paper*, Sidney Janis Gallery, New York, November 8–December 24.

*Christopher Wilmarth and Tony Smith: Mentor, Apprentice, Friends*, Hirschl & Adler Modern, New York, December 6, 1997–January 24, 1998.

**1998**

*Denaturalized*, Museum of Contemporary Art, Chicago, February 14–July 4.

*Edward R. Broida Collection: A Selection of Works*, Orlando Museum of Art, Fla., March 12–June 21.

**1999**

*Another Form: Drawings into Sculpture*, New York Studio School of Drawing, Painting and Sculpture, October 14–November 13.

*Then and Now: The Nielsen Gallery Thirty-fifth Anniversary Exhibition*, Nielsen Gallery, Boston, January 9–February 20.

*Carved, Modeled, Assembled, Welded, Drawn: Sculptors' Works in the Collection of the Albright-Knox*, Albright-Knox Art Gallery, Buffalo, February 27–April 11.

**2000**

*A Decade of Collecting: Recent Acquisitions of Prints and Drawings from 1940 to 2000*, Fogg Art Museum, Harvard University Art Museums, Cambridge, Mass., June 3–August 27.

*Minding Glass*, Susquehanna Art Museum, Harrisburg, Penn., July 17–September 29.

*Tina Turner, Christopher Wilmarth; In the Blue Blackness of My Sheep, Leonid Lerman, from the Edward R. Broida Collection*, Museum of Fine Arts, Houston, October 15–November 26.

*Material Language: Small-Scale Sculpture after 1950*, the Art Museum, Princeton University, N.J., October 17–December 30.

**2001**

*About Objects*, Museum of Art, Rhode Island School of Design, Providence, June 29–September 9.

*Clement Greenberg: A Critic's Collection*, Portland Art Museum, Ore., July 14–September 16, and tour.

**2002**

*More Than Skin and Bones*, Nielsen Gallery, Boston, March 16–April 20.

# BIBLIOGRAPHY

## Edward Saywell

### STATEMENTS, WRITINGS, AND INTERVIEWS

Hagenberg, Roland. "The Sun Is Just a Square upon the Wall." *Artfinder*, spring 1987, 60–65.

Wilmarth, Christopher. [Statement]. In Corinne Robins, "The Circle in Orbit." *Art in America* 56, no. 6 (November/December 1968): 63.

———. [Statement]. In Joseph Masheck, *Christopher Wilmarth: Nine Clearings for a Standing Man*. Exh. cat. Hartford, Conn.: Wadsworth Atheneum, 1974.

———. "The True Story of the Gift of the Bridge." In Peter O. Marlow, *Christopher Wilmarth: Matrix 29*. Exh. cat. Hartford, Conn.: Wadsworth Atheneum, 1977.

———. *Breath: Inspired by Seven Poems by Stéphane Mallarmé, Translated by Frederick Morgan*. New York: privately printed, 1982. [Reprinted as "Pages, Places, and Dreams (or The Search for Jackson Island)." *Poetry East*, nos. 13 and 14 (spring/summer 1984): 174–76.]

———. [Statement]. In Charlotte Kotik, *Working in Brooklyn/ Sculpture*. Exh. cat. Brooklyn: Brooklyn Museum, 1985.

———. "Seven Interviews by Celadón." In *Chris Wilmarth: Delancey Backs (and Other Moments)*, 6–33. Exh. cat. New York: Hirschl & Adler Modern, 1986.

———. *Remembrance: A Memorial to those American Merchant Marines who lost their lives in peaceful commerce and in wars against foreign foes, in defense of the freedom this nation now enjoys*. Privately published in a limited edition of 20 copies, 1987.

### SOLO-EXHIBITION CATALOGUES

Ashton, Dore. "Mallarmé, Friend of Artists," 9–23. In *Christopher Wilmarth: Breath*. Exh. cat. New York: Studio for the First Amendment, 1982.

———. "Christopher Wilmarth: Layers," 3–12. In *Christopher Wilmarth: Layers, Works from 1961–1984*. Exh. cat. New York: Hirschl & Adler Modern, 1984.

———. "Christopher Wilmarth: Inside Out," n.p. In *Christopher Wilmarth: Inside Out*. Exh. cat. New York: Robert Miller Gallery, 2003.

Coppola, Regina. "Living Inside," 7–33. In *Christopher Wilmarth*. Exh. cat. Chicago: Arts Club of Chicago, 2001.

Galleria dell'Ariete. *Chris Wilmarth: Sculpture*. Exh. cat. Milan: Galleria dell'Ariete, 1973.

Geldzahler, Henry, and Christopher Scott. *Christopher Wilmarth: Sculpture and Drawings*. Exh. cat. New York: Grey Art Gallery & Study Center, New York University, 1977.

Graham Gallery. *Christopher Wilmarth*. Exh. cat. New York: Graham Gallery, 1968.

Hirschl & Adler Modern. *Christopher Wilmarth: Drawings, 1963–1987*. Exh. cat. New York: Hirschl & Adler Modern, 1989.

Marlow, Peter O. *Christopher Wilmarth: Matrix 29*. Exh. cat. Hartford, Conn.: Wadsworth Atheneum, 1977.

Masheck, Joseph. "Wilmarth's New Reliefs," n.p. In *Christopher Wilmarth: Nine Clearings for a Standing Man*. Exh. cat. Hartford, Conn.: Wadsworth Atheneum, 1974.

Nielsen Gallery. *Christopher Wilmarth: Layers, Clearings, Breath*. Exh. cat. Boston: Nielsen Gallery, 1998.

Rosenstock, Laura. "Christopher Wilmarth: An Introduction," 10–18. In *Christopher Wilmarth*. Exh. cat. New York: Museum of Modern Art, 1989.

Rosenthal, Mark. *Christopher Wilmarth: Sculpture and Drawings from the 1960s and 1980s*. Exh. cat. New York: Sidney Janis Gallery, 1997.

Saywell, Edward. *Christopher Wilmarth: Drawing into Sculpture.* Exh. cat. Cambridge, Mass.: Fogg Art Museum, Harvard University, 2003.

Seattle Art Museum. *Christopher Wilmarth.* Exh. cat. Seattle: Seattle Art Museum, 1979.

Sidney Janis Gallery. *Christopher Wilmarth.* Exh. cat. New York: Sidney Janis Gallery, 1995.

Wilmarth, Christopher. *Chris Wilmarth: Delancey Backs (and Other Moments) with Seven Interviews by Celadón.* Exh. cat. New York: Hirschl & Adler Modern, 1986. [See also Statements, Writings and Interviews.]

## PERIODICALS, REVIEWS, BOOKS, AND GROUP-EXHIBITION CATALOGUES

Aldrich Museum of Contemporary Art. *Cool Art—1967.* Exh. cat. Ridgefield, Conn.: Aldrich Museum of Contemporary Art, 1967.

———. *Highlights of the 1968–1969 Art Season.* Exh. cat. Ridgefield: Aldrich Museum of Contemporary Art, 1969.

———. *Highlights of the 1970–1971 Art Season.* Exh. cat. Ridgefield: Aldrich Museum of Contemporary Art, 1971.

Anderson, Alexandra. "Christopher Wilmarth: Portfolio." *Paris Review* 15, no. 58 (summer 1974): 102–10.

Art Institute of Chicago. *Seventeenth American Exhibition.* Exh. cat. Chicago: Art Institute of Chicago, 1972.

Artner, Alan. "Abstract Reflection." *Chicago Tribune,* October 14, 2001. Review of *Christopher Wilmarth,* Arts Club of Chicago.

Ashton, Dore. "Radiance and Reserve: The Sculpture of Christopher Wilmarth." *Arts Magazine* 45, no. 5 (March 1971): 31–33.

———. *Drawings by New York Artists.* Exh. cat. Salt Lake City: Utah Museum of Fine Arts, University of Utah, 1972.

———. "Christopher Wilmarth's Gnomic Sculpture." *Arts Magazine* 55, no. 4 (December 1980): cover and 93–95.

———. "Christopher Wilmarth: Layers." *Cimaise* 31, no. 169 (March/April 1984): 69–72.

———. "Homage to Christopher Wilmarth." *At Cooper Union,* spring 1990, 6–7.

Baro, Gene. *Carnegie International.* Exh. cat. Pittsburgh: Museum of Art, Carnegie Institute, 1982.

Beardsley, John. *Spectrum: Three Sculptors: Chris Wilmarth, John Duff, Peter Charles.* Exh. cat. Washington: Corcoran Gallery of Art, 1987.

Boyce, Roger. "Through a Glass Darkly: Christopher Wilmarth." *Art New England* 22, no. 4 (June/July 2001): 22–23. Review of *Christopher Wilmarth: Living Inside,* University Gallery, University of Massachusetts, Amherst.

———. "Becoming Transparent." *Art in America* 92, no. 2 (February 2004): 110–13. Review of *Christopher Wilmarth: Drawing into Sculpture,* Fogg Art Museum, Cambridge, Mass.

Braff, Phyllis. "Thoughtful Works by Important Talents." *New York Times,* August 14, 1994. Review of *Christopher Wilmarth,* DIA Center for the Arts, Bridgehampton.

Butterfield, Jan. "New Beauty." *Pacific Sun,* March 28–April 3, 1974. Review of *Chris Wilmarth: Recent Sculpture,* Daniel Weinberg Gallery, San Francisco.

Calo, Carole Gold. "Nielsen Gallery/Boston: Christopher Wilmarth." *Art New England* 15, no. 1 (December 1993/January 1994): 54. Review of *Christopher Wilmarth: Sculpture and Works on Paper,* Nielsen Gallery, Boston.

Camper, Fred. "Christopher Wilmarth: Light Heavyweight." *Chicago Reader* 31, no. 2 (October 12, 2001): 34–35.

Cleveland Museum of Art. *Contemporary Artists.* Exh. cat. Cleveland: Cleveland Museum of Art, 1981.

Cohen, Ronny. "Christopher Wilmarth: Hirschl and Adler Modern." *Artnews* 83, no. 6 (summer 1984): 185–86. Review of *Christopher Wilmarth: Layers, Works from 1961–1984,* Hirschl & Adler Modern, New York.

Comune di Udine, Civici Musei e Gallerie di Storia e Arte. *Arte americana contemporanea.* Exh. cat. Udine, Italy: Comune di Udine, Civici Musei e Gallerie di Storia e Arte, 1980.

Corn, Alfred. "Reveries in Glass and Steel." *Artnews* 88, no. 8 (October 1989): 201.

Corning Museum of Glass. *The Corning Museum of Glass: A Guide to the Collections.* Corning, New York: Corning Museum of Glass, 2001.

Cowart, Jack. "Recent Acquisitions: *Free Ride*, by Tony Smith; *Invitation #3*, by Christopher Wilmarth." *St. Louis Art Museum Bulletin* 13, no. 3 (May/June 1977): 66–68.

Delahoyd, Mary. *A New Beginning: 1968–1978*. Exh. cat. Yonkers, N.Y.: Hudson River Museum, 1985.

Delahoyd, Mary, Bruce Goldberg, and Ed DiLello. *Questions Answers*. Exh. cat. Bronxville, New York: Sarah Lawrence College Art Gallery, 1974.

Des Moines Art Center. *An Uncommon Vision*. Des Moines: Des Moines Art Center, 1998.

Dietz, Paula. "Constructing Inner Space." *New York Arts Journal* 9 (April/May 1978): 26–28.

Edelman, Robert G. "Christopher Wilmarth at Sidney Janis." *Art in America* 83, no. 6 (June 1995): 103. Review of *Christopher Wilmarth*, Sidney Janis Gallery, New York.

Eisler, Colin. "Prints by Contemporary Sculptors." *Art Journal* 42, no. 3 (fall 1982): 247–48.

Fondation Maeght. *L'Art vivant aux Etats-Unis*. Exh. cat. Saint Paul-de-Vence, France: Fondation Maeght, 1970.

Freedman, Paula B., and Robin Jaffee Frank. *A Checklist of American Sculpture at Yale University*. New Haven, Conn.: Yale University Art Gallery, 1992.

Friedman, Martin, Robert Pincus-Witten, and Peter Gay. *A View of a Decade*. Exh. cat. Chicago: Museum of Contemporary Art, 1977.

Gelburd, Gail. *Androgyny in Art*. Exh. cat. Hempstead, N.Y.: Emily Lowe Gallery, Hofstra University, 1982.

Gelburd, Gail, and Geri De Paoli. *The Thread: Asian Philosophy in Recent American Art*. Exh. cat. Hempstead, N.Y.: Hofstra Museum, Hofstra University, Annandale-on-Hudson, N.Y.: Edith C. Blum Art Insitute, Bard College, 1990.

Geldzahler, Henry. *American Accents*. Exh. cat. Stratford, Ontario: Rothmans of Pall Mall Limited, 1983.

Gerrit, Henry. "Christopher Wilmarth: Hirschl and Adler Modern." *Art in America* 72, no. 8 (September 1984): 212–13. Review of *Christopher Wilmarth: Layers, Works from 1961–1984*, Hirschl & Adler Modern.

Gibson, Eric. "Christopher Wilmarth." *Sculpture* 7, no. 3 (May/June 1988): 35.

———. "Wilmarth and Serra." *New Criterion* 8, no. 2 (October 1989): 51–55.

Glueck, Grace. "Christopher Wilmarth: Graham Gallery." *Art in America* 56, no. 5 (September/October 1968): 112. Review of *Christopher Wilmarth*, Graham Gallery, New York.

———. "Christopher Wilmarth: Paula Cooper Gallery." *Art in America* 59, no. 2 (March/April 1971): 46–47. Review of *Chris Wilmarth*, Paula Cooper Gallery, New York.

———. "Mallarmé Poems Inspire Glass Sculpture." *New York Times*, May 14, 1982. Review of *Christopher Wilmarth*, Studio for the First Amendment, New York.

———. "Christopher Wilmarth's 'Layers.'" *New York Times*, March 23, 1984. Review of *Christopher Wilmarth: Layers, Works from 1961–1984*, Hirschl & Adler Modern, New York.

———. "Christopher Wilmarth: Sidney Janis Gallery." *New York Times*, April 4, 1997. Review of *Christopher Wilmarth: Sculpture and Painting from the 1960s and 1980s*, Sidney Janis Gallery, New York.

Goldenthal, J. "Wilmarth Exhibit at Atheneum." *Hartford Courant*, November 17, 1974. Review of *Christopher Wilmarth: Nine Clearings for a Standing Man*, Wadsworth Atheneum, Hartford, Conn.

Greben, Deidre Stein. "Christopher Wilmarth: Sidney Janis." *Artnews* 94, no. 6 (summer 1995): 123. Review of *Christopher Wilmarth*, Sidney Janis Gallery, New York.

d'Harnoncourt, Anne. *Eight Artists*. Exh. cat. Philadelphia: Philadelphia Museum of Art, 1978.

Henry, Gerrit. "Christopher Wilmarth at Hirschl and Adler Modern." *Art in America* 72, no. 8 (September 1984): 212–13. Review of *Christopher Wilmarth: Layers, Works from 1961–1984*, Hirschl & Adler Modern, Boston.

Hinson, Tom E. *Contemporary Artists*. Exh. cat. Cleveland: Cleveland Museum of Art, 1981.

Hirschl & Adler Modern. *Cy Twombly, Christopher Wilmarth, Joe Zucker*. Exh. cat. New York: Hirschl & Adler Modern, 1986.

———. *Repetition.* Exh. cat. New York: Hirschl & Adler Modern, 1989.

Horowitz, Stash. "Magic, Not Merchandise." *The Back Bay Courant,* April 28, 1998. Review of *Christopher Wilmarth, 1943–1987: Layers, Clearings, Breath,* Nielsen Gallery, Boston.

Hughes, Robert. "Poetry in Glass and Steel." *Time,* June 26, 1989, 88.

———. *Nothing If Not Critical: Selected Essays on Art and Artists.* New York: Alfred A. Knopf, 1990.

———. *The Shock of the New.* New York: Alfred A. Knopf, 1991.

Indianapolis Museum of Art. *Painting and Sculpture Today, 1972.* Exh. cat. Indianapolis: Indianapolis Museum of Art, 1972.

———. *Painting and Sculpture Today, 1974.* Exh. cat. Indianapolis: Indianapolis Museum of Art, 1974.

Jewish Museum. *Superlimited: Books, Boxes and Things.* Exh. cat. New York: Jewish Museum, 1969.

John Berggruen Gallery. *John Berggruen Gallery: Sculpture and Works in Relief.* Exh. cat. San Francisco: John Berggruen Gallery, 1986.

Kalina, Richard. "Christopher Wilmarth at Sidney Janis." *Art in America* 85, no. 10 (October 1997): 117–18. Review of *Christopher Wilmarth: Sculpture and Painting from the 1960s and 1980s,* Sidney Janis Gallery, New York.

Kaufman, Jason Edward. "Wilmarth's Landscapes of Glass and Steel." *New York City Tribune,* June 16, 1989. Review of *Christopher Wilmarth,* Museum of Modern Art, New York.

Kimmelman, Michael. "Sculptures at the Modern by Christopher Wilmarth." *New York Times,* June 23, 1989. Review of *Christopher Wilmarth,* Museum of Modern Art, New York.

———. "Christopher Wilmarth: Sidney Janis Gallery." *New York Times,* March 17, 1995. Review of *Christopher Wilmarth,* Sidney Janis Gallery, New York.

Kingsley, April. *Dialogue: Shapiro, Wilmarth.* Exh. cat. Huntington, W. Va.: Huntington Galleries, 1978.

Klein, Mason. "Tony Smith/Christopher Wilmarth." *Artforum* 36, no. 8 (April 1998): 117–18. Review of *Christopher Wilmarth and Tony Smith: Mentor, Apprentice, Friends,* Hirschl & Adler Modern, New York.

Koslow Miller, Francine. "Christopher Wilmarth: Fogg Art Museum, Harvard University Art Museums." *Artforum* 42, no. 3 (November 2003): 193–94. Review of *Christopher Wilmarth: Drawing into Sculpture,* Fogg Art Museum, Cambridge, Mass.

Kotik, Charlotte. *Working in Brooklyn/Sculpture.* Exh. cat. New York: Brooklyn Museum, 1985.

Kramer, Hilton. "The Delicate Touch of a Constructivist." *New York Times,* December 8, 1974. Review of *Christopher Wilmarth: Nine Clearings for a Standing Man,* Wadsworth Atheneum, Hartford, Conn.

———. "Christopher Wilmarth." *New York Times,* January 20, 1978. Review of *Christopher Wilmarth: Sculpture and Drawings,* Grey Art Gallery & Study Center, New York University, and of *Christopher Wilmarth: Recent Sculpture,* Studio for the First Amendment, New York.

———. "A Sculptor in Pursuit of the Poetry in Light and Shadow." *New York Observer,* June 5, 1989. Review of *Christopher Wilmarth,* Museum of Modern Art, New York.

———. "Chris Wilmarth Is the Hero in a Tale of Two Sculptors." *New York Observer,* December 22, 1997. Review of *Christopher Wilmarth and Tony Smith: Mentor, Apprentice, Friends,* Hirschl & Adler Modern, New York.

———. "Wilmarth Drawings in Etched Glass, Index Sculptures." *New York Observer,* June 16, 2003. Review of *Christopher Wilmarth: Drawing into Sculpture,* Fogg Art Museum, Cambridge, Mass.

Krane, Susan, Robert Evren, and Helen Raye. *Albright-Knox Gallery: The Painting and Sculpture Collection, Acquisitions since 1972.* New York: Hudson Hills Press, 1987.

Kunitz, Daniel. "Christopher Wilmarth: Every Other Shadow Had a Song to Sing." *New Criterion* 18, no. 10 (June 2000): 50–51. Review of *Christopher Wilmarth: Every Other Shadow Had a Song to Sing,* Robert Miller Gallery, New York.

Kuspit, Donald. "Christopher Wilmarth: Museum of Modern Art." *Artforum* 28, no. 2 (October 1989): 170. Review of *Christopher Wilmarth,* Museum of Modern Art, New York.

———. "Christopher Wilmarth: Sidney Janis Gallery." *Artforum* 33, no. 9 (May 1995): 98. Review of *Christopher Wilmarth,* Sidney Janis Gallery, New York.

Larson, Philip. "Christopher Wilmarth at N.Y.U.'s Grey Gallery and the 'Studio for the First Amendment.'" *Art in America* 66, no. 3 (May/June 1978): 117. Review of *Christopher Wilmarth: Sculpture and Drawings*, Grey Art Gallery & Study Center, New York University, and of *Christopher Wilmarth: Recent Sculpture*, Studio for the First Amendment, New York.

Lee, Pamela, and Christine Mehring. *Drawing Is Another Kind of Language: Recent American Drawings from a New York Private Collection.* Exh. cat. Cambridge, Mass.: Harvard University Art Museums, 1997.

Linker, Kate. "Christopher Wilmarth: Nine Clearings for a Standing Man." *Arts Magazine* 49, no. 8 (April 1975): cover, 52–53.

Littman, Brett. "Christopher Wilmarth's Glass Poems." *Glass: The Urban Glass Art Quarterly*, no. 71 (summer 1998): 44–47.

Lubowsky, Susan. *Sculpture since the Sixties: From the Permanent Collection of the Whitney Museum of American Art.* Exh. cat. New York: Whitney Museum of American Art, 1988.

Lyon, Christopher. "Another Place for Dreams." *Members Quarterly of the Museum of Modern Art* 2, no. 1 (summer 1989): 12, 23.

Madoff, Steven Henry. "Christopher Wilmarth at the Studio for the First Amendment." *Art in America* 70, no. 10 (November 1982): 119–20. Review of *Christopher Wilmarth: Breath*, Studio for the First Amendment.

Mann, Audrey. *Recent Glass Sculpture: A Union of Ideas.* Exh. cat. Milwaukee: Milwaukee Art Museum, 1997.

Marian Locks Gallery. *The Purist Image.* Exh. cat. Philadelphia: Marian Locks Gallery, 1986.

Masheck, Joseph. "Chris Wilmarth." *Artforum* 10, no. 10 (June 1972): 81. Review of *Chris Wilmarth*, Paula Cooper Gallery, New York.

———. "Chris Wilmarth, Rosa Esman Gallery." *Artforum* 12, no. 9 (May 1974): 65–66. Review of *Chris Wilmarth: Drawings and Small Sculptures*, Rosa Esman Gallery, New York.

McDonald, Robert. "Chris Wilmarth." *Artweek* (Oakland, Calif.) 5, no. 12 (March 23, 1974): 5. Review of *Chris Wilmarth: Recent Sculpture*, Daniel Weinberg Gallery, San Francisco.

———. "Rich Effects in Steel and Glass." *Artweek* (Oakland, Calif.) 9, no. 32 (September 30, 1978): 1. Review of *Chris Wilmarth: Recent Sculpture and Drawings*, Daniel Weinberg Gallery, San Francisco.

McFadden, Robert D. "Christopher Wilmarth, Artist, Is Apparent Suicide." *New York Times*, November 20, 1987.

McQuaid, Cate. "Reflecting on Works Both Light and Dark; Christopher Wilmarth: Layers, Clearings, Breath." *Boston Globe*, April 30, 1998. Review of *Christopher Wilmarth: Layers, Clearings, Breath*, Nielsen Gallery, Boston.

———. "In His Works, a Graceful Relationship between Drawing and Sculpture." *Boston Globe*, June 22, 2003. Review of *Christopher Wilmarth: Drawing into Sculpture*, Fogg Art Museum, Cambridge, Mass.

Megged, Matti. "The Void and the Dream: New Sculptures by Christopher Wilmarth." *Arts Magazine* 61, no. 10 (June/summer 1987): 74–75.

Miedzinski, C. "The Poetry of Breath." *Artweek* (Oakland, Calif.) 14, no. 23 (June 18, 1983): 5. Review of *Christopher Wilmarth: Breath*, University Art Museum, Berkeley, Calif.

Museum of Art, Rhode Island School of Design. *The Albert Pilavin Collection: Twentieth-Century American Art II.* Providence: Museum of Art, Rhode Island School of Design, 1973.

Museum of Modern Art, New York. *Contemporary Sculpture: Selections from the Collection of the Museum of Modern Art.* Exh. cat. New York: Museum of Modern Art, 1979.

———. *An International Survey of Recent Painting and Sculpture.* Exh. cat. New York: Museum of Modern Art, 1984.

———. *A Decade of Collecting: Selected Recent Acquisitions in Modern Drawing.* Exh. cat. New York: Museum of Modern Art, 1997.

Naves, Mario. "Christopher Wilmarth." *New Criterion* 14, no. 6 (February 1996): 49–51.

———. "The Simplicity Rothko Longed For, in Wilmarth's Uncanny Sculpture." *New York Observer*, May 8, 2000. Review of *Christopher Wilmarth: Every Other Shadow Had a Song to Sing*, Robert Miller Gallery, New York.

Nielsen Gallery. *Then and Now: The Nielsen Gallery Thirty-fifth Anniversary Exhibition.* Exh. cat. Boston: Nielsen Gallery, 1999.

Noble, Alastair. "Christopher Wilmarth: Robert Miller Gallery." *Sculpture* 19, no. 9 (November 2000): 59–60. Review of *Christopher Wilmarth: Every Other Shadow Had a Song to Sing*, Robert Miller Gallery, New York.

Paula Cooper Gallery. *New York '72*. Exh. cat. New York: Paula Cooper Gallery, 1972.

Pincus-Witten, Robert. "Christopher Wilmarth: A Note on Pictorial Sculpture." *Artforum* 9, no. 9 (May 1971): 54–56.

Poirier, Maurice. "Christopher Wilmarth: 'The Medium Is Light.'" *Artnews* 84, no. 10 (December 1985): 68–75.

Robins, Corinne. "The Circle in Orbit." *Art in America* 56, no. 6 (November/December 1968): 62–63.

Rubinfien, Leo. "Christopher Wilmarth, Grey Art Gallery, N.Y.U., and Studio for the First Amendment." *Artforum* 16, no. 7 (March 1978): 70–72. Review of *Christopher Wilmarth: Sculpture and Drawings*, Grey Art Gallery & Study Center, New York University, and of *Christopher Wilmarth: Recent Sculpture*, Studio for the First Amendment.

Schultz, Douglas G. *Eight Sculptors*. Exh. cat. Buffalo, N.Y.: Albright-Knox Art Gallery, 1979.

Schwabsky, Barry. "Chris Wilmarth." *Arts Magazine* 61, no. 5 (January 1987): 121. Review of *Chris Wilmarth: Delancey Backs (and Other Moments)*, Hirschl & Adler Modern, New York.

Schwendenwien, Jude. "Christopher Wilmarth: Hirschl and Adler Modern" *Sculpture* 15, no. 6 (July/August 1996): 59–60. Review of *Christopher Wilmarth: Sculpture*, Hirschl & Adler Modern, New York.

Scott, Sue. *The Edward R. Broida Collection: A Selection of Works*. Exh. cat. Orlando, Fla.: Orlando Museum of Art, 1998.

Sherman, Mary. "Wilmarth Works Reveal Mastery of Nuance." *Boston Herald*, March 18, 2001. Review of *Christopher Wilmarth: Living Inside*, University Gallery, University of Massachusetts Amherst, Amherst.

———. "Drawing into Sculpture." WBUR Public Arts Web site (http://www.publicbroadcasting.net/wbur/arts.artsmain?action= viewArticle&id=489380&pid=30&sid=6), accessed April 29, 2003. Review of *Christopher Wilmarth: Drawing into Sculpture*, Fogg Art Museum, Cambridge, Mass.

Singer, Susanna. *Drawings for Outdoor Sculpture, 1946–1977*. Exh. cat. New York: John Weber Gallery, 1977.

Smith, Roberta. "Chris Wilmarth." *New York Times*, November 7, 1986. Review of *Chris Wilmarth: Delancey Backs (and Other Moments)*, Hirschl & Adler Modern, New York.

Smith, Tony. "Sculture di vetro." *Arte Milano* 2, no. 2 (June 1973): 18–19.

Sozanski, Edward J. "Poetry in Glass and Steel." *Philadelphia Inquirer*, July 23, 1989. Review of *Christopher Wilmarth*, Museum of Modern Art, New York.

Spalding, Kelly. "Christopher Wilmarth: Still Life/Still Alive." *Arts Media* (September 1996): 21. Review of *Christopher Wilmarth: Still Life/Still Alive*, Nielsen Gallery, Boston.

Stapen, Nancy. "Must-see Works by a Legendary Artist." *Boston Globe*, October 28, 1993. Review of *Christopher Wilmarth: Sculpture and Works on Paper*, Nielsen Gallery, Boston.

Stoops, Susan. *The Contemporary Drawing: Existence, Passage and the Dream*. Exh. cat. Waltham, Mass.: Rose Art Museum, Brandeis University, 1991.

Taylor, Robert. "Christopher Wilmarth: Breath." *Boston Globe*, April 10, 1983. Review of *Christopher Wilmarth: Breath*, Institute of Contemporary Art, Boston.

Tucker, William. *The Condition of Sculpture: A Selection of Recent Sculpture by Younger British and Foreign Artists*. Exh. cat. London: Hayward Gallery, 1975.

Unger, Miles. "Christopher Wilmarth: Layers, Clearings, Breath at Nielsen Gallery." *Sculpture* 17, no. 9 (November 1998): 70–71. Review of *Christopher Wilmarth: Layers, Clearings, Breath*, Nielsen Gallery, Boston.

Vassar College Art Gallery. *Twenty-Six by Twenty-Six*. Exh. cat. Poughkeepsie, N.Y.: Vassar College Art Gallery, 1971.

Walker, Barry. *Tina Turner, Christopher Wilmarth; In the Blue Blackness of My Sheep, Leonid Lerman, from the Edward R. Broida Collection*. Exh. cat. Houston: Museum of Fine Arts, 2000.

Wasserman, Emily. "Christopher Wilmarth, Graham Gallery." *Artforum* 7, no. 5 (January 1969): 59–60. Review of *Christopher Wilmarth*, Graham Gallery, New York.

Whitney Museum of American Art. *1966 Annual Exhibition: Contemporary Sculpture and Prints.* Exh. cat. New York: Whitney Museum of American Art, 1966.

———. *1968 Annual Exhibition: Contemporary American Sculpture.* Exh. cat. New York: Whitney Museum of American Art, 1968.

———. *1970 Annual Exhibition: Contemporary American Sculpture.* Exh. cat. New York: Whitney Museum of American Art, 1970.

———. *1973 Biennial Exhibition: Contemporary American Art.* Exh. cat. New York: Whitney Museum of American Art, 1973.

———. *Two Hundred Years of American Sculpture.* Exh. cat. New York: Whitney Museum of American Art, 1976.

———. *1979 Biennial Exhibition.* Exh. cat. New York: Whitney Museum of American Art, 1979.

———. *The Decade in Review: Selections from the 1970s.* Exh. cat. New York: Whitney Museum of American Art, 1979.

———. *Minimalism to Expressionism: Painting and Sculpture since 1965 from the Permanent Collection.* Exh. cat. New York: Whitney Museum of American Art, 1982.

———. *In a Classical Vein: Works from the Permanent Collection.* Exh. cat. New York: Whitney Museum of American Art, 1993.

Wiener, Daniel. "Christopher Wilmarth: Museum of Modern Art." *Flash Art*, no. 149 (November/December 1989): 142–43. Review of *Christopher Wilmarth*, Museum of Modern Art, New York.

Wilkin, Karen, and Bruce Guenther. *Clement Greenberg: A Critic's Collection.* Exh. cat. Portland, Ore.: Portland Art Museum, 2001.

Worth, Alexi. "Christopher Wilmarth: Sidney Janis." *Artnews* 96, no. 3 (March 1997): 109. Review of *Christopher Wilmarth: Sculpture and Painting from the 1960s and 1980s*, Sidney Janis Gallery, New York.

Yale University Art Gallery. *Prints by Contemporary Sculptors.* Exh. cat. New Haven, Conn.: Yale University Art Gallery, 1982.

Yood, James. "Christopher Wilmarth." *Artforum* 40, no. 6 (February 2002): 134–35. Review of *Christopher Wilmarth*, Arts Club of Chicago.

Zucker, Barbara. "Christopher Wilmarth," *Artnews* 77, no. 9 (November 1978): 181. Review of *Christopher Wilmarth: Sculpture, 1972–1973*, André Emmerich Gallery, New York.

# INDEX

# COPYRIGHT AND PHOTOGRAPHY CREDITS